101

TOP TIPS FROM PROFESSIONAL

MANGA
ARTISTS

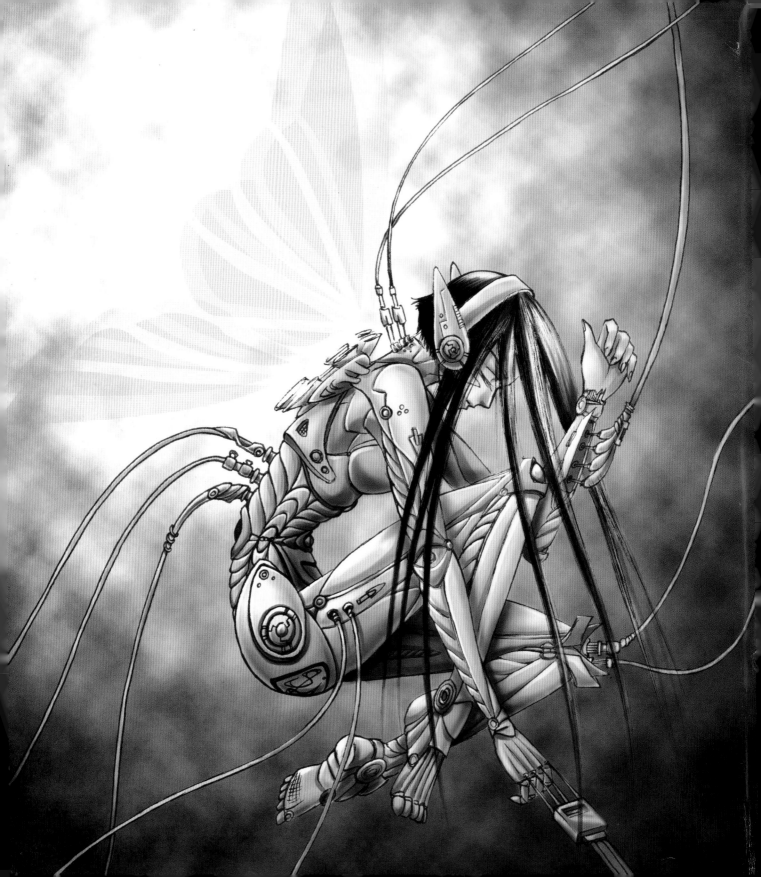

101

TOP TIPS FROM PROFESSIONAL

MANGA
ARTISTS

SONIA LEONG

First edition for the United States, its territories
and dependencies, and Canada published in 2013
by Barron's Educational Series, Inc.

All inquiries should be addressed to:
Barron's Educational Series, Inc.
250 Wireless Boulevard
Hauppauge, New York 11788
www.barronseduc.com

ISBN: 978-1-4380-0206-4

Library of Congress Control Number:
2012948428

This book was conceived,
designed, and produced by:

ILEX
210 High Street
Lewes, East Sussex
UK, BN7 2NS

Publisher: Alastair Campbell
Creative Director: James Hollywell
Managing Editor: Nick Jones
Senior Editor: Ellie Wilson
Art Director: Julie Weir
Designers: Chris & Jane Lanaway

Color Origination: Ivy Press Reprographics

Printed in China

9 8 7 6 5 4 3 2 1

CONTENTS

Introduction

Many people are attracted to the bright and exciting imagery of Manga. This form of cartooning and comics from Japan comes in a wide spectrum of styles ranging from cute and adorable, through sharp and stylish to near-realism. Despite the variety, there are common design elements in the way characters and environments are expressed and presented to the reader.

Manga artwork has a firm grounding in reality, using many theories and practices from classical illustration. It distills the subject matter into a more minimal form. The line work is selective—expressive, exaggerated, but generally cleaner. Even when drawn in a very cute style intended for young children, the colors, shading, and character designs tend to be more complex than their Western counterparts. This is particularly apparent when you look at Japanese comics, the real meaning of the word "Manga." Manga does not actually refer to stand-alone artwork, it refers to comics and sequential art. The techniques employed in Manga to tell a story through comics are highly sophisticated, with dynamic page layouts, extreme close-ups, and ever-changing camera angles. This is also achieved despite being a primarily black-and-white medium. Color is usually only reserved for covers, splash images, and short previews. The cheaper printing costs of working in black and white make it possible for creators and consumers to indulge in long-running, epic story lines.

Manga art is also closely linked to Anime, or Japanese animation. The character designs and raw drawing knowledge required are essentially very similar, but the finish and presentation are different

Given the multifaceted nature of Manga, it is important to identify the key features of the format without limiting yourself to copying someone else's style. This book aims to collect insider knowledge of professional Manga artists who produce images for the industry on a regular basis. We all have our own styles, but we have practiced with numerous tools and techniques to create polished work in many formats. You may be a total beginner or an experienced artist looking to add Manga to your repertoire—whatever the case, we cut right to the point and provide tailored advice on the essentials. We hope that you find our tips useful!

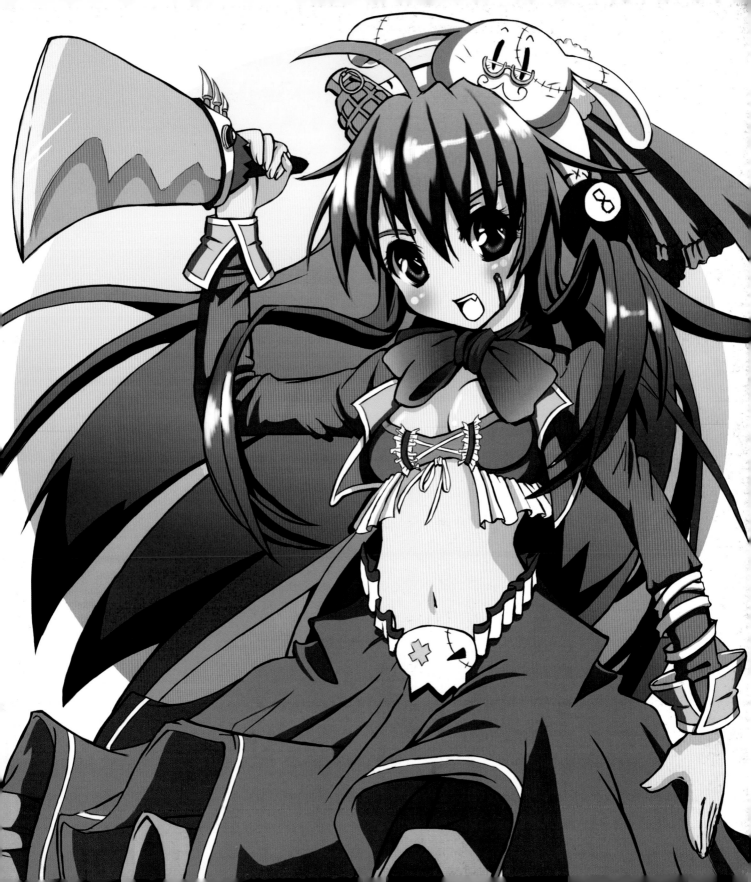

Getting Started

Like any other form of comic and sequential art, Manga is a combination of images and story. Even if it is a stand-alone piece of art, you should try to achieve a high level of polish and have a good understanding of the popular styles of Manga so that you are best prepared to tackle it. Before you throw yourself into drawing that epic project, take some time to plan your approach so that your work flow won't suffer from any snags. Research your subject matter thoroughly so that your character designs, setting, and plot points are accurate and appropriate. Get your sketches, notes, and ideas all down in one place so that it is a convenient reference for you to use throughout your project. Make sure you have the right tools, or learn how to get the most from your available tools, so that your images look their very best.

GETTING STARTED:
RESEARCH AND INSPIRATON

Research and Inspiration

Let's face it—no one becomes a writer or an artist without being inspired by something or someone. Whether it gradually builds up in your subconscious, or is that spark that drives you crazy unless you give it an outlet, inspiration gives you the impetus to start creating. But inspiration alone cannot create Manga. You need to do your research in order to make a quality product that can be appreciated by others. Good research will ensure your story and artwork stand up to scrutiny, but it also provides focus and relevance to a project.

TIP 001

Primary Research

Primary research in Manga is about getting your references and sources firsthand—that is, seeing it in front of you, actually experiencing it, or at least viewing accurate photographs of your subject matter.

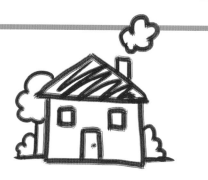

Left: To many beginners, a house is a square with a triangle on top for a roof, square windows on the front, and a rectangular door. But in real life, a house does not really look like that at all.

Above: See the differences between the theory, the photo, and the drawing?

Below: This scene is set in Cambridge, England, so actual photos of Cambridge were referenced to get the backgrounds right.

I always say to those who are not confident in their drawing skills that everyone has the ability to draw, but not everyone has learned how to see. Many beginners draw things based off a stereotypical concept or symbol, so you get cartoonish renditions of people's faces, trees, or houses.

Let's take an even simpler concept: a table. Some would describe and draw it as a square with four legs of equal length. While in theory many tables are such, you would never see a table in real life looking like that. You would most likely see a rhombus/diamond shape, and the legs would appear with different lengths because of the viewing angle.

Expanding from this simple idea, never feel like you should forgo any research if you cannot visualize your subject matter accurately. Does your next comic involve

lots of animals? Look at real animals—go to the zoo or spend an afternoon with a friend who has pets. Do you need to draw bicycles? They are notoriously difficult to get right, so be sure to look at lots of photos or designs. Is your Manga set in a particular building? Go there if you can. In a faraway country? Check online for tourist photos.

Leaving the visuals aside, get the facts right if you are writing. If your Manga is set in a desert, your character cannot ride a bicycle! Consider cultural elements as well—people dress, speak, and gesticulate in different ways around the world.

Never forget where your favorite Manga characters and stories have come from—the creator has had to study real people and real settings in order to create a believable world. (SL)

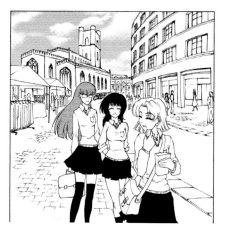

Secondary Research

Almost as important as primary research, secondary research involves learning something from someone else's works or accounts. In the scope of Manga, this means referring to other people's artwork, writing, and designs. This has both positive and negative results, so it is important to know where acceptable limits lie.

Manga artwork is often very minimalist in execution—as such, it is extremely useful to know how other artists choose to render their subject matter, particularly human. Despite the fact that so many Manga artists are drawing the same species (humans), the range, style, and output is huge. When looking at another Manga artist's work, think about the lines they decided to put onto the paper and why they made that decision. Think about what parts have been emphasized and what has been left out.

It is also imperative to read other Manga comics to recognize the shortcuts and common elements used in storytelling. Particular techniques and theories will be covered later in this book, but nothing beats reading widely to see how to execute an exciting fight scene or efficiently introduce a new character.

Finally, one of the best reasons to collect art books or a Manga series by a particular artist is if it is in a fantasy or science-fiction setting. Video games in particular are a great source of design and concept art, as the creators have spent a lot of time creating completely immersive worlds. It's great to quickly get an overall feel of what elements are important, but also to see which designs won out in the end and worked on a practical level.

The danger is referencing so much that you end up practically copying another artist's work. There are many similar-looking character designs out there, which is innocent enough in most cases (as there is so much Manga out there, it's nearly impossible these days to come up with a character that looks completely original!), but if paired with the same composition and posing, or rendered in the same medium or drawn in a similar style, it's just too much. The same goes for stories: You can be inspired and reference heavily from your favorite action series, but if it's a thinly veiled swapping of the original characters' names for your own, it's not good! (SL)

Above: The original image.

Above: This shows the differences between the original photographed subject, a more realistic pencil drawing, and a very stylized Manga ink version.

GETTING STARTED:
RESEARCH AND INSPIRATON

TIP 003

Life Experience and Hobbies

Doing the necessary research for your Manga is vital for producing something that stands up to scrutiny, but why not draw on your own experiences and the knowledge that you already have? You can save a lot of time by using your observations and memories to create sympathetic characters, settings, and original story lines.

When making a Manga in a contemporary setting, personal experience can really flesh out your dialog and help you create rounded, believable characters. Readers can be very touched by story lines that they could imagine themselves going through—even more so if they share an experience with the characters.

Don't feel restricted to slice-of-life stories in real-life settings, though. It can be fun and exciting to mix your experiences with other environments. Often, an unbelievable setting can be kept believable and relevant by incorporating elements of reality, or vice versa.

Incorporating your hobbies and interests into your Manga is a great way of utilizing your existing knowledge and resources to accurately portray characters and settings. If you love gardening, why not make a Manga about a gardener, or someone who runs a gardening store? You probably know exactly what problems they would face and how to plan the scenery

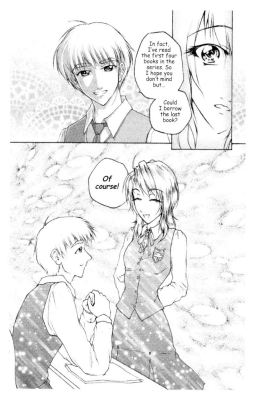

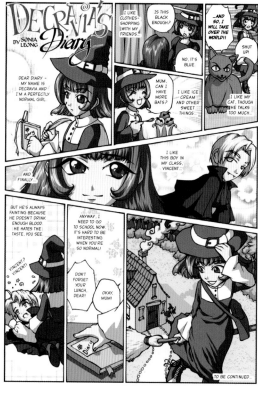

Far Left: This story line is based on how I actually became friends with a boy at school. We got to know each other by swapping each other's fantasy novels.

Left: This is about the everyday life of a schoolgirl (something which I have been through), who happens to be a witch in a fantasy world.

realistically, and you likely already own magazines and reference materials about drawing plants and flowers. You can also appeal to your readership, as people who like the same things you do will be interested in your Manga. Market your work to your fellow enthusiasts!

However, making any type of comic of any length requires a lot of dedication and commitment if it is more than just a few pages long. When seeking motivation, nothing is better than if you have a personal interest or passion for what you are working on—it keeps you going after months of working on the same thing.

While putting much of yourself and what you like into your Manga is mostly a good thing, be wary of making a "Mary-Sue" (an idealized, wish-fulfillment character). Self-insertion can work to a degree and in the right circumstances, but making a character a little too perfect or too much like you (when they are not meant to be you) can be cloying. (SL)

Right: This is set in modern-day England (where I live) with a character who has Chinese origins (like me), but with Chinese ghosts!

Top, Top Right, Far Right: One of my hobbies is fencing and collecting antique or replica weaponry, so I love incorporating my collection into my artwork.

GETTING STARTED:
TOOLS, EQUIPMENT, AND MATERIALS

pen and pencils

Tools, Equipment, and Materials

Talent and skill will always show through, regardless of the materials used, but some tools make achieving specific finishes much easier, so it's important to identify the things you need for a certain look. Be wary of hype—you don't always need expensive or specialist materials; often you just need to use the cheaper stuff more effectively. As the old adage goes: it's not what you've got, but what you can do with it that counts!

Color pencils

TIP 004

Getting the Best From Common Resources

Before rushing off to an art supplies store and spending lots of money buying new things, think about what you already have at home and in the office, or what you can pick up at any convenience store or supermarket's stationery section.

Specialist paper with pre-printed margins and crop markings is convenient to use but can be expensive. You can do almost everything on standard office printer paper that you can buy cheaply in reams, so long as you understand its limitations. Pencils and drier forms of inking and coloring (such as fineliner pens, colored pencils, subtle marker work) will work on the standard paper. Using anything more liquid? Just put some extra sheets underneath to soak it up.

The cheapest and most plentiful of drawing tools is the pencil. Traditional wood-cased pencils can be sharpened to a point to draw thin, crisp strokes—this is good for outlines and hatching or crosshatching. Medium to harder leads (HB, H, 2H, 3H, and onwards) are better suited to such lines. Pencils can also be blunted or chiseled to an edge through use, which makes them good for thicker lines and

soft, gradient shading. Soft leads (B, 2B, etc.) suit this sort of work and can also produce dark fills.

You can also buy mechanical or propelling pencils that can take leads of different hardness in varying thicknesses (usually 0.3, 0.5, or 0.7)—great for lines, just not as expressive as traditional pencils for shading. The benefit here is not having to sharpen your pencil constantly.

Pencils look their best if used entirely in grayscale (so on their own or mixed with other materials in black and white), or as very soft outlines for expressive, high-contrast, high-textured colors (such as watercolors). Don't use them with colored pencils! Both the outlines and colors lose their vibrancy and wash each other out.

You can spend as much as you want on pens, but those you're most likely to find scattered around your home, school, or office are rollerball gel pens and ballpoint pens. The quality of these will vary a lot, and you may need to test a few out first. Ballpoint pens are drier with a more viscous, oil-based ink. Using a softer touch, you can vary the levels of ink so

Watercolors

it lends itself very well to shading, similar to a pencil (this makes it unsuitable for sharp black inking). In contrast, rollerball gel pens have a faster flow of ink, with a strong, black line. This makes it a viable option for inking and hatching with fairly clean lines.

If you want to ink on top of a rough pencil draft and then erase the pencils, stick to rollerballs and give them time to dry. Don't use ballpoints for this—they will smear!

Colored pencils are cheap, plentiful, and easy to use, but they require a good technique to achieve a high polish. Watercolors are also easily available and affordable but require additional preparation before using, such as brushes, palettes, jars of water, and the right sort of paper. (SL)

Choosing Specialist Tools

Many beginners mistakenly think that they have to spend lots of money to get specialist tools and materials. The secret is in choosing your investments carefully to mix with your existing resources and picking items that complement your drawing style.

When drafting pencil roughs by hand, I often use non-photo (or non-repro) pencil leads in various colors with my mechanical pencils. These lines cannot be picked up by most photocopiers, or once scanned they can be filtered out by most image-editing software. As such, I can draw over my color sketches with black ink without needing to erase my rough pencil sketches.

There are different brands and prices available, so it's worth shopping around. The most popular size is 0.7 thickness. Softer leads are erasable but break easily, whereas harder leads are more robust but cannot be erased.

Much Manga artwork relies on clean black lines (or if textured, each smear and spot is pure black ink on white paper with no shades of gray). Our specialist inking tools are therefore geared toward producing this finish.

Fineliners are the easiest inking tools for someone to start using. Their fiber tips are forgiving, and their convenient all-in-one packaging makes them great for travel. There are many brands available with different qualities (marker-proof, fade-proof archival ink, or water-based) in widths from as thin as a 0.05 through to 1.0. It takes practice and a light touch to get good amounts of line-width variation.

Brush pens are similar in that they have an inbuilt (sometimes refillable

or interchangeable) ink reservoir attached to a brush tip, so it's another convenient all-in-one tool for inking. By varying your pressure and angle, you can create incredibly fine, thin lines or great swathes of thick, textured strokes. There aren't as many manufacturers of this type of pen, but there are still plenty of varieties and sizes for you to try out.

Dip pens are the traditional tools of cartoonists the world over. Buying the pen holder, a selection of pen nibs, and a big bottle of ink doesn't cost that much and will last you hundreds of pages. They can be so expressive but take a lot of getting used to, and mistakes can be very costly! You can also use traditional brushes in black ink to fill in large areas or use as a brush pen, but you need to keep dipping as you go along.

Manga is shaded in black and white, so artists tend to use sheets of tone—stickers with dots and patterns, which you cut out and paste onto your lines. This reproduces consistently in black-and-white printing. You can buy all sorts of varieties from different manufacturers.

High-end felt-tip markers are often alcohol-based to reduce streaks and have brush-like, flexible tips as well as chisel tips. Getting these professional markers can be a big investment, but they really do deliver—you can quickly achieve a smooth, high-quality finish on any sort of paper. No need to splurge on loads of colors at once, though! Build up your collection gradually with skin tones and pale or smokey colors to produce a sophisticated palette from the outset. (SL)

Alcohol-based felt-tip markers

Drafting pencil and colored leads
(non-photo leads that can fit standard mechanical pencils)

Sheets of tone

Fineliner pen

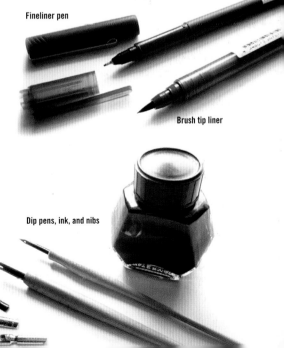

Brush tip liner

Dip pens, ink, and nibs

GETTING STARTED:
TOOLS, EQUIPMENT, AND MATERIALS

TIP 006

Working Digitally

Nowadays, many artists start off their work as a quick sketch on paper, which they then refine and polish on a computer. Even staunch traditionalists may have to process digital versions of their work when getting it printed or sending it to a publisher. On the other extreme, there are artists who work entirely on the computer, from initial sketches through to the final product—even publishing it digitally so there is never a hard copy of the work at any stage. However you choose to work, there are various tools out there, some of which can be considered necessities and others as very helpful options.

Computers don't need to be top-of-the-line for them to be useful. Anything less than ten years old is capable of running basic image-editing software, or older/simpler versions of well-known professional programs. Processing power essentially governs how large a file you can work with (that is, actual physical dimensions and size, detail, resolution, and how many layers and effects you can use) and how long it takes for things to happen.

What is important in selecting a computer setup or laptop is the screen quality. Large, vibrant screens with high resolutions are ideal for artists in order for them to get a good overall view of their work. It's also vital that when dealing with modern flat screens the viewing angle doesn't affect the colors and tones of your artwork too much—something that many laptops do.

Initial sketch

Final digital image

Above: A graphics tablet from Wacom.

Using a graphics tablet instead of a mouse is an absolute necessity if you want to do anything more than cropping, dropping images into a document, or lettering. Your drawing hand is in a much more sustainable position for general administrative tasks (selecting, dragging, etc.), and you will have precision control for creating lines or shading like you would naturally. Furthermore, unlike a mouse, most graphics tablets are sensitive to drawing angle and pressure so that you can produce varied line widths and opacities, just like real pencils, pens, and brushes.

There are products that merge the screen and the tablet together, but unless you are willing to invest the large amounts of money in buying something geared toward art production specifically, general purpose tablet computers cannot detect the nuances of a drawing tool as well as even a budget graphics tablet can.

Digital cameras are capable of capturing good images of your traditional artwork, just as cameras have reproduced large scale paintings in the past, but you need to get the lighting and angle right.

Scanners also capture your artwork conveniently and accurately with a strong, consistent light through a glass platen. New models are coming out all the time, so I would suggest prioritizing speed and resolution.

Once you own the hardware, you need to be able to edit or create artwork on the computer using software. At the most basic level, you will want to use a program that allows you to work in layers (so you can keep some parts of your artwork separate and fully editable) and that can detect the pressure sensitivity from your graphics tablet (so that you can draw and paint effectively).

Software selection is a tricky road to travel, as there are so many new developments in the field—it is hard to know what is best at the time. But you shouldn't neglect what you may already own! Much hardware comes bundled with CG painting or image-editing software, so if you have recently

purchased a graphics tablet or a scanner, look around for the packaging and any installation CDs/DVDs. This software has been chosen or designed to work with your hardware, so it will be useful and capable of doing much of what you need.

Don't feel as if you need to get the latest version of any particular program. If there have been many popular versions and developments over the past few years, you can obtain older versions that can still produce very good work at a much cheaper price. You can also save money by buying starter versions or pared-down editions of professional programs. (SL)

Left and Below: You can buy digital cameras that can take pictures at high resolutions for fairly affordable prices. Make sure the model you choose can handle close-ups of artwork.

Right: A scanner that can capture your artwork at speed in a high resolution without washing it out is very important for artists working in traditional mediums.

GETTING STARTED:
KEEPING A SKETCHBOOK

Keeping a Sketchbook

In my opinion, everyone should keep a sketchbook or some form of diary, regardless of whether they consider themselves to be artists or not. They are so useful and practical to have around, even just for notation purposes, but don't limit yourself by thinking that all they're good for is writing a couple of things down. Choose the right sort of sketchbook to suit your way of working, then push yourself with different activities and exercises to keep your drawing muscles in peak condition.

TIP 007

Establishing Routines and Good Practices

When picking out a sketchbook, the first thing I think about is size. Something fairly small and portable is most versatile, as it will fit into most bags and is easy to use in all situations, even when you're cramped into a small car or train seat. If it's too small it becomes difficult to draw anything substantial, particularly if you're the type of artist who prefers to use bigger, roomier strokes. I recommend anything from half letter (8.5 x 5.5 in) to letter size (8.5 x 11 in) or A5 (5.8 x 8.3 in) to A4 (8.3 x 11.3 in).

The paper shouldn't be too thin. As you fill it up, you'll most likely end up drawing on both sides of the paper, so make sure the weight can handle that. And don't use black-ruled paper. Plain, clean surfaces are best—unless you want guidelines for getting certain lengths and proportions right, in which case ruled or graph paper can work, but make sure the markings are in a very light color so it's possible to filter them out in scanning.

Optional but useful extras include: a stiff board back or covering that allows you to sketch without needing a hard drawing

surface like a table or clipboard; spiral binding so that you can fold back each page fully for keeping your working area compact and easy to scan; inbuilt clips or straps or magnets to keep the book closed; cover flap pockets for keeping any extra scraps; and perforated pages in case you want to remove anything (although this works against you if you want your pages to stay intact in the book).

You can also go digital. There are various tablet computers and other electronic scribing devices that allow you to notate or draw with a stylus or finger in a similar manner to how you would work with a traditional pen/pencil and sketchbook, but they vary in quality and sensitivity. It's a different experience, so think of it as a supplement.

For me, the sketchbook is where I get all of my ideas out of my head and onto the paper, including character designs, poses, and expressions that show off their personalities; graphic designs of covers or logos; and story lines and script. Sometimes it can take several attempts before I can get a character right; other

times, the image I have imagined is so clear, I just need to draw it one time. It's great for tracking the progression of ideas and comparing characters.

Always carrying a sketchbook with you will mean that you'll be able to doodle whenever and wherever inspiration strikes. You know those times when you come up with an amazing story but don't have anything to write it down on? Or when you're waiting for your bus and the sun comes out of the clouds and suddenly that mother and child playing on the swings nearby are bathed in light and they become a work of art that you wish you could capture? This is a thing of the past, if you keep your trusty sketchbook with you!

It is also a great way to encourage you to practice your drawing skills. Many scientists have theorized that it takes ten thousand hours of practice to become an expert at something—this roughly equates to a little under three hours a day for ten years! As such, having a sketchbook with you constantly allows you to build up those hours every day, a little bit at a time.

Before you start drawing anything serious or important, start off your session with something simple and fast. It's like stretching your muscles before going for a swim—you don't want to cramp up in the middle of something important! My favorite thing to do is a quick line drawing of a character that I know inside out. Then, if you're stuck for things to do with your sketchbook, try some of the exercises below.

Speed sketches
Draw something in front of you in less than thirty seconds. If it's a face, just focus on the profile. A crowd? Draw stick figures to quickly show movement. Increase the time limit to one minute, then three minutes.

Shift your mind-set
Artists intuitively see in different ways—some see volumes, others see shades of light and dark, and yet others see outlines and contours (and of these, some see the spaces left behind, rather than the object itself). One way of seeing isn't superior to another; some people are more suited to certain disciplines, styles, and media. Your sketchbook is a good place to explore and push your comfort zones, so make yourself see in a different way the next time you try drawing something. If you're used to drawing volumetric guidelines, try contour drawing, sticking only to outlines. Conversely, if you like drawing in outlines usually, try mass drawing, or shading areas and masses with no outlines.

Change one thing
Draw a subject matter that you are comfortable with in a medium that you are used to. Then for your next drawing, change one thing. If starting off with a pencil, switch to a marker, a pen, or a crayon. If you prefer to shade by pen and ink hatching, switch to a gray wash. Draw a familiar character and then try changing the hair, clothes, eyes, and build. What if your character lost a lot of weight? Experimentation can be lots of fun! (SL)

Below Left to Right: Many of my images start as rough sketches with design notes in my sketchbooks. The fairy moves from notes and a different pose to the version pictured. The girl with the bicycle was sketched on paper, then redrawn and colored digitally.

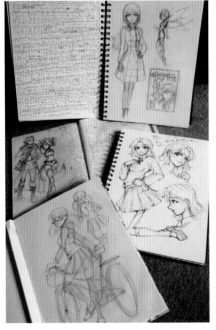

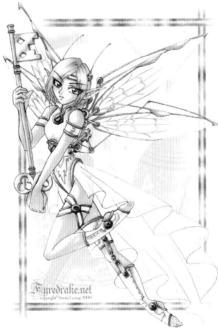

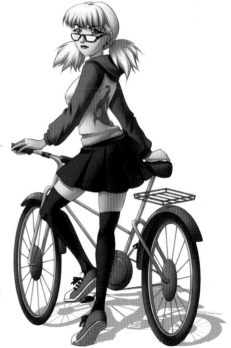

Drawing Characters

All of us learn through emulation and reinterpreting the work of others, and it is important for artists to be able to copy. Artists should also be able to observe subject matter in front of them, then reproduce it as an image on paper. But what separates a good comic artist from others is the ability to understand and analyze the structures, proportions, and relationships that are underneath the surface of what they see. Manga is a relatively clean, minimalist style, which simplifies real life. So to draw Manga characters, you must practice and learn from real-life anatomy in order to have a solid foundation to work from. Then you must identify what features are commonly exaggerated or understated, and when it is appropriate to do so. It is vital to commit key proportions and ratios to memory in order to consistently draw characters in many poses and angles.

DRAWING CHARACTERS:
DRAWING THE HEAD

Drawing the Head

It can be intimidating for a beginner to try to draw such distinctive and strongly styled Manga faces, but it is a mistake to simply copy or trace examples without understanding the proportions and structure underneath. With a few simple shapes and guidelines, you can develop a template that you can apply to many different characters in a variety of poses.

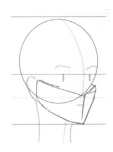

Above: These two images show how you can use a sphere as a starting point for drawing the head from the front, then construct the jaw coming from it. A three-quarter view is also shown for comparison so that you can see how the jaw and cheekbones extend.

Below: Note the softer, rounded face of the girl, compared with the much more clearly defined jawline of the guy.

TIP 008

General Construction and Front Profile

The human face can be constructed from simple geometric shapes. One popular method is to use a sphere, with a flattened jaw and mouth area wrapped around it.

This method is useful when considering the way the face will stretch when the mouth is open. By extending the jaw area you can accommodate a larger mouth, which is perfect for shouting, beaming joyfully, and other expressions.

Another good method is to start from a cylinder and round the jawline and top of the shape as appropriate. This method can be useful when drawing extreme angles. People have different shapes of face and head, so don't be afraid to mix up your methods to suit different characters.

The illustration of cheekbones will make a huge difference to the way a character looks. The cheekbones are often defined less predominantly in Manga than in Western illustration styles (such as Disney or Marvel). Dominant cheekbones will also be more common in adult characters, or those with exaggerated features.

Softly rounded cheeks are a popular aspect of Manga style characters. Try to make the line between the forehead and the chin a smooth and uninterrupted flow. Round cheeks can achieve a childish look to the face, especially when depicted without extra folds or lines.

Additional lines defining the shape of the face typically make the character look older. If the features are so bold that they need accentuating, it's likely the character has a sense of physical maturity. Manga often reduces character facial definition to as few lines as necessary, but this can vary depending on the style employed. (HS)

Side Profile

It's critical to be able to draw characters from all angles, and something as simple as the side profile can be difficult to capture. A common mistake is to treat the face as if it were flat. We're used to seeing our own faces in the mirror or in photographs, and this can lead to the impression of a face being flatter than it actually is.

The face will take up the entire front half of the head from the side, with the center line at the front of the ears. The outer edge of the eyes should align halfway into the face area. This can be easier to imagine when you draw a line defining the cheek at this point of the face.

Above Right: This side profile is drawn with vertical markers so that you can identify the relationships between the parts of the face. Some features protrude more than others.

Below: These male and female characters have very subtle differences in their side profiles—note the male's nose length and the generous spacing between the features compared with the closeness of the upturned nose, mouth, and chin of the female.

Below Right: These two guys are facing off in a sword fight. The one on the right has a very angular nose bridge and jawline.

The structure of the face varies significantly from person to person, but most of the variations rely on the same set of rules:

Lips are positioned in front of the chin, but be careful not to slope the chin too far backward.

The nose extrudes further than the mouth. A small, stumpy nose will often have a rounded face to ensure facial proportions are maintained.

The forehead shouldn't extend beyond the lips. It's good to give some brow definition above the eyes, but make sure it doesn't begin too far forward. (HS)

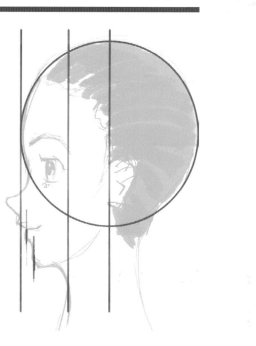

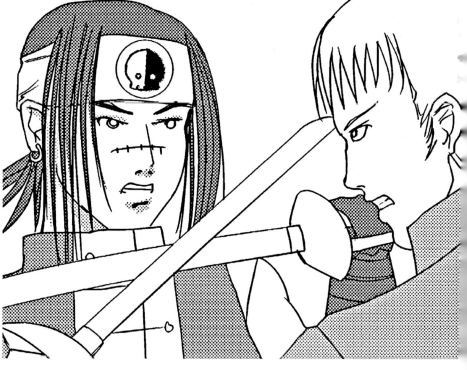

DRAWING CHARACTERS:
DRAWING THE HEAD

TIP 010

Changing the Angle and Direction

Most of the time when we think about the shape of a head, we think of the front and the side. These are crucial foundations but can be limiting when trying to draw the head from more interesting angles. A few more rules need to be considered.

Rotating sideways
Consider a vertical line on a face that crosses the outer edge of the eye. This vertical line, which can be referred to as the "cheek line" captures many important parts of the face shape and helps to define the face from almost every angle.

The cheek line shows how deep the eye socket is and how prominent the brow is as well. High cheekbones and softly curved faces will be captured effectively with this angle.

Rotating vertically
Because of the way the neck bends, heads will be more-or-less straight most of the time. If you want to show them angled down or up, a few simple methods can be employed.

Usually, the eyes will be aligned with the top of the the ears. If tilted down, the ears will appear higher and the eyes will appear lower. Tilting up will do the opposite.

Tilting backward will bend the curve of the face backward, which has a direct effect on the mouth. When the head tilts backward a flat mouth will curve downward. Using this method effectively can give great impact to expressions! (HS)

Above: This three-quarter view has a slight upward incline because the ears are a little lower than the eyes and eyebrows. His cheek line shows a high cheekbone and pointed chin.

Left: Three views showing side, three-quarter, and front profiles, respectively. The character is kept on a pure sideways axis rotation.

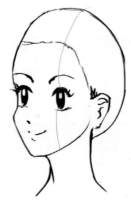
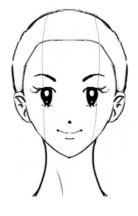

Extreme Angles

The vast majority of the time we see other people from a fairly limited range of angles. We're typically viewing from a relatively similar height, and rarely do we look at other people directly from below or above.

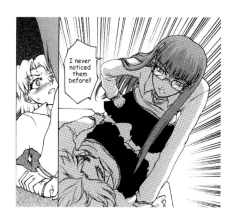

Capturing characters from a dramatic angle is a very intimate portrayal, often implying a close connection to the character, or that their presence conveys a particular emotion.

Drawing people from below often gives an air of status or creates a distant and aloof type of glance. The strong jaw definition creates a guarded sensation and mild disinterest in any onlookers.

When looking at a character from above, it grants a sense of intimacy, or even intimidation. The angle gives the audience an advantage, and you will perceive the character depending upon the chosen expression.

Consider the eyes and expression. A few alterations in the mouth and eyes can change someone from sweet and innocent to wild, aggressive, or, more subtly, assertive. (HS)

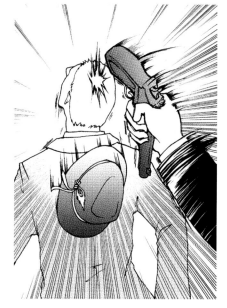

Right: The "camera" angle is very low, but the character's face is not tilted. She looks aloof and intimidating! Note only some of the underside of the chin is seen, and her furthermost eye is partially obscured by her nose.

Top Left: One schoolgirl pins another below her and looms over her threateningly. The girl in glasses has angled her face downwards, so her nose, mouth, and chin are squished together closer. The girl below is looking sharply upwards at her assailant, so you mainly see her forehead and the tip of her nose. Her eyes appear as thin lines.

Top Right: This character has her face tilted very strongly upwards, but we are viewing her from below. The underside of her chin is the main focus, along with a profile that shows the underside of her nose and nostrils.

Above: This man is being knocked out from behind with the butt of a gun. The camera is behind him as his head tilts back and he falls forward. You can only see part of his cheekbones and jaw and the tip of his nose.

DRAWING CHARACTERS:
HAIR AND HAIRSTYLES

Hair and Hairstyles

Artists sometimes have a love-hate relationship with depicting hair, as it is an amazing feature in real life. Flexible enough to be twisted into many shapes, with different textures and colors and thousands of strands, it can be drawn very simply or in a very complicated style. It is an important and eye-catching part of character design, so it's essential to understand how it works and what you can do with it.

TIP 012

Above: This character has unusual blocky hair. The straight ends and consistent shapes give an air of strict control due to the razor-sharp trim. These strong shapes are great for fantasy characters.

General Principles

Hair in Manga is often highly stylized, with aspects of the hair reduced to simple geometry. Illustration doesn't demand that every strand of hair gets drawn. It's better to use fewer lines and focus on the overall shape.

It's possible to create weird and wacky hairstyles in Manga that are quite impractical in real life. By using bold colors and elaborate shapes, you can create some fantastic-looking and distinctive characters that will always be recognizable regardless of what they are wearing. Even with tamer styles, it's always a great idea to give the hair plenty of thought, as an interesting hairstyle can really bring an image to life.

It's essential to get a good sense of where hair appears on the human head, and how you can use this to form different hairstyles. Marking out this scalp area before building up the hairstyle can help to ensure the body of hair looks convincing, even if heavily stylized.

One style popular in manga is to define "clumps" of hair, which fan out in small groups and finish in a sharp point. They can be brushed upward or backward for a "spiky" look, or arced downward into floppy bangs and bobs. (HS)

Far Left: Even without shading, you can tell that this sleek bob has a center parting, as the even and well aligned strands of hair lead up to the middle of the head.

Center: Here the hair is pulled back tightly into a low ponytail. It's crucial for the hair strands to go straight back from the hairline. A few loose strands can occur.

Left: This hairstyle is similar to the top image but has longer, wispy strands at the bottom and a side parting. The spacing in the clumps of hair imply that it hasn't been brushed neatly, or, if it was, it has been tousled by the wind.

Styling and Finish

It can be useful to think of clumped hair as "leaves." These flat sections of hair can be grouped together through the whole shape of the hairstyle and will follow in alignment to the head. Try layering flat strips onto the head to construct the body of the hairstyle, and splinter into finer detail later on.

Always consider the origin of every hair! All hair, and all clumps of hair, need to originate from the scalp. Even with complicated and heavily layered styles, it's crucial to consider where the hair is actually coming from. Simply drawing extra chunks of hairs sticking out at the side or jutting down from the back will always look fake. Long hair always needs to trace back to the scalp, even when it's folded or bunched in complicated ways.

Don't be afraid to draw plenty of construction lines for your hair, as you can make it simpler when it comes to inking. The more confident you are about the construction of your hair, the more freedom you have to change

and alter the hair to better suit the drawing.

When coloring and highlighting hair, remember that hair is highly reflective, often reflecting several light sources and refracting nearby tones. It's important to have very sharp highlights and bring as much richness to the colors as possible. Remember that shiny surfaces often brighten into different hues, so blue hair will become more yellow as it becomes lit, working through green to yellow to white. Play around with highlights to make the most of the volume you've defined.

Lots of styles have the hair fanning outward from a specific parting in the hair. If you draw lines radiating outward from this point, you can capture the sense of layered hair with plenty of depth. (HS)

Below Left: When drawing ponytails, leaving some sections loose can add dynamism and movement to close-ups.

Below: This girl has very sleek hair on top, with distinct, tousled curls at the ends, implying a blow-dry and the use of a heated curling iron.

Top: For blond hair, be sure to use enough levels of shading so that it looks shiny. Use a darker orange or light brown for the darkest shadows, and pure white for the highlights.

Below: Beautifully defined curls look impressive weaving in and out of each other. Be careful when shading and keep track of areas of light and shadow.

DRAWING CHARACTERS:
HAIR AND HAIRSTYLES

TIP 014

Complicated Styles

Hairstyles in Manga can be larger than life, with complicated construction that would give most hairstylists nightmares! By using a variety of techniques, you can present complex and interesting styles in a convincing way.

Mixing beads and ribbons into hairstyles is a great way to introduce detail and color into the hair and break up the colors. Treat these accoutrements in the same manner, giving consideration to volume and making sure they weave into the rest of the hair in a believable fashion.

Ponytails and pigtails can add dynamism to a character portrait, as the way they fall and blow with the air gives a bold and interesting shape. This sort of hair presents an air of youth and vibrancy and is actually pretty easy to draw!

Pull all hairlines from the scalp into the bunching point, and then follow the lines down and outward. Hair will often have enough natural stiffness that it can extend outward from the rest of the head.

Braids introduce a lot of detail to an image, whether as a central part of the style or added as a point of interest to an otherwise simple long hairstyle. By drawing a repeating fold pattern, you can quickly add variety to the image. Braids have a simple rope-like quality to the way they move, so they have more swing and energy than the rest of the hair.

Layered curls can be considered as multiple rows of cascading long hair. By breaking the construction of the hair into larger areas, this complicated style is easier to manage. (HS)

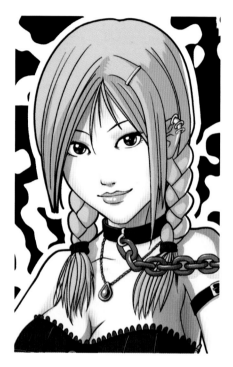

Below: The long hair of the mermaid isn't all loose, as there are two twisted sections in the front, as well as sparkling jewels woven throughout. She would also have very floaty hair that moves all around her with a slightly higher position to show she is immersed in water.

Above: Look carefully at the way the braids are formed in the hair. Take careful note of the lines used and the angles of the lines to get it right. When securing the hair at the ends, the hair ties squeeze the hair tighter before the loose ends spread out.

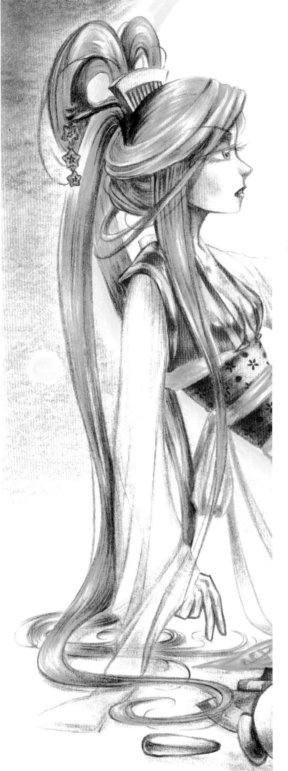

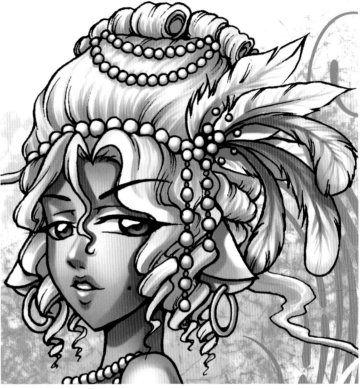

Above: This character has tumbling curls framing her face but a very high rococo-style updo with pearl strands and feathers. Treat each section separately so it is easier for you to shade and add texture and direction to the hair.

Left: This maiden has a very complicated updo in a romantic Chinese historical style. Her hair is extremely long, so even though it is pulled into loops with combs and pins, the ends still cascade down to the floor.

DRAWING CHARACTERS:
CHARACTERIZING FACES

Characterizing Faces

Manga is all about telling exciting stories with characters that leave a strong impression on you, so you need to bring your characters to life with faces that suit them, features that can differentiate them from other characters, and expressions that show what they are thinking.

TIP 015

Facial Features

Let's look at basic interpretations of the features of the face according to how they appear in various views and their relationship to each other.

Eyes are hugely variable in Manga, as they play such an important part in the storytelling technique with frequent close-ups. Ultimately, they are emphasized and clearly delineated more often than in other forms of cartooning.

The top line of the eyelashes is usually thicker than the bottom line. This frames the iris and pupil. The main thing to remember is putting in a highlight—this can be outlined and left as white paper before adding the details of the pupil and iris pattern outside it, or added afterward by erasing sections digitally or highlighting with white ink.

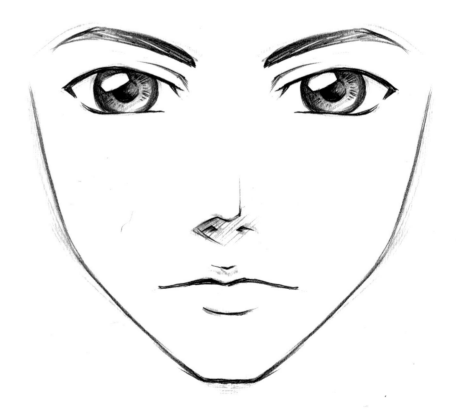

Right: Manga eyes are often larger and more expressive than in real life. Take inspiration from real life for eyebrows if you're struggling for variety. Front views of noses should be represented mainly by the shadows to keep the look clean. The same applies to the mouth; don't outline the lips in full, but focus on the mouth opening and defining the lower lip.

Eyebrows also come in many shapes, sizes, and angles.

Front views of a nose should be depicted with very minimal lines, showing the shadows. This can be interpreted simply or realistically according to your preferred style. The mouth is also very minimal and the lips are not usually outlined, unless the character is wearing makeup or has naturally protruding lips.

In a side view, eyes form a triangular shape, or at least have a sharp point at the outer corner. The eye becomes more compact and the shape of the iris gets narrower. The full nose shape is drawn in the side profile, and the underside of the nose leads into the philtrum (the cleft above the upper lip). The fullness of the lips is defined quite clearly in this view. Remember to match the curve of the lip to the actual opening of the mouth.

In three-quarter views or anything else considered in between, it takes practice to learn how much to shrink or stretch the features of the face so that it matches the perspective and angle of the head. You also need to gauge how strong to

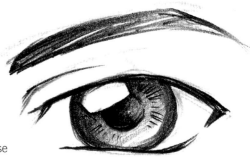

outline the nose because you see more of its shape the further to the side you go, but less as the character turns to face you. (SL)

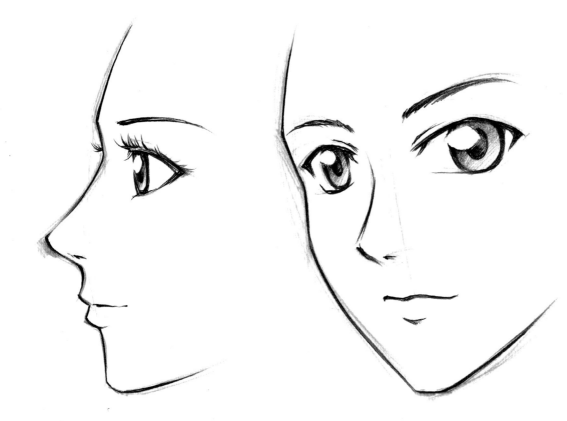

Above: A close-up of the eye from the front.

Far Left: The side view shows off the curve of the forehead, the actual nose shape, and the fullness of the lips. Eyes appear as triangle shapes and are not as wide as in the front view.

Left: This three-quarter view clearly demonstrates how you have to shrink and stretch features depending on where they are positioned on the face and how far they are away from you. This is most apparent in the eyes; compare their widths.

DRAWING CHARACTERS:
CHARACTERIZING FACES

TIP 016

Showing Age

There are many ways to show if someone is younger or older by manipulating a few elements of the face—namely, the tautness of the skin, the size or shape of the features, and the positioning of the features.

The more mature we are, the more defined the folds of the skin become. So there are few, if any, lines on the face for children. Teenagers and younger adults will only have lines appear when they scrunch up their faces with certain expressions (like a frown or a really wide smile). Older people will have lines in those areas all the time, and even a few extras as we get to old age and the skin really starts to droop.

Think also about the type of flesh beneath the skin—very young children have "puppy fat" and chubbier, rounded faces. This gradually disappears as we move into adulthood, and our bone structure and musculature become more visible. Then as we age more, this gets covered by drooping skin.

Youth is also associated with cuteness and softness, so this affects how large we draw certain features and where we place them. The eyes of a child tend to be larger and rounder, the nose and mouth smaller and more delicate. As we age, our eye size stays the same as the rest of us gets bigger, so our eyes appear smaller and lengthened. Our faces also lengthen, so the nose and mouth not only get larger but seem lower on the face. (SL)

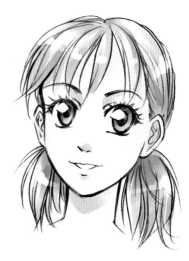

Top Right: The face of a child. Note the smooth skin, the large, round eyes but smaller nose and mouth, and the high positioning of the nose and mouth.

Right Center: The face of a teenager. Notice that the face shape has lengthened.

Right: The face of an adult. There is stronger bone and muscle definition, the eyes are smaller, and the other features are larger.

Far Right: The face of an elderly person. Skin wrinkles are evident, even pushing into the eyes.

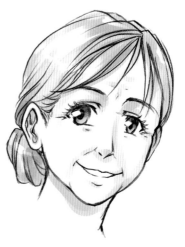

Giving Faces Individuality

A good artist knows how to change the features of the face to match the personalities and backgrounds of their characters and make it easy for the reader to tell them apart, even if rendered in simple black-and-white style, zoomed in for a close-up of just the face or the eyes, or if the characters are all the same age.

You can start by playing with masculine and feminine characteristics. Eyebrows make the biggest statement—low, thick, and dark eyebrows are more masculine. Play with the eyelash length and style— usually fluttery lashes give a delicate and pretty look to match more feminine characters. Fuller lips add a sensual side to your character, particularly if female.

A stronger nose and wider mouth is more often associated with male characters.

But don't restrict yourself! Knowing what is considered traditionally masculine or feminine is useful, but it is so much fun to mix and match these elements to add layers of complexity. For example, if you're drawing a girl who is a bit of a tomboy, she may not wear makeup and wouldn't be high maintenance, so give her stronger eyebrows and a wide smile.

Think about what separates us from each other in real life, such as our bone structure and the features reliant on it (such as eye position and nose shape), which can also be linked to ethnicity.

Our build also affects our face shape, particularly the cheekbones and jawline. By changing the shape and angle of the eyes, you can give an impression of the types of people the characters are and how they usually conduct themselves. Sharper, narrower eyes and straight but angled eyebrows would suit someone who is very serious, coolheaded, and meticulous. In direct contrast, large but heavy-lidded eyes that angle down at the outer corners look much more laid-back and carefree.

Even when stylized, you can vary the size and shape of the features to make sure that there's something visually different about each character. (SL)

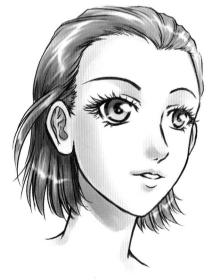
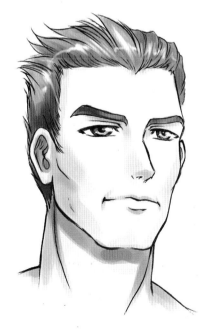

Left: Making a face look more masculine or feminine is a common problem among beginners. You can clearly see the differences between the two in these examples.

DRAWING CHARACTERS:
CHARACTERIZING FACES

TIP 018

Realistic Expressions

The key to drawing believable expressions is knowing what features are affected by the muscles on your face and linking certain combinations to emotional states.

Certain eyebrow shapes are predisposed to looking more severe than others, but once you have established a baseline, just shifting the inner edges up, down, or closer together in a furrow can be very expressive.

Our cheeks affect the shape of our eyes; they push up into the bottom line of the eye when we squint, scrunch up our faces, or genuinely smile. When the cheeks are relaxed, the bottom eye line should be flatter or curve down slightly.

Noses don't change shape that much, but the skin around the bridge of the nose can wrinkle. We can flare our nostrils, and the bottom line of our cheek muscle becomes more obvious in either wide grins or sneers.

The mouth is probably the most pliable of the features, as it can be widened, lengthened, pursed, curved up or down, twisted, or crooked. But don't neglect the cheeks either; with clever positioning, you can make cheeks look puffed out or make it look like your character is chewing on something. If your drawing style makes the lips obvious, you have another layer of things to play with, such as pouting or biting the lip.

The final and most important piece of advice I can give is to look in the mirror! It teaches you the limits of what a face can do in real life, but it also shows you the subtleties of more complex emotions and combinations of facial movements, which are not immediately obvious. (SL)

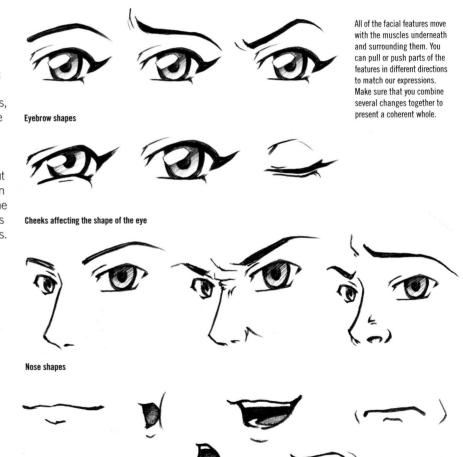

Eyebrow shapes

Cheeks affecting the shape of the eye

Nose shapes

Mouth shapes

All of the facial features move with the muscles underneath and surrounding them. You can pull or push parts of the features in different directions to match our expressions. Make sure that you combine several changes together to present a coherent whole.

TIP 019

Comical Expressions

Very much the domain of chibi renditions of your characters, you can distill the essence of many expressions into simple lines and shapes to great comic effect. The key to creating comical expressions is to take advantage of the stereotypes people associate with certain expressions.

Take the main features of the face and simplify them down into basic shapes and lines. You can even get rid of some facial features completely if they are unnecessary. For example, most wrinkles disappear and often the nose is removed.

You can also use symbols on and around the face to make an expression stronger or more comical. These symbols are known as "visual grammar" in comics and cartoons. Some are universally understood—for example, the love heart can be drawn near a girl's face to show that she likes someone. Others have gradually spread from Japan to global recognition, like the sweat drop.

Animal features are great fun to incorporate into expressions. Try using cat ears and mouths for slyness, or sharp teeth for ferociousness. Pick animals that have strong associations with certain types of personalities. (SL)

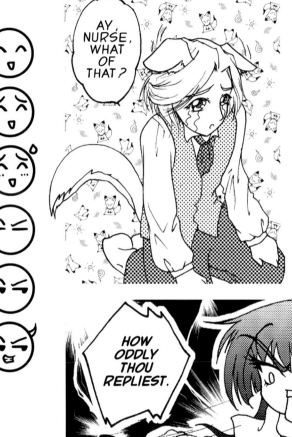

Far Left: You can start with a happy expression, which can change to embarrassment by tilting the eyebrows and adding a sweat drop. By adding different features, you can quickly change the emotion of your character, sometimes with unexpected results.

Left and Below: Romeo is being chastised and thus is shown literally as a wounded puppy dog. Juliet is angry and fed up with the nurse, so she shouts with her sharp teeth on display.

Manga Shakespeare: Romeo and Juliet © SelfMadeHero.

Bottom Far Left: You can take away the whites of the eyes and just leave the top line and the pupil. You can even depict the eyes as just dots or lines.

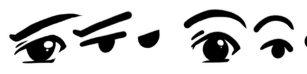

Depicting the eyes

DRAWING CHARACTERS:
DRAWING THE BODY

Drawing the Body

Drawing the human body can be complex, especially when dealing with playful styles. It's important to recognize the rules of human proportion in order to be able to play with stylization.

Below: Leonardo da Vinci's famous *Vitruvian Man* is a useful guide when dealing with proportion.

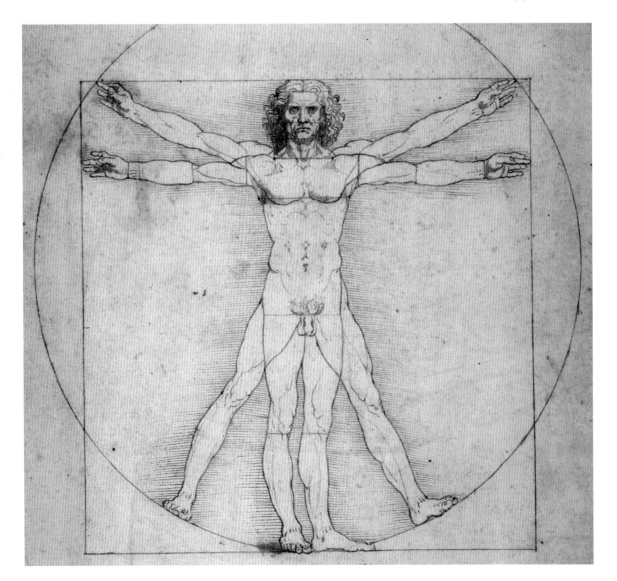

TIP 020

Basic Proportions

The hips are usually the base of any pose, so it's essential to use this as a foundation for the body and legs to extend from. Drawing a solid torso build up from the hips will make it easier to plan the rest of the image and provide reference for the length and position of the limbs.

I find it useful to break the body into simple geometrical shapes. The limbs and neck are basic angled cylinders, but the torso is the most important area to get right. I imagine a block for the hips, a roundish area for the stomach, and then an inverted shape for the rib cage.

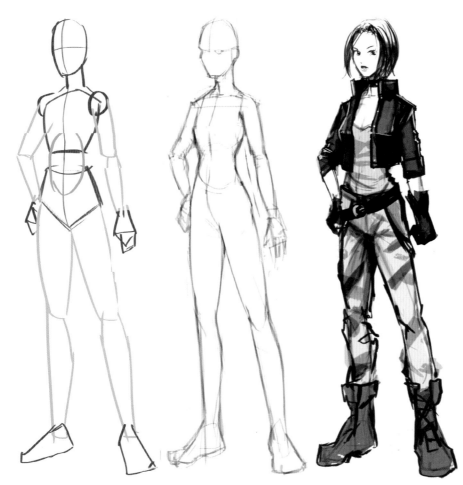

Consider the length of limbs and the character's ability to interact with objects. Even with different character proportions, you generally find that a character's arms will still reach down to the groin. It's also worth considering whether the character would be able to reach their face or feet with their arms.

Remember that the body can only twist a limited amount. If you're drawing a twisty pose, try putting your own body in the position, and check the Internet for photographic reference. It's reasonable to assume that a fantasy character may be more bendy than most real-world artists, but it's easy to unintentionally make an image look ridiculous by twisting the torso too much. (HS)

Left: Drawing the obscured sections of the body helps to maintain a solid construction.

Above: Characters reaching their feet or touching their face demonstrates good use of human proportions.

DRAWING CHARACTERS:
DRAWING THE BODY

TIP 021

Different Body Types

When a character puts on weight or loses weight, the location of that weight is centralized to certain areas of the body. The skeleton remains the same regardless of weight, but the limbs thicken accordingly. Consider this when choosing the weight of your characters, and be careful not to alter their proportions.

Weight tends to accumulate on the cheeks and neck, the upper arms, the bottom of the chest, the belly, and upper thighs. Children have the weight more evenly distributed throughout their body, but adults will have the weight pooling more around the bottom of each section.

When making a character very thin, don't be tempted to simply shrink without regard for the skeleton—even a starving body will still have a significantly sized rib cage and pelvis, for example.

With female characters it helps to think of their chest shape without breasts first, then add the curves for the chest relative to the armpits and shape of the body. Even an exaggerated female figure looks best with a torso area that is correctly proportioned. (HS)

Below: Weight gain is concentrated to certain areas of the body, which has an effect on body shape.

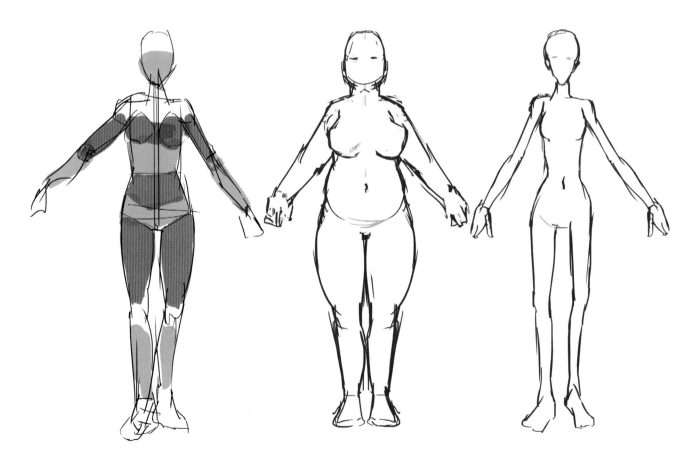

Exaggerated Styles

The basic construction of characters will persist irrespective of the style or proportions you've chosen for them. As long as the characters can operate in a believable way within the world you've placed them and don't clash with other characters in your world, you can have plenty of fun with exaggerated styles.

Start with the torso, as it is the central core of your character's body. Experiment with shaping and skewing the block representing the chest and rib cage—adding bulk here and making it wider at the top broadens the shoulders and suggests power and strength. Decreasing the size here gives a frail impression, as though the character won't have very much staying power. Then work on the pelvis area—a narrow or smaller pelvis is

associated with youth, slimness, or male characters. A wider pelvis with a strong, heavy-bottomed trapezium shape adds voluptuous curves and is very feminine.

By applying these techniques you can ensure every drawing has a convincing solid form before working on the details of face and costume. (HS)

Below: You can use this method for a multitude of character types and shapes.

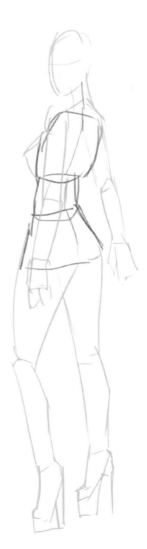

DRAWING CHARACTERS: **DRAWING THE BODY**

Chibi

TIP 023

Chibi

In Anime and Manga, chibis are mini versions of full-sized characters. The actual word is Japanese slang for a short person. A good way to think about it is that it stands for "C" and "B" for Child Body.

Although artists will use many styles and will deform the body in different ways (hence why it is also called "super-deformed" style), all will use cute, childlike proportions. This style is mostly used for comedy situations.

Overall proportions

The key to getting the ratios right is to use a young child's proportions. The body should be between three to five heads tall. Because the head makes up such a high percentage of the overall height, use the height of the shoulder from the floor to divide in half and allocate to the leg length. Once you have that, it's surprisingly similar to drawing people in normal proportions—the arm span matches the length of the body; the elbows are halfway from the shoulder to the wrist; the knees are halfway from the hips to the ankles.

Left and Below: I've drawn a male and a female chibi in underwear so that you can clearly see the body shapes used. The female's body is smoothed over slightly and is very pear-shaped. The male's body would normally have broad shoulders and narrow hips in an inverted triangle, but in chibi form he's almost a rectangle.

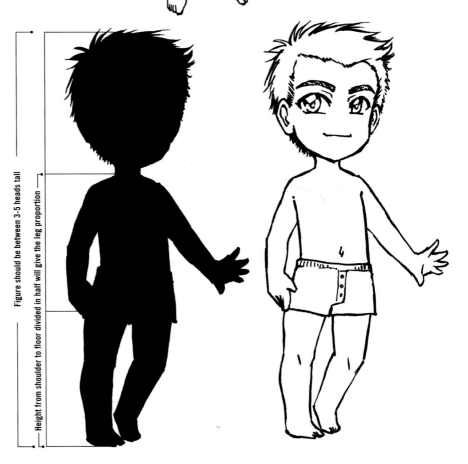

Figure should be between 3–5 heads tall

Height from shoulder to floor divided in half will give the leg proportion

Right: You can see clearly from this silhouette how large the head is. Note the arm and leg lengths and the height of the shoulder.

Left: In this front and side view of the same character, see how large the eye areas are, even with an eye closed. The nose isn't drawn in the front view, but when you see it from the side, it looks high, cute, and snubby.

Face

Even if the character is a mature adult or elderly person, the facial features are given childlike qualities. The shape of the head is very round, and the face can't be drawn too long. The eyes are drawn larger (or if the eyes are very narrow or closed, at least the eye socket area appears large); the nose is much smaller or often not drawn at all.

Body shape

The most important thing to remember when drawing chibis is that they are squished down, so their neck becomes very short and their bodies get chubby, even quite pear-shaped. Make the neck very short and thin—some artists don't even draw them at all. The shoulders become quite narrow, almost the same width as the head. The waist and hips should look quite wide. When drawing the arms and legs, give them a chubby, squishy feel.

Body shaping is a very personal choice, though, so there are thinner styles out there, chibis with large hands and feet, and so on. Have fun, experiment, and try breaking one rule at a time to see what happens. It's good to keep consistency, though—for example, if you use skinny arms, use skinny legs too. (SL)

Above: This saloon girl sitting among scattered playing cards is sized using normal body lengths and proportions.

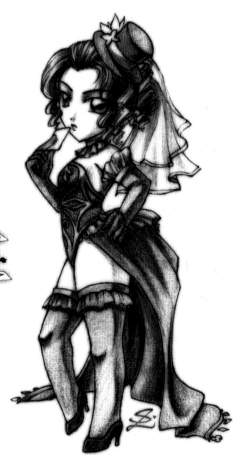

Above: This pencil drawing of the same character shows her in chibi form; she is only three-and-a-half heads tall. Notice how her torso and legs look chubbier.

DRAWING CHARACTERS:
HANDS AND FEET

Hands and Feet

Hands and feet are some of the hardest things to draw, simply because there are so many components to them. The hands especially are essential to creating a sense of emotion and expression through gestures, while the feet emphasize body language by accentuating pose and posture—the way a character sits and points its toes or shuffles around when walking, for example, can express personality.

TIP 024

Hands

Let's start by looking at the anatomy of a hand—the muscles and joints and how they move together to create a gesture. Hand positioning is key to communicating certain emotions through body language. Spend some time watching people interact and you'll notice a lot of hand gesturing is used. We use hands to place emphasis on what we say, whether it be a simple subtle motion or a thumbs up.

To simplify the shape of the hand, think of the palm as a spade that the fingers and thumb attach to at set points. The fingers themselves are made up of three little cones, with a joint between each. The cones are limited and restricted by the joint below them, which gives you a starting point as to how far the fingers and thumb can stretch away from the palm.

Typically the level of detail depends on the genre you are aiming for. The more details of the muscles you draw, the more realistic the image becomes. It also helps to make the hands look more masculine. Certain poses lend themselves to the idea of masculinity and femininity. Clenched fists, with defined knuckles, are perfect for that *shounen* pose (*shounen* meaning

"boys" Manga), and dainty, outstretched fingers are good for getting a softer feel.

Draw the wrist as a ball that the spade is connected to. At the top part of the spade, four circles represent the knuckles, and from the knuckles come the fingers. The length of the fingers differs for everyone— my little finger is tiny in comparison to my other digits—but there are a few rules with the other fingers. Typically the index finger and ring finger will be roughly the same size, with slight variation from person to person, and the middle finger will be slightly longer. The pinky will finish about three-quarters of the way up the index finger (unless you have my hands, in which case your pinky will be just over half the size!).

Don't leave hands out of your drawing! Practicing hands makes them easier over time, and they won't be as daunting as when you first started. Use guidelines to visualize the hands before you start drawing, and draw from life too. Sketching your own hands in the mirror quickly will help you get a feel for it, especially if you're drawing a particularly tricky pose. Take photos of your hands

Above: Basic hand structures and poses.

Above: Detail depends on your style and type of comic.

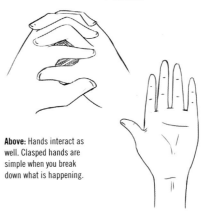

Above: Hands interact as well. Clasped hands are simple when you break down what is happening.

doing the things you are struggling to draw. Hands holding objects can be very tricky, especially objects that are large, like basketballs. (RK)

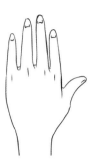

Above: Compare a normal hand to a chibi hand. The fatter you make it, the more childlike and cute it will be.

Round out the spade of the palm and shorten the fingers that extend from it.

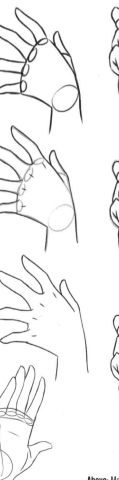

Above: More complicated views of a hand

Feet

With the feet, once again, it's important to take a look at the anatomy. Although the feet might seem simple at first, they are made up of nearly as many joints as hands are—and five toes are just like five small fingers!

Take the same approach with the feet as you would with the hands. The ankle is the equivalent of the wrist; a ball will represent this. From this is a similar shape to the spade, but with another ball-like shape attached to the bottom, representing the heel. At the base of this spade will protrude the toes. Draw the five circles to represent the digits and make sure they are evenly spaced! It is easy to think that the big toe will take up more space, and in theory it does, but if you make the big toe take up more space unevenly, the foot will end up looking very strange. As you move down the toes, they decrease in size, but not by much. Don't be tempted to make the little toe a lot smaller than the rest of the digits.

Although feet may not seem too important, they can usually help with expression. Think of how a dancer points her toes or a warrior holds a strong pose. The feet in both of these images are very different and help sculpt the overall body language. Masculinity and femininity also apply. Men's feet will have more details on them and more lines, while women's feet are much daintier—they will have daintier poses and look more streamlined when moving.

Try to keep the feet in proportion to each other—big toes on the inside! With complicated poses, always check the pose first. Is it natural? Are the feet in perspective? Always draw from life if you can, as that way you'll get a better feel for how the feet move in real life. (RK)

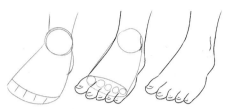

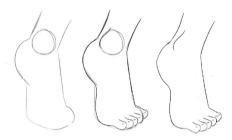

Above: Basic foot structure.

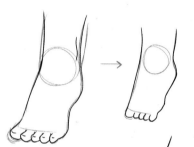

Above: Chibi feet are affected in exactly the same way as chibi hands. Many artists don't even bother with drawing the toes and will just draw a rounded stump.

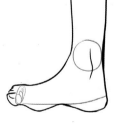

Above and Right: More feet poses.

DRAWING CHARACTERS:
HANDS AND FEET

TIP 026

Gloves and Footwear

Now that you have your hands and feet, it's time to dress them with their own fashions. A lot of the time, your characters will probably not wear gloves, but if they do, why not spice up the designs? Shoes are a given, though, even if it is tempting to have your characters barefoot all the time.

When dressing the hands, the fabric of the gloves will naturally ruffle around the knuckles and the joints. While you might not be able to see the hands underneath, where the fabric drops will indicate the various details of the hands.

Gloves are the ultimate fashion accessory, especially if you're trying to glam up your characters or give them a unique selling point. Most magical girls and uniformed characters will wear gloves, so it's a good way of making your characters look different, and they are easy to add details to. Butterflies, sequins, lace—they all help to make something look unusual.

Gloves are also a good way of indicating a historical setting or a fantastical one. And the good thing with this is that you can be as ornate as you like with your gloves. Find some inspiration by doing some research on the period you are aiming for. Large bell sleeves; ornate, lacy long-sleeved gloves . . . really go to town if you're going for historical glam. If you are to draw bell sleeves on your gloves, make sure you indicate where the arm is by drawing lines in the fabric, as this will show that the glove is fitting around the arm and not just randomly flowing around it.

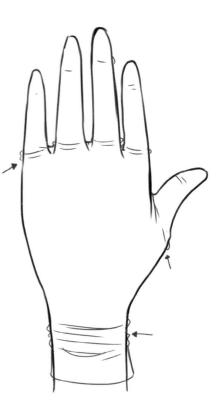

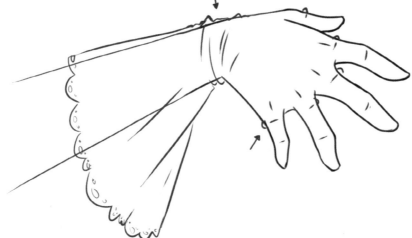

Above: Notice where the creases and gathers of the fabric will be.

Left: Fancier glove designs can tell you a lot about the setting or the character.

When drawing shoes, start with the foot shape—after all, you're dressing the feet up with their own clothes. If you jump straight into drawing the shoes, you'll most likely draw them out of proportion, so start with the simple sketch underneath before you jump into the details. If you only want a simple sketch underneath, draw a triangle that tapers at the end, which will give you a very rough basic outline without having to go into plenty of details and will save time.

Shoes are a girl's best friend, and you will have a lot of variety to choose from when you come to dress up the female foot. Luckily high heels and heeled shoes generally will fit nicely with the under shape of the foot, so the arch will naturally guide where the heel will go. The higher the heel, the flatter the toes will be spread at the bottom. Ever see anyone tottering around on those crazy high heels? Their legs are practically straight down into the shoe, with not much room to maneuver. It's no wonder it's such a pain to walk in stilettos!

With flat shoes, the arch is obscured, so the foot will look more blocky than usual. You'll run into this issue a lot when drawing male feet, but as long as you maintain the triangular shape of the foot, it won't look odd. A good style of shoe to practice drawing is the boot. It covers up the ankle, so if your proportions are off, it won't be noticed as much as if you were drawing strappy sandals.

If you are stuck for ideas with shoes, take a look through some catalogs or online (do some shopping!). Modern fashions can always give you insight into what can and cannot be created physically with shoes in the real world, which will give you a good idea of what would be possible with your own drawings.

Don't be tempted to avoid the starting stages of drawing shoes, especially if you don't have that much practice with them. If you are stuck, always look in the mirror and draw from life. As painstaking as it might seem, it will be very helpful for you when you come to drawing a full body. (RK)

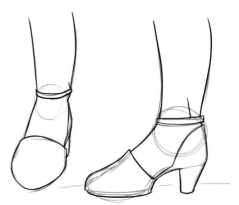

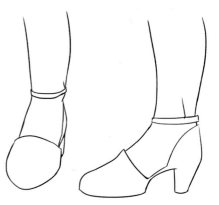

Above: Think about how the foot is positioned inside the shoe.

Left: More shoe styles.

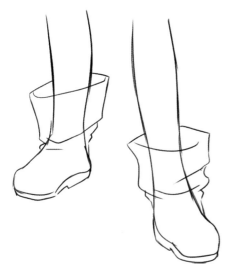

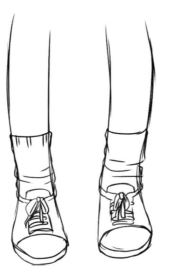

DRAWING CHARACTERS:
POSE AND MOVEMENT

Pose and Movement

Being able to draw a character with the correct anatomy is one thing, but bringing it to life with poses and movement is another. It can be hard striking a balance between realism and total fluidity, but picturing where its body moves, where the weight swings, and how movement progresses through the body will help you remove any stiffness. Work your anatomy knowledge hard by pushing your character into dynamic angles.

TIP 027

Dynamism and Action Lines

When I draw an action shot, I work out what the intention of the image is, whether it's a single illustration or part of a sequence. This lets me decide on the focus of the image, which helps in the development of the dynamic visual. There is usually a point toward which you lead the viewer's eye or some sort of directionality.

Static images can be made more dynamic with action lines. They can be used to draw the eye to a focal point, create speed, or describe an action in a single image. Using simple guide points such as focal dots, rulers, and curve tools, you can get very effective and neat results.

Focal lines are the guidelines that funnel to the focal dot placed where you want the viewer's eye to be led. The actual action lines are drawn to the edge of the guide circle.

Parallel lines can give the illusion of speed. A set square can be used to draw the parallel lines.

I create a guide for myself when I draw action lines. In this case (the final panel), the action is curved, leading from the start of the action to the focal point at the end where the hand is. When the action lines are drawn in, this gives an impression of a smooth, sweeping motion.

Guides can be drawn in pencil if you draw on paper by hand, or they can be drawn on a removable layer if done digitally.

To make scenes seem more dynamic, I will often use a viewpoint other than a direct view. Using a lower viewpoint or one from above can create a more dramatic image. I also exaggerate a little, giving things a gentle, perspective-based curve. You can apply this to all objects in the scene as long as they follow the same perspective guide. (NM)

 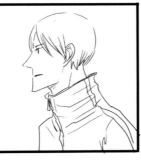 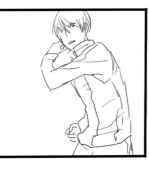

Left: Static images before the focus lines are added.

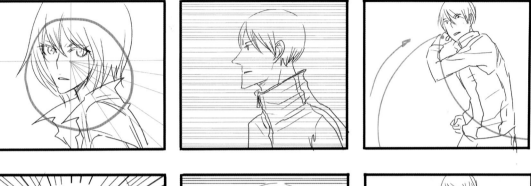

Row 1: Creating guides for various effects.

Row 2: Finished examples of action lines with guides removed.

Row 3: Action lines can be adapted in many ways. Even small changes in angle or position can have different effects and interpretations.

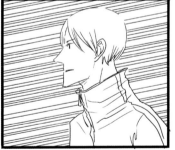
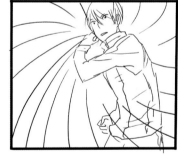

Row 4: Altering the viewpoints and exaggerating angles with perspective curves add dynamism to images.

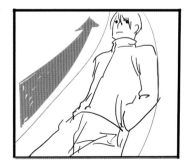

DRAWING CHARACTERS:
POSE AND MOVEMENT

TIP 028

Foreshortening

I feel that learning to draw foreshortening in people is something that is developed with practice from learning anatomy drawing, but even just learning the basic breakdown of the body in the form of boxes and joints will help as a shorthand guide toward doing this. Becoming aware of foreshortening and the fact that you observe it all the time whenever you see a person will make it easier to remember how it looks so that you can move to the next part—drawing what you can see in conjunction with what you know about the shape of people.

Foreshortening looks odd because it's not what we know is there or what we expect to see. We very often know what things look like in their component parts and structure and will be most familiar with a head-on front view—it's our most common viewpoint. But changing the view of something like an arm to a more uncommon viewpoint contests with what we have learned when it's familiarly posed. Practice and observation in all different poses are the main ways to gain familiarity.

I'd strongly suggest that you practice anatomy drawing, life drawing, and reference drawing often if you wish to learn to draw foreshortening more easily. It is a form of perspective drawing and will often follow the same rules—establishing a point in the distance that objects will taper toward.

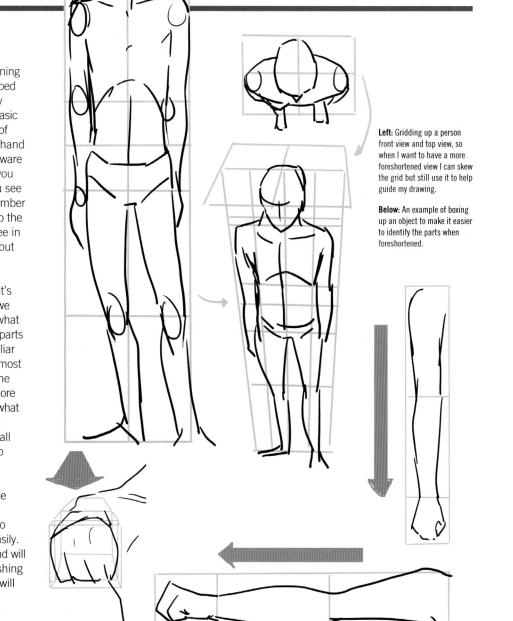

Left: Gridding up a person front view and top view, so when I want to have a more foreshortened view I can skew the grid but still use it to help guide my drawing.

Below: An example of boxing up an object to make it easier to identify the parts when foreshortened.

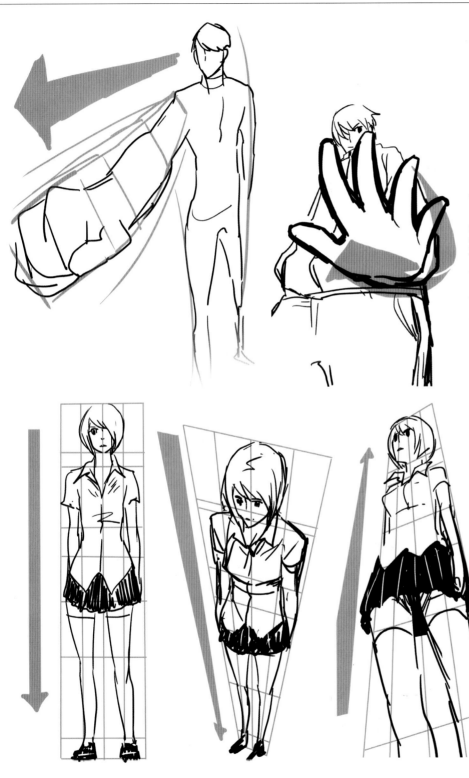

However, if you require instant access to a pose, you can easily make your own reference if you need to accurately draw something—just ask a friend to pose for you so you can photograph him or her for drawing reference. Take shots from different viewpoints; you can reference how a pose looks from a 360-degree angle with this method. In absence of a helpful assistant, a mirror is also a useful tool!

When I look at a real-life reference, it can appear a little flat and normal, but I exaggerate features and also skew the viewpoint to make it more in your face if necessary. Doing this can create a sense of movement rather than just setting the scene.

In comics I'll often deliberately draw the lines of objects closer to the viewer with bolder lines to give the illusion of something being closer, even though it is constructed from lines alone. (NM)

Above: Exaggerating foreshortening! You can be quite creative using the perspective guides in foreshortening to create more dramatic poses.

Left: If I use a grid pattern to map out the stance of a person head-on, I can use this grid to help when I skew the view of the person.

Character Design

Once you have gained some proficiency in drawing
the face and the human body in different poses, angles,
and styles, it's time to add some artistic flair. Your main
characters need to be striking and recognizable to the
reader, so you have to create a good balance between
detail and general impact. When dressing your characters,
make an effort to nail the costume design so that it suits
their setting, their personality, and their purpose. When
using real-life settings such as modern-day contemporary
locations, exotic getaways, or historical periods, it is
essential to get the details correct with plenty of research.
If playing with fantasy or sci-fi settings, it is still important
to do your research so that both costume and creature
design accurately reflect the technology and biological
systems available. Use the closest real-life equivalents for
reference; it makes everything much more believable.

CHARACTER DESIGN:
SHAPE AND SILHOUETTE

Shape and Silhouette

Character design is a big topic. Wherever there's visual storytelling, characters will be involved. In comics, as in any other storytelling medium, characters are essential to bring the audience into the story. A good design can tell you a lot about a character's personality and background. They can also be designed to be iconic and striking, which is particularly useful for mascots and characters that need to be easily recognizable, like in video games. Whether you're designing characters for comics or something else, the principles are pretty much the same. But how you emphasize different aspects of the design will give you a very different effect.

TIP 029

Silhouettes

One of the most basic principles of character design, or any kind of design for that matter, is silhouette. The strength of silhouettes lies in their simplicity. Even though they're flat shapes, without much information, they can still suggest much more complex structures if they're placed correctly. The brain actually doesn't need much information to work out what's going on. The silhouette strips out all the detail so that you can focus your energy on creating a striking design. As a rule of thumb, if a design has an interesting silhouette, chances are that it will also work well as a final drawing.

Right: Silhouettes can be used to explore different variations of a design on the basic shape level.

A good silhouette should leave little doubt as to how characters are posed. It should also suggest how they're built, what they're wearing, their hairstyle, and so on. This is where your design sense comes into play. Varying the shapes that make up the character's body, outfit, and accessories will give you a more visually interesting silhouette. The variation between big and chunky and thin and graceful, or smooth and simple and jagged and detailed, will make your design more appealing and convincing as a whole.

In practice, for everyday illustrations, I rarely start out with a silhouette. Instead, I draw out the character with a pencil like you normally would. However, the things that affect the silhouette, such as pose, shapes, textures, and detail are constantly on my mind. If there's something about the design that doesn't look quite right, and you can't put your finger on what it is, check the silhouette. Usually that can help you spot unresolved areas of the design. You can also start out with the silhouette and explore different variations of a design before moving on to draw it in more detail. This method is often used in the video game industry, where silhouette is especially important. There, characters need to be quickly and easily recognizable in the midst of the on-screen action. (NL)

Above Left: This was drawn directly as a black silhouette, without any underlying sketching. Even though there's hardly any detail, the design is distinctive because of the different shapes used.

Above: It's often useful to check the silhouette of a drawing to make sure that everything is readable and that the design is varied enough. The negative spaces between the arms and the body, or between the feet, are separate elements that add to the clarity of the drawing.

CHARACTER DESIGN:
SHAPE AND SILHOUETTE

TIP 030

Overall Shape

A character's presence is largely defined by its size, shape, and visual contrast. The human eye is naturally very used to interpreting and reading a person from only a small handful of visual cues, and these can be put to great use during character design and composition. Implying something greater by the visible shape allows you to create a much more interesting image without cluttering it with visible detail.

Boldly contrasting colors will always make an image easier to read, because all clothing and body parts are clearly distinguished. Adding too many colors can make the image noisy and confusing, so a limited palette with coordinating elements can be easy to quickly interpret.

Drawing beyond the frame is a great method to make an image have more impact. Always remember that people are able to read shape that is implied; not everything needs to be shown. If you crop the elbow off the framing of an illustration, people will still be able to read the shape of the arm. As a result, you can bring greater attention to the the face and other focal elements.

If cropping parts out of the frame, be very careful about ensuring the anatomy or construction of the illustration is internally consistant. Just as the viewer can naturally read the missing shape, it may feel awkward and disjointed if you don't make sure all the pieces fit together realistically.

Left: This chibi has his limbs evenly balanced around him, filling space effectively for use in web graphics and accompanying text. The color scheme is bold and simple. Note the lines are dark blue, matching the darkest shadows.

Left: This close-up extends beyond the frame, but you can infer the parts you can't see. Her right hand is clearly smoothing down her hair on her head, even though you can't see most of her arm.

Above: A striking image of a spinning girl. The loose drape and flow of her dress billows out, making a strong triangle, balanced by her outstretched arms. The hair is also loose and wavy. She feels carefree.

The choice of freely flowing clothing will have a significant impact on the silhouette of a character. Try to make the most of the character poses when choosing the clothing for them, and don't be afraid to change a hairstyle or outfit later in the drawing process if you think it can enhance the overall image. (HS)

TIP 031

Shape in Finer Detail

There are several ways you can define shape to add to the composition of your characters and help create a sense of movement within your Manga panels. Here are ideas for defining shape for you to consider.

Using colors

It's possible to build an image of how an object is constructed by interpreting just blocks of color. Try to make the most of your character's shape and volume when blocking out the colors, and consider using higher contrasts to enhance the sense of shape and volume. Using light colors against dark, or vice versa, allows you to incorporate the strong visual effect of negative space and helps balance the character's shape against its background.

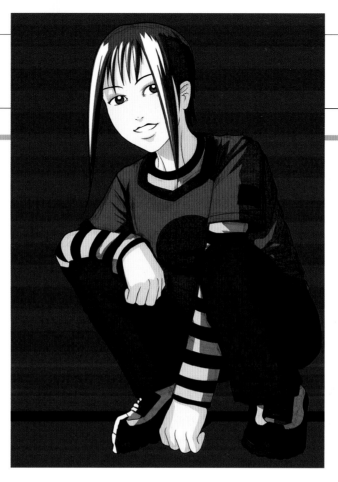

Left: This character's shape uses several techniques to make him stand out from the background and add depth and volume to his body. The overall colors used on the character are blue in tone, which makes him very striking against the consistent bright red of the background, giving the effect of negative space. He also has striped sleeves that curve around the contours of his arm, giving him volume.

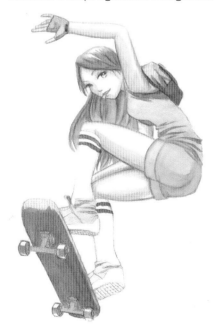

Left: The complex pose of this skateboarder has a lot of depth and dynamic movement. Some parts of the image are closer to the viewer, obscuring other parts behind it, giving an active low angle shot and the feel that she is leaping toward and over you.

Using geometric and perpendicular lines

Straight lines are common in clothing, and the way these lines curve, bend, and break gives us a lot of information about the shape we're reading. It's possible to use this to our advantage when designing characters, as something as simple as the side seam in a shirt or pair of pants tells us precisely where the side of the character is. Lines perpendicular to the overall shape direction give a sense of curvature and volume. Giving a character a striped long-sleeve shirt will help to show the shape of the character even without any additional shading. Stripes, cuffs, hemlines, and other clothing elements will all add to the sense of shape. These horizontal lines will also help when showing a sense of depth, as the width between lines becomes wider or narrower depending on the angle and distance.

Considering movement and motion

American superhero comics are well known for their characters wearing capes. These capes don't only add to the bold status symbol of the character, but they introduce dynamism to every image featuring movement. From the movement of the cape alone you can read how the character is moving. This principle lends nicely to every type of character you design in a Manga style, with aspects such as hair, ribbons, belts, skirts, and sleeves all adding to the way a character is perceived. (HS)

55

CHARACTER DESIGN:
FANTASY DESIGNS

Fantasy Designs

The world of fantasy has long captivated readers and creators alike in literature, art, and music. You cannot help but think of romance and exoticism, chivalry and epic battles, and myth and magic woven into our own real-life medieval history. Fantasy is really only limited by your own imagination, but be warned! There are pitfalls here . . . you still need to make that world believable and functional.

TIP 032

Fantasy Costumes

What is it we think of when we think of fantasy? Fairy tales? Is it the long, flowing clothes, capes, and shining armor? The sky is really the limit within this genre—you have such a large, vibrant selection of races and backgrounds. By designing costumes with contrast, you want the reader to be able to tell immediately what a character's history, role, and status is just by looking at what they wear.

Think about who the character is, what they are, what is it that they do. These are all important aspects of creating a fleshed-out design. Even if you think it isn't relevant information, you can infer a lot about someone by the details in their clothing and what they are carrying, so don't overlook anything! Think about limitations on clothing with nothing obviously too modern, and stick with the basics of fabric, using nothing too bold or psychedelic.

Details, gold, or other ornate patterns can add so much depth and are highly loved within high fantasy, especially if your man or woman is of noble birth. Practically speaking, I think it's believable to research as modern an era as the

nineteenth century for inspiration, but it really does depend on the setting and personal opinion. Most of all, think about your character's background and try to draw from it when creating your design.

It's not all about fancy clothes and weapons of choice. Get your character's body type down as well. Although this isn't limited to fantasy, it is a good and important first step, and if you have a large cast of characters, you'll definitely want some contrast. I always find it best to play with combinations of facial expressions, body weight, and overall attitude. It's not only important in general design; it can really build on a personality within a fantasy setting. Are they a plucky thief? Or a discontented paladin?

So with a rough idea of your character's personality and body type, what can we do about their clothes? What will suit certain types? First think about what holds it together. Think about fastenings—as they add a high level of detail that far too many artists leave out—and different types of cloth. Leather and plates will have different ways of holding it all together. In general

Above and Below: Here is the initial outline and finished version of the same fantasy character. You can see from the crossover seams and buckles that he's from an Old World setting, which doesn't have modern technology. He's different from ordinary humans as he has a fox tail. Note how the colors are earthy, a mixture of beige, brown, and forest green; he probably travels a lot as a layman.

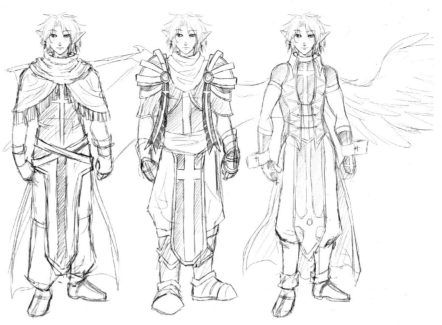

you want to avoid using zippers, though I've stuck some on boots occasionally. Like anything, moderation is key, and your outfit needs to look balanced.

Think about your theme, and try more than one design. What is it about them that unifies the look? You should be able to reflect various aspects of your character through different outfits if you've picked on the key representations well enough.

What about differences in classes? What's appropriate for one character over another to wear? This has a significant impact on your character's role and making it believable to an audience. For example, it's simply no good to weigh down a fleet-footed rogue with bulky garments or heavy armor. Likewise, when you think of mages, you see them in very light gear, predominantly cloth. Perhaps we have been spoiled by the video game and RPG genre for showing us archetypes within fantasy design. But I, for one, believe they are important to keep in mind and are universal for all renditions.

But what about colors? What do colors really do for a fantasy theme? They can help flesh out your character too. Colors can give us instant recognition of good and bad, rich or poor. Vibrant, healthy-looking colors really show a rich cultured background, while muddy or dulled shades may identify someone from a much more humble upbringing.

So while spending your time drawing out your character, block out your colors and be as messy as you like—I'll usually change over the colors several times before

I settle (so experimenting digitally is great!). You may even have to start from scratch several times, but what's important if you haven't drawn the character before is getting those color combinations and gradients down for future use in a nice reference sheet.

Ultimately, I think it's important to remember there is no right or wrong within fantasy or your own ideas. There can only be guidelines. I can't tell you how much I have picked up from general media and literature. Never be afraid to look at other examples and gather your own interpretations. And most of all, experiment! The more wonderful and unheard of it is, the more likely you are to be hitting the right marks. Since fantasy really is a touch of the unreal, you can afford to be outlandish with it. So let your imagination run wild. Just go for it! (DS)

Above: The character is kept in the same pose while I experimented with different costume designs and silhouettes.

Below: This mysterious, ghostly-looking character looks very effective with cool, desaturated colors. I kept the colors flat (unshaded) so that it's not only easy to tint differently, but so I can pull the color values directly from the image digitally to use as a reference point.

CHARACTER DESIGN: **FANTASY DESIGNS**

TIP 033

Other Races

What would classical fantasy be without elves, dwarves, orcs, or ogres? Ever since J. R. R. Tolkien first wrote about Middle Earth and created our modern version of these characters, they have pretty much come to define most people's idea of "High Fantasy."

Designs for elves, dwarves, and orcs are as numerous as there are works that feature them. It's easy to think that drawing elves is just about making the ears pointy, and dwarves about drawing a short, stocky, bearded person, but there are certain design aesthetics that can be pushed to create a more believable character design.

Elves are graceful and beautiful, and they are generally considered a bit aloof and haughty. They live long lives, often close to nature. As always with character design, a character's background, environment, and personality will be the most important things to consider when drawing a specific character. Consider incorporating motifs that echo the natural habitat of your elf into your design. Their pointed ears, staffs, and bows should also complement their slight, narrow features. Elves should summon up an image of superiority. Their clothes and silken hair flow and billow in the wind. Think flowing curves, swirls, and light marks for your design. They should look like they've spent hours preening themselves to perfection, although of course that's the elfish magic flowing through their veins!

Dwarves are the exact opposite of elves; living underground, their stature is short and squat. As master builders, their clothing is far more practical and less ornamental. Their colors should mimic the earthy, solid landscape that they inhabit. Where elves see beauty in natural curves, the dwarven race traditionally find it in strong, steady architectural lines. However, dwarves also traditionally have a love of gold and gems chiseled from the earth. Practical work wear embellished with gold and jewels is a good start for a dwarven design; steel-capped boots are a favorite of mine. It's also important to make dwarves look like they've been laboring. While elves look like they've never lifted a shovel in their lives, a dwarven character needs to look like they've been born holding one. Clumps of mud and dirt, and even the way you draw the (absolutely vital) scraggly beard, should give the feeling of someone who's spent their lives down a deep, dark mine.

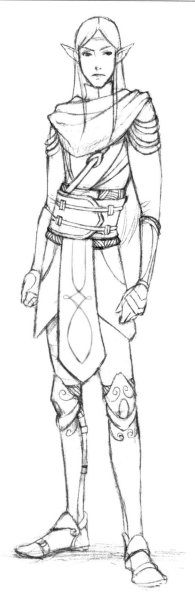

Left: Male elves are often considered quite beautiful, and a good way to portray an almost otherworldly beauty is to make the faces more androgynous.

Above: Elves are graceful characters, and even in war I wanted to show that they carry with them an air of sophistication. The belt was inspired by Japanese obis, and the swirling patterns have a lightness that suits the character.

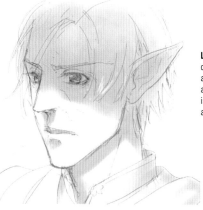

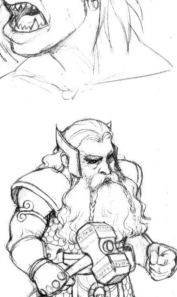

Orcs, trolls, and other monstrous creatures, whether you decide to make them evil or not, should have an air of "muscled stupidity." They embody the animal nature in all of us and are happier to start a fight with a giant spiked club than engage in conversation! With this in mind, it's often good to look to animals for your inspirations. The sloping forehead, dragging knuckles, and highly muscled arms of a gorilla is a helpful pose. Perhaps also incorporate the jutting jaw and tusks of a warthog, or the horns and leathery hide of a rhino. Orcs and trolls are the fantasy equivalent of giant wild beasts, with just enough brains to be told where to point their fists. Once you've made quite an animalistic creature, you can start to bring human elements back into the design. (NL)

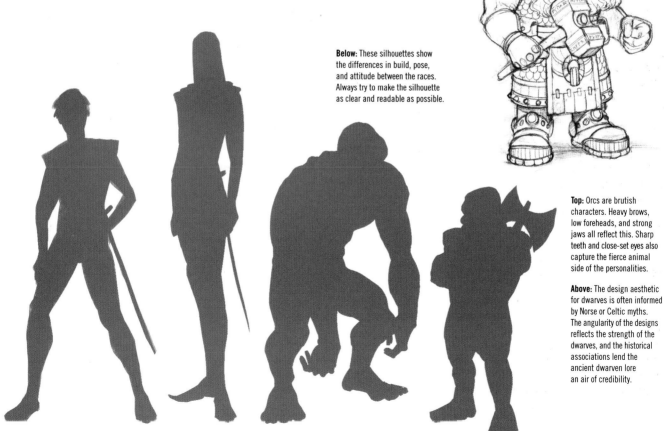

Below: These silhouettes show the differences in build, pose, and attitude between the races. Always try to make the silhouette as clear and readable as possible.

Top: Orcs are brutish characters. Heavy brows, low foreheads, and strong jaws all reflect this. Sharp teeth and close-set eyes also capture the fierce animal side of the personalities.

Above: The design aesthetic for dwarves is often informed by Norse or Celtic myths. The angularity of the designs reflects the strength of the dwarves, and the historical associations lend the ancient dwarven lore an air of credibility.

CHARACTER DESIGN:
FANTASY DESIGNS

TIP 034

Fantastic Creatures

Magical creatures in fantasy come in all shapes and sizes, but most are based on some form of reality. Nature is full of amazing diversity to get inspiration from. Animals, insects, plants, and even rocks can be invaluable sources to look to for ideas. Often creatures have varying degrees of human traits as well. An undistorted human face is easy to relate to, but the more modified the face gets, the more alien and exotic it will seem to us.

The centaur is a mythical creature, half man and half horse. Since the face and upper body of the centaur is human, we see them more as humans than animals, and so centaurs are rarely portrayed as creatures of darkness. Probably the most difficult part about drawing centaurs is getting the horse half of the body right. Horses are very hard to draw without reference, so I recommend doing some research and getting some reference images beforehand. As with a human body, a horse is made up of two major rigid masses: the rib cage and the pelvis.

If you make sure that each section is given proper volume and distance in relation to the other, you will have a good starting point for the rest of the body. Imagine the spine running down the back of the human and connecting with the spine of the horse in one smooth curve. This will help with making the transition between the two parts work nicely. The proportions of the legs are quite different from human limbs, so this is where the reference comes in handy. Pay extra attention to the joints and the way they bend, as this part can make or break the drawing.

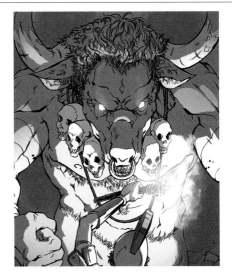

Above: Whereas centaurs are human enough to sympathize with, the lack of any humanity in the face of the Minotaur makes it much easier to vilify this character.

Left and Above: The trick to drawing centaurs is to pay close attention to horse anatomy. The proportions between body and limbs are quite different from what we're used to when drawing humans, so reference images are crucial.

Left: Incorporating animal features into a face can have some interesting results. The best source for ideas is always nature!

When drawing dragons it's also useful to reference nature in your designs. Photos of lizards, crocodiles, snakes, and bats can give you all the elements you need to create a truly terrifying flying lizard. If you feel like your dragon doesn't look quite strange enough, it's worth looking to creatures that live in the deepest oceans. Even the face of some types of small fish would be pretty scary if it were the size of a house! One important thing to consider when designing a dragon is what you're going to base the body on. While a dragon's features might be that of a snake, they tend to have the essential body structure of a horse or a large lizard. If you pick one of these, it makes them look much more convincing when they rear up to strike or carry their rider off into the distance. To really draw great dragons, look very closely at how lizards, crocodiles, and snakes move. If you can get that pose of a snake about to spit venom, then your dragon will look much more believable, even if it's about to spit fire!

Winged creatures are very popular in myths and fantasy, and it's no wonder since we have dreamed about flight since the dawn of humanity. Wings might seem complex, but once you understand the structure they're really not that difficult to draw. The key is realizing that the bones in a wing look more or less like an arm, except the hand forms a part of the wing tip with the longest wing feather. Muscles and skin bridge the gap between shoulder joint and wrist, and together with the array of long wing feathers they form the characteristic silhouette of the wing.

Fairies are, much like elves, slight and airy. Their wings are thin and insectoid, so despite being beautiful creatures, looking at bugs and insects is a great starting point. Most flying insects have beautiful iridescent colors on their wings, which can be incorporated into your designs. Fairies are creatures of the forest, so design elements shaped like petals, leaves, and other facets of the forest work well. It's also worth remembering that fairies are very small. The scale is established by the size of the things that you draw around your fairy. You can also use very small manmade items that your fairy might have repurposed into clothing, tools, or weapons to show their size. (NL)

CHARACTER DESIGN:
SCI-FI DESIGNS

Sci-Fi Designs

Science fiction has long fascinated us, and all forms of comics, including Manga, have brought such visions to life vividly, using our imaginations and predictions about how our technology will advance. But just like any other genre, you need to do your research so that you can create believable environments and characters. The difference with sci-fi is that much of it depends on the real world's latest, cutting-edge inventions and discoveries. Keep up to date with vehicular design and the technologies of space exploration. Learn the jargon of astronomy and engineering. You may even need to refer back to your old physics textbooks!

TIP 035

Sci-Fi Costumes

Fashion and costume is such an important way to convey the world of your comic to the reader. Science fiction can be particularly challenging, as it is a projection into the future (or an alternative present) of what we know and experience today. Look at the latest designs in haute couture or professional sportswear for inspiration. Put yourself into the mind of a forward-thinking fashion designer and consider the following aspects when creating the clothes of your futuristic humans.

Fastenings
One of the best ways to track the history of human clothing and the way it has developed is to look at the fastenings. From basic pins to laces, then buttons, then zips, and on to contact fasteners like Velcro and snap buttons, it has changed how quickly we can take our clothes on and off, and allows for a huge variety of shaping and draping. If you want clothes to look futuristic, go for the latter few fastenings, or imply something even more outrageous and not yet achieved—liquid-

or energy-based zips, invisible seams, buttons with extra mechanisms, perhaps?

Materials
We have woven fabrics out of plant and animal fibers for centuries but only relatively recently introduced more synthetic materials to spin thread from, with remarkable properties like increased shine, lighter weights, high insulation, different levels of opacity, and so on. We can even make synthetic fabrics as whole sheets without weaving at all, so materials can be watertight, or even airtight. In the realms of sci-fi, take advantage of this by creating shapes and silhouettes that look out of this world—how about large vacuum-tight shapes that flare out with little support, projected lights, and floating sections?

Military
I'm including a special focus on the military here, as they are so strongly featured in the sci-fi genre, be it fighting aliens or amongst ourselves. The main

Above: This boy riding his new robot toy has very straight, clean lines to the edges of his clothing.

thing you must consider is whether the costume is appropriate for your character's job. In an administrative role and normal environments, military personnel will either be in reserved and formal civilian clothing or in dress uniform. The military is strongly associated with history and tradition, so although you can play with the fastenings and material, it is good to incorporate some real-life historical designs and embellishments into your outfits. When out and about, however, the costume must match what their job entails—and if in a sci-fi setting, it should be airtight for working in space, armored for protection, and closely fitted with flexible joints for movement. (SL)

Above: This soldier investigating the hold of a space shuttle is in field gear: airtight body armor for fighting in unpressurized environments.

Right: The officer making the distress call on the control panel screen is in dress uniform. Note the strong traditional military feel with the shoulder-to-hip strap and epaulettes, yet the clean, invisible joins on her jacket.

Top Right: This bionic human has a cybernetic costume, with holographic wings projected from her back.

Far Right: This futuristic, trendy teenage girl has a dress made from high gloss material. Her hair and wrist accessories also seem to float perfectly in place.

CHARACTER DESIGN: **SCI-FI DESIGNS**

TIP 036

Robots

Giant mechanical fighting machines (or mecha to fans of Anime) are very popular across many Manga series and illustrations. The Japanese have always had a fascination with robotics, particularly those that are modeled on human shapes, characteristics, and movement. They are one of the world leaders in this field. As expected, the imagination of the Japanese when it comes to their sci-fi robots is also very exciting and dynamic.

Size
In real life, the constraints of gravity and materials' inner strength mean that articulated robots with large moving parts cannot get too large or their structure would collapse. If your setting is in the near future, there has to have been some major developments in technology to have very light, but strong, substances, or some form of floating or anti-gravity mechanism for very large robots (skyscraper height) to operate.

This can be side-stepped if your setting is in the vacuum of space! Battles off-planet are exciting, truly futuristic, and can be very dramatic as you can have huge battleships and robots flying around.

Purpose
Robots can be autonomous and function relatively independently, i.e., piloted via remote control, simple programming, or through artificial intelligence. This makes sense in storytelling if the robot fulfils simple tasks or is small in stature. Something that can do major damage or is very valuable is best to be fully controlled rather than left on its own, or worse, become sentient and rebel!

Some robots work effectively as battle suits, which are piloted from inside, and the limbs are like natural extensions of the pilot's own limbs. The larger type

Above: This giant robot will still maneuver quickly in space and low-gravity environments. It is armed with a blaster gun. It also has a shield and reinforced plates on its shoulders, elbows, and kneecaps.

of robot will have a cockpit, with a pilot (or several pilots) inside. These robots are used for combat. Think about the environments they will need to operate in and the weapons they will use. Humanoid shapes are very popular, as we can picture the robots leaping and bounding, twisting, and holding guns.

Practical design elements

The most difficult thing to account for are the joints of the robot. The robot is made from hard surfaces but still needs to be able to move its limbs and be flexible. Look at your own joints for inspiration and guidance if working on a humanoid design (although don't feel restricted to humans!). Some joints are simple levers that can bend up and down like your elbow. Others have more rotation, like the ball-and-socket joint of your hip. You may want to consider rubber concertina sections or something flexible to allow for stretching and shrinkage in these areas.

Think about straight lines, gradual curves, and the overall feel and shape of your robots. In many respects, automobile design can be a great reference when it comes to getting a style or feel to your robot, as it's clear to see fashion as well as material constraints when you observe how blocky or curved a car can be. If you have too many right angles, squares, and rectangles, it looks inappropriately primitive, but if it is too curved, it may look too organic.

Another subtle factor to consider is how your robot is powered and ventilated. In the future, one can assume batteries are able to store large amounts of electrical charge for at least short periods of battle, so incorporating something that hints at a battery pack can work well. A different approach is using an internal power generator, probably a nuclear one or something similar to keep the look sleek and clean. In most cases, however, it is likely that some form of cooling system and ventilation is needed, so try to have some kind of slits or fans for venting heat. (SL)

Above: In front of the ominous troupe of reptilian aliens is one of their sentry droids. Try designing the robots of a particular culture to match their appearance. Again, it hovers, but its arms have mini blaster guns.

Above: This mecha robot brandishes a sword as he towers above the buildings. Look at the simple lever joint of the elbow and compare to the hip area, where the tops of the legs seem to insert into bottom of the pelvis, implying a ball-and-socket joint.

Above: In the foreground is a repair droid with narrow, slim arms with several points of articulation so that it can reach tricky places. It hovers, again to help with working on different machines and vehicles with different heights.

Above: Look at the open slots on this robot's chest and on the sides of its upper arms. It is likely needed for ventilation.

CHARACTER DESIGN:
SCI-FI DESIGNS

TIP 037

Aliens

Aliens can be wonderfully fun to design, as there are very few limitations to the creatures you can come up with. That in itself can also be a problem because if you go too far, you lose the sci-fi look, ending up more fantasy. Furthermore, it stops being believable.

Humanoid shapes
It is very popular for artists to design aliens that are physically similar to humans. It helps readers understand and sympathize with the alien character if they appear similar to us. It is also easier for the artist, as they likely have experience at drawing humanoids in different poses. But there is also some theoretical justification!

On Earth, humans are essentially the top of the food chain—sentient beings capable of manipulating their environment and other creatures. We've evolved as bipeds with arms and hands that have opposable thumbs for enabling us to do detailed, controlled work. We also have binocular vision, most often seen on predators. It would not be outrageous to assume similar traits for sentient aliens on other planets.

Evolutionary influences
Humans are very similar to apes and monkeys in structure, but things may have evolved differently on other planets. Consider the levels of gravity, the gases that make up the atmosphere, the land masses and liquid distribution. Why not have the top species evolve from another type of animal? A watery world may have fish beings, for example. On a lower gravity planet, larger and taller beings may be more common.

Left: This intimidating alien behind the glass door is intentionally humanoid; it infiltrates and camouflages as its host humans. Its true appearance is sharp and predatory.

Below: This alien appears fairly similar to a human female but has fins on her head instead of hair, and unusual eyes with a different pupil pattern.

Environmental adaptation

Just like us humans when we go into environments that we are not designed for, you should think about whether your alien is made for space and whether it would also need some technological help. If you want your alien to be able to move around in space and survive, think about what it needs to protect itself and keep itself functioning. If you look at animals that can survive in the most extreme environments on earth, you can extrapolate designs from them. For example, extreme cold will require a creature with high insulation, or a circulation system that doesn't rely on heat to function. You can also dress your alien in space suits or enhance them with cybernetics so that they can survive (just like humans who need to wear flight suits in airplanes at high altitudes, or diving gear underwater). Dressing or equipping your alien being appropriately is actually one of the best ways to visually distinguish a fantasy monster from a sci-fi alien. (SL)

Above: A reptilian alien regards the reader cooly from slitted pupils behind its holographic headpiece.

Below Left: This alien has just been defeated in battle, but you can see clearly its protective body armor and enhancements, as well as tubes that hint at life support systems.

Left: This reptilian alien officer is connected to the spaceship's mainframe through data tubes attached to its head.

Below: A space parasite, you can imagine that an alien insect similar in design to a cockroach could survive in extreme environments. After all, our real-life cockroaches do!

Left: The structure of this alien was inspired by birds. The bird-like influences are obvious from its feathers, beak-like nose, and smaller, clawed legs.

CHARACTER DESIGN:
CONTEMPORARY DESIGNS

Contemporary Designs

Designing contemporary characters can often be harder than creating fantasy or sci-fi designs. This is truly where they have to be based on real life and seem believable. You cannot get too many details of the silhouette or tailoring wrong, or the character will look awkwardly dressed. Fashions can date easily, as strong styles are associated with different eras. You can use this to your advantage to help with context, or go for a timeless outfit.

TIP 038

Children

When drawing children you want to keep all features as simple and childlike as possible. A child's features are much more rounded than older characters, so lines will feature fewer bumps and overlaps. Large hands and feet will also help to make a character look more childlike.

Additionally, children often have very exaggerated emotions, so whether someone is bashful or excited, you can use this to emphasize youthful vibrancy.

It's helpful to remember that children often wear ill-fitting clothing because they're constantly growing! Drawing children with baggy clothes will not only demonstrate that they're growing but also exaggerate that they're so much smaller than adults and teenagers.

The use of cute and childish designs on clothing will also help to emphasize the young age of a character. Boots with frog designs, or backpacks that look like ladybirds, for example, will make it clear that the character isn't yet a teenager. Toys and similar items will reinforce this juvenile image. (HS)

Above: This girl is dressed in very bold and bright clothing with blocky, simple edges and details. Large buttons are very approriate for younger, less-coordinated hands. Her striped socks and frog hat are cute and childish.

Left: This boy is reaching up toward a black balloon. His outfit is a loose-fitting red tracksuit with a T-shirt and sneakers. Children tend to wear simple and easy-to-choose outfits, and clothes can look baggy on them as they are unlikely to find a perfect fit.

Teenagers

Teenage characters are often regarded as center stage in the realms of Manga. Many of the most vivid and famous aspects of Japanese culture come from their street fashion and youthful characters. Colorful hair is often used for teenage characters too, which helps to emphasize their youth and playful attitude.

Teenagers can generally get away with wearing all sorts of elaborate and outlandish outfits! They can be oversized, undersized, childish, or mature—it's a flexible age for character design that can carry a lot of different styles. Be sure to take advantage of this when dressing your characters.

Below: Many teenagers live for their role in school. Sporty or scholarly, whatever it may be, there are associated uniforms, both formal and casual.

Below Middle: Teenagers experiment— this boy has a strong side-swept fringe and an interesting neckline.

Awkward, playful, clumsy, and ridiculous—make the most of the transitional stage inherent with this age of character, and grant your characters bold and colorful styles.

Consider roles when choosing clothing. Characters may choose to still wear their school uniform outside of school but wear it with items such as a fancy jacket to make it distinctive and their own. Sporty and vibrant characters may choose to wear sneakers with the majority of their outfits, and wealthy or fashionable types will mix designer items into their everyday wardrobe. (HS)

Right: Bright colors, spikey hair, stripes, pleats, and funky footwear make strong design statements.

Below Right: This fashion is "Punk Lolita"—a mish-mash of British tartan, punk spikes, and goth elements with youthful and cute schoolgirl influence.

CHARACTER DESIGN:
CONTEMPORARY DESIGNS

TIP 040

Adults

Many of the differences between adults and teenagers are a matter of body definition and facial features becoming more distinctive.

The addition of facial lines will show less softness in the face than is typical with a teenage character. It's possible to make a character look more mature with the effective use of lines under the eyes, around the mouth, or around the forehead.

Muscle tone and definition doesn't usually become visible until adulthood. While teenage characters have their limbs defined simply, an adult character will need to have folds and indents that are more pronounced. Figure shape doesn't fully develop until adulthood, so making use of this can show maturity in your characters.

Left: This character radiates a strong personality. His face and build are indicative of an adult man, while sunglasses, wristbands, and a belt chain show a rebellious nature.

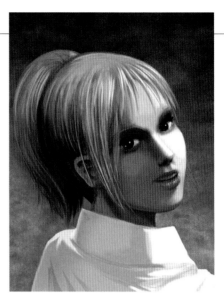

The clothing styles of adults tend to be less playful and colorful than teenagers, and outfits are more fully coordinated. Choosing appropriate wardrobes for adult characters will make a big difference to the way they're perceived. (HS)

Below: Here are sketches of a mature man with various expressions. Look at the way his facial muscles move—these lines would not be seen in younger characters.

Above: Adult design is elegant and understated. This woman has a neat ponytail and is wearing a chic, clean white coat. It's lady-like and not too youthful or extreme.

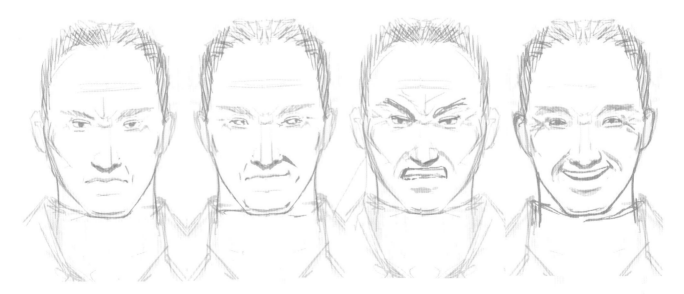

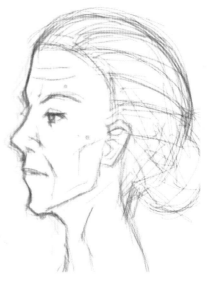

TIP 041

Elderly People

Elderly people lose some of their strength of posture and will naturally slouch slightly. This shortens the appearance of the neck and generally hunches the body together.

Clothing becomes more conservative with age but also will often make more allowances for comfort. Clothes will be styled to cover the arms and legs. Colors are less bold, and fashions will be more modest and classic.

Props such as glasses or pipes for men make a big difference to capturing age. Small details such as age spots or moles on the skin will also be effective to represent elderly characters.

As the face ages, contours become more defined. Parts of the face begin to sink, so previous straight lines bend into a concave shape. Sometimes the bone structure becomes so defined that a second parallel line helps to show the edge. (HS)

Right: Conservative cuts and colors are typical for older characters, as they tend to be less body-confident than when they were younger.

Suits that skim over figures and smooth down anything are very appropriate, as they are both comfortable and flattering.

Below Left: More lines and wrinkles are a definite, but don't neglect the hair—many characters will have less hair and a hairline that has receded further back.

Below: Even if the character has never needed or worn glasses earlier in life, it is very likely they may use glasses more frequently as they age, as eyes tend to become weaker and need help to focus. Glasses are more comfortable and usually less of a hassle than contact lenses.

Below Right: Elderly women tend to cut their hair shorter or keep it tied in a bun as hair strength decreases with age, so the ends can easily become dry and brittle.

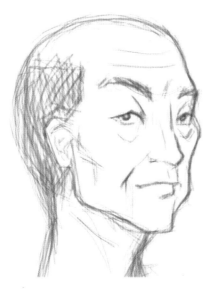

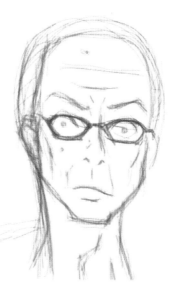

CHARACTER DESIGN:
CONTEMPORARY DESIGNS

TIP 042

Fashion

Most beginners learn how to draw Manga characters by copying from what they enjoy reading. In fictional settings like fantasy or sci-fi, this is a great way to start, as the professionals have a lot of experience and editors who point out what works well and what doesn't. But if it is a contemporary setting, beware! Some of the most well-loved series can be several years (and in some cases, even decades) old. It just looks awkward if you have characters using up-to-the-minute tablet computers, but dressed like they're from the 1990s. If you look at old Manga as reference, use them to practice drawing fastenings, different materials, and tight or loose-fitting clothing. Don't copy the whole outfit (as that is very dating), but look at the nuances and different elements of it.

For real fashion, try picking up some clothing catalogs or shop online to really understand the latest looks and trends. These can be better than high-end fashion magazines for inspiration, as they are much more wearable and easier to put in context. Not to mention that specific countries and cultures have their own styles—it's great to be into Japanese street fashion, but outside of Tokyo, typical teenagers don't wear that style.

Think about what people actually choose for their clothing. You don't buy an all-over skintight outfit, so account for common sense—if a girl wears tight leggings, she'll probably wear a loose hoodie. You wouldn't wear a plain white T-shirt all the time; you would more likely choose something with some pattern or slogan on it. Older or more bashful characters tend to dress more conservatively. Different climates also affect what we are likely to choose. (SL)

Left: See how there is some pull in the material where she has put her hands in her pocket?

Below: Many designers used loose-fitting jumpsuits in their 2010–2012 Spring/ Summer collections.

Below Far Left: Look at the difference between a plain T-shirt and a patterned one!

Below Middle: An older gentleman living in a cooler climate would probably wear a shirt with a sweater and khakis rather than a T-shirt and jeans.

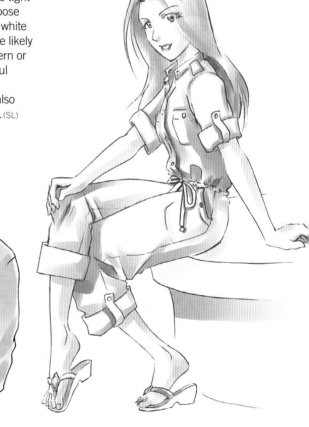

Uniform

Uniforms feature quite strongly in many Manga series. Characters are often part of something bigger, like their workplace or their specific job. It can convey a lot of information to the reader very quickly, so if you see a lady in a laboratory coat, you know she's a doctor or scientist. If you see a little boy in a blazer, with a coat-of-arms on the chest and necktie, he's probably going to an exclusive school.

Sometimes uniforms aren't necessarily that strict or standard—at times, it's a dress code or what is actually practical.

Musicians usually wear black-tie/formal evening wear when performing in an orchestra, but this can range from a variety of modest gowns to different waistcoats, cummerbunds, and bow ties. Construction workers usually wear overalls or dungarees, which can come in many colors and fits, with different pocket placements (and varying degrees of wear).

It is very important to do your research to learn what is suitable practically, and the subtle differences in shape and cutting that can denote a specific occupation or group. Both painters and crime scene investigators wear overalls, but the former can have old paint spatters and be partly fastened, with hair loose, which would be unthinkable for the latter. (SL)

Left: A typical sailor-collar Japanese schoolgirl uniform, complete with loose socks. Appropriate for Japan, but not usually seen elsewhere unless someone is in costume!

Above Right: A British Army general hands over a dossier near the end of World War II. When drawing characters in a real-life historical setting, do your research. The insignias and badges have to be accurate.

Right: A modern-day secret agent rappels from a helicopter wearing lots of practical and tactical gear—belts, straps, protective pads, and night vision goggles.

Background and Props

Although exciting characters are the core of Manga art and comics, readers and publishers will not be impressed if you can't draw the environment around them. A Manga artist needs to employ many of the key drawing skills used in life drawing and architectural design. Practice building up your original designs with basic shapes. Use photographs to inspire and flesh out your designs so that you gain a practical knowledge of how they look from different angles. Learn to use perspective grids and vanishing points to add depth and technical accuracy to your settings—this is absolutely imperative when dealing with man-made structures and buildings. Recognize ways to add historical detail, authenticity, and visual clues to your building design so that it matches your setting. Identify the different techniques used for outlines and shading when drawing natural settings.

BACKGROUND AND PROPS:
DESIGN USING SHAPES

Design Using Shapes

One of the most challenging tasks for comic artists is drawing the environment surrounding their characters, including props, vehicles, buildings, and interiors. They can seem daunting, as there aren't many factors in common to commit to memory—with everything you draw, it feels as if you have to start from scratch and learn all over again. Using 3-D models can help you visualize the structure of your objects.

1: 3-D object

TIP 044

3-D Visualization

3-D software such as Blender, SketchUp, and Autodesk 3ds Max can be used to place objects into a 3-D space and rotate them into place. Other tools such as Manga Studio EX will even assist you by rendering a version of the object in a "line art" style, which can help save time when drawing complex objects.

A basic 3-D scene can be constructed from simple blocks, spheres, and basic 3-D shapes. By making use of the grid lines you can even find it easier to judge distance when creating a more complex version of the object. Remember that the grid lines are merely a guide, and it's often worth adding detail and shape to the object just as you would any other image.

More complex objects such as skyscrapers can be constructed in the 3-D package, or you may be able to find samples available for reference in 3-D object libraries. If you want, you can even generate line art automatically using Manga Studio EX.

It can even be useful to create props in 3-D, especially when the object is complex or has difficult perspectives. Objects such

as swords, poles, and guns will benefit from this technique, as well as musical instruments such as this violin. Ordinarily, such an accurate image would require a lengthy illustration process or reference photos in the exact angle needed, but by using a 3-D object the process is made simple. (HS)

2: Drawing over the 3-D object

3: Final image

Left: Musical instruments are notoriously difficult to draw, as they are made with so much precision and appear so iconic; mistakes can be made very easily. With a 3-D model you can position instruments correctly and accurately to use as a basis for your final lines.

Above: Here you can see the 3-D model of a sofa. I added a few design elements like the cushion shapes and sofa feet to produce the final image with a character in place.

Effective Use of Reference

The use of photo reference makes a huge difference to the quality of artwork, but be aware that artists often come under fire for "photo tracing." The main criticism for this stems from people using photos as a source and reproducing the image precisely, with little deviation. Try to use your own photos as much as possible, and always make sure that your images vary from the original.

TIP 045

Uses Source Photos to Reconstruct Areas

Complex architecture can be difficult and time-consuming to reconstruct accurately without reference photos as a foundation. If you're able to, try using local landmarks as a source for your image and then drawing the outlines based on the photograph. This allows you to get interesting angles that are most suitable for your artwork.

Be aware that distinctive buildings will be known for their location, such as this drawing of Queens College Chapel in Cambridge, England. This can be useful if your story takes place in the location, but trying to include this drawing in a fictional world without modification may be jarring to anyone who recognizes it.

When drawing comics it's really important to have good establishing shots for scenes and locations. A couple of strong, simple images will give the reader a great sense of place, and they will find the story easier to interpret. Photos of your own home, or even a friend's house, are a unique and convincing basis for your art, with many of the lines and angles perfectly in place.

Photos are also useful for capturing specific body poses, such as a hand holding props and items at difficult angles. You can do this by taking photos of your own hands or by using photo sources. If you draw the line art first, you only need to reference specific parts of the body. Change as many parts of the pose as needed. (HS)

Below: Drawing a character holding a pen or cigarette is harder than it looks. This example uses a photograph to get the position of the hand and cigarette correct and realistically positioned, while the rest of the character is more stylized.

Above: If the setting is real life, reproduce the main perspective lines and key features as best as you can. Use your own lines and shading or coloring, though—this identifies it as your art, as your style will show with the marks you make.

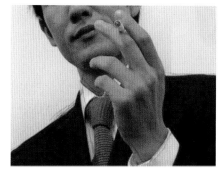

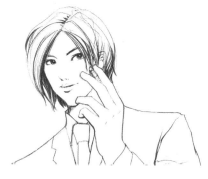

BACKGROUND AND PROPS:
PERSPECTIVE

Perspective

Perspective is the most common way to create depth and realism in your piece, giving a 3-D effect of space to a 2-D image. Depending on your intent, you can use multiple vanishing points to give the reader a strong sense of place or a glimpse of unreality.

TIP 046

Vanishing Point Theory

Vanishing point theory can be used to make perspective-based drawing look more realistic and three-dimensional. It can be applied to very simplistic scenes and objects or immensely intricate and complex constructions, so irrespective of what artistic level you are at, your drawing can always benefit from understanding this theory.

Single-point perspective is where all perspective lines converge at a single point—the vanishing point (illustrated in the diagrams as a green dot)—which insinuates a perceived distance. A simple real-world example of single-point perspective would be viewing a long, straight road or a set of train tracks going toward the horizon.

The first single-point-perspective diagram shows a basic landscape format with the vanishing point at the center of the horizon. The vanishing point (and the horizon, for that matter) can be placed anywhere on your image, or even off the canvas completely—but you need to be aware of where the vanishing point is so that you can bring all perspective lines to it, or where it would be. The line of

horizon can be at any angle you wish, depending on the effect you're looking to achieve, although for most purposes horizontal tends to be the natural starting point (after all, the term is derived from the word "horizon"). The vanishing point is always somewhere along this line.

I've illustrated a single-point perspective grid over a photograph so you can see how this works. If you've never really worked with vanishing point theory before, working over a single-point perspective grid of this kind is a good place to start.

You can take a piece of paper in landscape or portrait format and, using a ruler, draw a straight line of horizon and pick a point along that line to be your vanishing point. Next, rule lines from all four corners of your paper to your vanishing point. Add as many more lines from the outside edges of your paper to your vanishing point as you like, and if you want, you can also add line rectangles decreasing in size toward the vanishing point (with the corners placed along the diagonal lines drawn from the corners of your paper).

Left: A basic one-point perspective grid. Use the spot in the middle as a starting point for any straight lines of buildings, roads, or rows of trees that disappear off into this point.

HORIZON

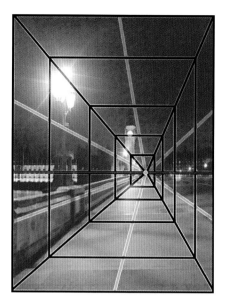

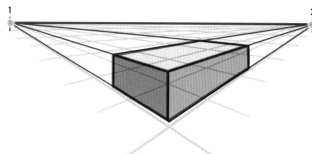

Above: The two-point perspective grid drawn on top of a photo of a car.

Below: To capture the dynamism of looking at an object from a very high or low angle, there are three vanishing points in three-point perspective. Two are along the horizon line, but the last point is either far above or far below the object.

With your completed one-point perspective guide grid in place you can begin drawing over it, perhaps using it to trace over on a new piece of paper. Try drawing some basic 3-D shapes such as cubes using the perspective lines as angle guides. Then, when you're happy that the 3-D effect is looking right, use this technique to draw a cityscape with skyscrapers and roads, or perhaps a room full of furniture, and you'll be well on your way!

Two-point perspective should be an easy enough concept to grasp once you've got your head around single-point perspective, as it's fairly self-explanatory. Here, there are two vanishing points on the line of horizon, but there is a little twist: instead of perspective lines all coming in to converge at the vanishing point(s), lines come out of the vanishing points toward a vertical line perceived as closer to the viewer. This technique is good for depicting objects being viewed from the side or at an angle in the foreground, for example, a vehicle or a building on a street corner.

The two-point perspective diagram with the cube conveys this in simplistic terms, while the two-point perspective

grid superimposed on the photo of a car demonstrates how vanishing points can be situated outside of the canvas/final viewable image area.

With three-point perspective, another dimension is added with a third vanishing point, situated either above or below the horizon line. Images using this technique often have an almost surreal, fish-eye lens appearance. It's good for presenting objects viewed from above or below. The diagram presents a view of a block from below in a simple manner.

Drawing using three-point perspective can be quite challenging, so you need to be very aware of which convergence points on your guidelines are relevant to the object(s) you are drawing. It helps to have a technical mind-set when working with three or more vanishing points, but if you can master these techniques, you should find that you will be a very accomplished artist indeed! (NH)

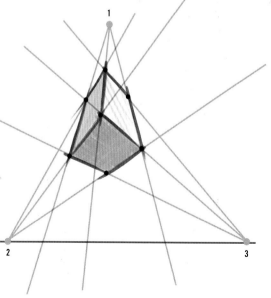

BACKGROUND AND PROPS:
PERSPECTIVE

TIP 047

Practical Applications

Having covered vanishing point theory, here are some practical applications for perspective in your art. In addition to the purposes mentioned before, you can also use vanishing point theory to achieve a sense of vertigo with a view over rooftops or between buildings looking down toward the ground. Another technique for achieving a sense of distance is to use colors and shades that fade out, getting lighter and less saturated toward the horizon. This is called aerial perspective.

If you draw on a regular enough basis, you may find that you naturally envision how 3-D forms will translate into a 2-D drawing before you put pencil to paper (or stylus to tablet). If not, you may want to sketch simple 3-D forms (such as cubes, cylinders, and pyramids) to plan placement and correct angles of final objects and components in your scene. If you're confident in drawing figures in standard views but less experienced in depicting them at extreme angles, try drawing a guide box at your desired angle (you can use vanishing point theory for this) and working the character into it.

I've included an array of examples here that feature elements of perspective in practice; some are extremely simple, others less so.

In the past I've had to illustrate some fairly simple indoor scenes of bedrooms

Above: This sketch of a comic page showcases a low angle view from below a showman. It adds to the sense of excitement as he shouts to the crowd.

for which one-point perspective has been ideal, as well as some loosely rendered outdoor scenes where perspective has played an important part in making such images believable, even just at a glance.

With my extreme downhill cycling image I wanted a sense of great depth, movement,

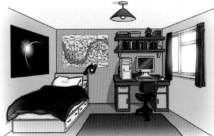

Left: Use three-point perspective subtly when drawing characters from high or low camera angles by placing vanishing points far off the edge of the image.

Right: In rustic historical settings, the street and buildings may not be perfectly aligned, but using a perspective

Above and Far Right: Simple one-point perspective can work well for interiors such as these two bedrooms and this elevator. It quickly gives a sense of depth.

point to help with roughly outlining the edges of the roofs and windows on the same levels gives a solid impression.

Above: Ensure all straight lines and edges lead back to your vanishing point.

Above Right: One-point perspective is used in this dynamic downhill bike race.

Right: This image is lifted with a sense of movement because of the low angle.

Bottom Right: One-point perspective is used to generate basic shapes in this scene.

and vertigo. I had sketched out a rough layout beforehand with the land in the foreground using a single vanishing point, but there was a secondary mountainous horizon behind it that was set higher up, giving the impression that the foreground was directed downhill. In addition to this, I subtly curved and distorted the lines of perspective on the foreground hill and angled the trees in such a way as to direct the viewer's attention toward where the cyclists are heading: "over the top." Along with some zoom-in type motion blur, this gives a tunnel vision effect. Note also the use of aerial perspective on the far mountains—I played with the contrast, color balance, and saturation until I had the sense of distance I was looking to achieve. Overall the picture is a little more saturated than a real-life scene would be, as the purpose of the image was to set the mood and feel for a video game concept. The idea was for it to be quite realistic but also stylized enough to heighten gamer appeal and emphasize the "extreme" nature of downhill mountain biking.

In the illustration of my character Peg-Chan in the crow's nest, I feel a sense of perspective lends a lot to the image. Without it, it would just be a rather boring depiction of a character *in situ*, so it just goes to show how perspective can make or break a drawing.

The final illustration with the "slime-blob" characters was done as a cover image for a retro-style puzzle game, which to my knowledge has never been released. This is another example of single-point perspective coming into use, although the scene and its contents are all quite surreal. The game itself was to be presented in a top-down view with any perspective merely insinuated, so in using extreme perspective in the cover my aim was to add more of a sense of drama and grab the viewer's attention, much in the same way as many examples of cover art found in the early gaming era this game emulated. (NH)

BACKGROUND AND PROPS:
ACHIEVING DEPTH AND ATMOSPHERE

Achieving Depth and Atmosphere

Just like a passage of description in writing, atmosphere in art achieves a greater feeling of realism. Unlike lengthy prose, it can set instant ambiance and create a mood for the viewer with just a glance.

TIP 048

Light, Smoke, and Dust

Using these kinds of atmospheric effects will definitely enhance the mood of the drawing, so use them wisely and effectively. In order to realize these effects, some inking techniques such as dotting, hatching, and crosshatching are essential, so make sure you do some practice. If you are a digital artist, it might be a good idea to search for some useful brushes that are compatible with the software you use, or even try to design some by yourself.

Let's start with how to draw light. There are several different styles of lights, including dim light, bright flashes, and moving lights.

If you want to draw dim light, one of the ways to do so is to use two layers of screentones: one very light layer and another one or two steps darker (use screentones that are different shades but the same density to avoid unwanted moiré). Apply the lighter screentone on paper first and lay the darker one on top. Scrape away circles only from the darker screentone, making sure that the edges of the circles are as soft as possible. You can also scrape away smaller areas from both screens or just add some dots with white ink in order to depict both dim and bright lights.

Above: An example of dim soft lights.

Far Left and Center: An example of dim city lights.

Left: An example of bright lights and search lights.

Opposite Left: Varied examples of smoke from fire.

Opposite Center: An example of trailing smoke.

Opposite Right: A representation of blown dust.

This page: *The Story of Lee Volume 1* © Seán Michael Wilson & Chie Kutsuwada, NBM.

As for bright flashes, draw a small dot with white ink on a dark background, and from each of these dots, draw straight radial lines that thin at the ends. If using software, you can find copyright-free digital brushes that draw this kind of flash automatically.

Now, if you want to draw moving light such as a distant vehicle's lights on the road at night, first add some white dots on a darkened background. From each of them, draw a horizontal line and make it thinner toward the end. Those added lines are afterglows, so don't make them too strong or long. It's quite effective if the line is wobbly to represent a vehicle's shaky movement. Make them varied so it looks like there are different types and sizes of vehicles moving.

For digital users, it's a good idea to try different brush opacities to create varied light shading on dark backgrounds.

For cityscapes, it's good to remember that starlight is very random, so you can just spatter white ink on a dark background, but city lights are quite regular, so arrange a few white dots on the same line and/or grid, imagining you are drawing street lights and light from building windows.

Now it's time for smoke. There are roughly two different types of smoke. One is wider, rolled-up smoke, such as from a house fire, and the other is trailing smoke, such as from a chimney or, on smaller scale, from a candle or cigarette.

When I draw big, rolled-up smoke clouds, I just draw the outline of smoke with the shapes of irregular semicircles. Since smoke moves and gets bigger, I use thin, smooth, curvy lines and not hard lines—they kill the feeling of movement. Often this kind of smoke is not just white but gray, or even black, so I might add shade with curvy, short line hatching or paint a darker area black. If the smoke you are drawing is from fire, it might be a good idea to add some blown-up ashes by drawing a few irregular freckles.

Trailing smoke, on the other hand, spirals up into the air and easily wavers with the wind. To represent these qualities, I use very irregular wide, wavy lines drawn from the starting point of the smoke and make sure the end of each line becomes very thin, as if it disappears in the air.

As for dust, when I draw blown dust, I first decide on the direction of the wind. Then I draw very short, scattered lines following the wind flow. Make sure that each of

these short lines start sharply and end in the same manner. If it is dust on the street, mix these scattered lines with varied irregular dots, small and distorted circles, and leafy shapes at random.

When drawing dust that's thrown up by one sudden movement—for example, when something quite heavy is dropped on a dusty place—you can use a few curvy round lines to express the outburst. These lines are similar to those used for expressing smoke roll-ups; however, using slightly wavy lines can express smoke density, while intermittent dotty lines make it look dustier. (CK)

Above and Left: *Hagakure The Code of The Samurai* © Seán Michael Wilson, Chie Kutsuwada, William Scott Wilson, and Kodansha International Ltd.

BACKGROUND AND PROPS:
DRAWING BUILDINGS

Drawing Buildings

It's very easy to get intimidated by the prospect of drawing large-scale buildings or backgrounds that feature lots of buildings. Getting into the right mind-set is key! Break everything down into shapes, chunks of work, or parts of a larger process. Complex things take time, so don't give up. Many Manga artists spend ten hours or more on creating a large building if it's important to set the scene.

TIP 049

Cities

Every city around the world has its own particular flavor. The shape of the skyline, the age of the buildings, the materials used in construction—think about how their appearance is linked to climate, development, age, and tradition.

As such, the first thing you should do is research the cities in question, particularly if your Manga is set in an actual location. The buildings in the center of modern and large cities, such as Tokyo, Japan, are likely to be very sleek and tall, with lots of glass and straight lines. Be sure to be rigorous with your perspective lines and vanishing points, as these will be absolutely essential.

If the city has a much older feel, such as Edinburgh, Scotland, there will be lots of period features like columns, architraves, wrought metal, cornices, and other moldings. The height of the buildings will also be much lower—at most, six to seven stories. Think about the infrastructure as well—cobblestone roads are very old and traditional.

If you are designing a fictional city, you should look for the closest real-life equivalents so that you can make them more believable. After all, real cities work in real life and suit their culture, history, and location. Colder climates demand more insulated and closed buildings, for example. (SL)

Top: These are some shops with historical features in the center of Cambridge, England. Note the embellishments on the front of the buildings.

Center: This is the skyline of a medium-sized traditional English city. The center of town is likely to have more traditional chimneys and tiled roofs alongside the more modern TV aerials.

Right: This scene is set in Ometesando, a famous shopping boulevard in the middle of Tokyo. *Manga Shakespeare: Romeo and Juliet* © SelfMadeHero.

Suburbs

City centers tend to have civic buildings (embassies, town halls, libraries); buildings of historical importance (cathedrals, museums); commercial properties (offices, department stores, restaurants); and high-density housing (apartments, condominiums).

Once we get to the suburbs, everything starts to sprawl out as ground space becomes more plentiful and affordable. There will be a lot more residential properties—apartments become lower and longer, houses will have more yard space. Buildings take up more ground with less capacity. Even though there will be some subtle differences depending on the country, it's definitely not as pronounced as with the city center or rural countryside. Most suburbs around the world have surprising similarities because they are associated with more modern construction and more land, as every city constantly expands its boundaries.

When depicting these suburban backgrounds and buildings, exercise common sense—think about door positions, garages for the cars, ceiling heights, window size, and fences. Don't forget to put some areas of greenery in and around plots.

If you're looking for inspiration, why not turn on the television and watch some property shows, or buy a few magazines on home decorating or DIY? To be even more accurate, try to source such material from the country you're setting your story in to get the popular styles of housing right. Don't draw a Japanese-style house if your comic is set in the French Riviera! (SL)

Below: These are a set of apartments, which are of a style often found in the suburbs of larger cities. The style is indicative of 1960s architecture, very blockish and urban.

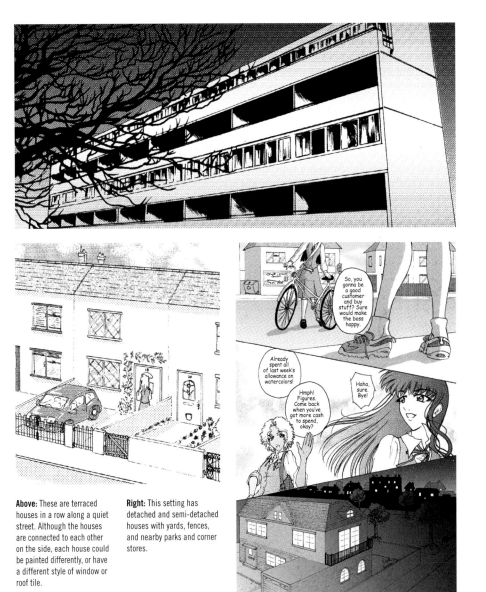

Above: These are terraced houses in a row along a quiet street. Although the houses are connected to each other on the side, each house could be painted differently, or have a different style of window or roof tile.

Right: This setting has detached and semi-detached houses with yards, fences, and nearby parks and corner stores.

So, you gonna be a good customer and buy stuff? Sure would make the boss happy.

Already spent all of last week's allowance on watercolors!

Hmph! Figures. Come back when you've got more cash to spend, okay?

Haha, sure. Bye!

BACKGROUND AND PROPS:
DRAWING BUILDINGS

TIP 051

Rural Areas

It goes without saying that when drawing the countryside, you need to work hard on your landscapes and scenery, but it's important to know what types of buildings work in rural settings, too.

Residential buildings are usually in a village setting—small settlements of a few thousand people or less. There would be very few buildings over four floors (if any), and the majority would be only one or two stories high. The busier areas would look like the suburbs, but then such pockets of housing will be surrounded by farmland or other forms of natural terrain (woodland, water, sand dunes, etc.). There would also be a few isolated houses with lots of surrounding land and little to nothing else nearby.

Other rural buildings are predominantly linked with agriculture or tourism. They will either be very traditional (farmhouses, manor houses, castles, barns, fishing huts, herders' tents) or very innovative (artists' retreat, eco-house, visitor center).

Rural settings are distinctive and unique to their cultures and locations, particularly if the buildings or structures have age. The lush and tropical seaside fishing settlements along the Indian Ocean are a world away from the painted red barns of the Midwest in the United States. Even within the same country, two villages only a few hours' drive apart will have their own quirks: in England, the flat fenland villages of Cambridgeshire are visually different from the warm sandstone cottages of the Cotswolds. Research is crucial! (SL)

Above: This fantasy witch's cottage is in a woodland clearing. Note the dormer window just visible off the side of the roof, the heavy lintels above the doors, and the narrow windows.

Left: These huts are based on traditional Scandinavian designs where the story of the Snow Queen is set. Some areas have a full-length triangular roof design; others have a hexagonal shape.

Below: This is a modern tourist center in the middle of a forest, hosting a school trip.

Drawing Buildings: Specialist Structures

"A mysterious clock tower overlooks a remote European village in the mountains. Here resides Tockr, Guardian of Time."

With this original premise for *Tockr's Tower* (that, oddly enough, came to me in a dream), the tower itself is as integral to the concept as the title character, Tockr. This tower is almost a character too, in a sense, with a life of its own. I wanted to create an architectural structure with an eclectic and eccentric design, borrowing from all sorts of eras and cultures.

I approached the design of the tower in a relaxed kind of way and just let my mind wander, guiding my pencil while I sketched. To go into an almost trance-like, daydreaming state seemed somewhat appropriate considering how the idea had come about in the first place. At college I had studied architectural styles in Art History so I had a fair

amount of inspiration in mind to draw from and apply, so of course I would recommend reading up on plenty of reference material if your art calls for specialist structures.

In the initial tower sketch (drawn with a mechanical pencil loaded with red lead), you can pick out architectural references ranging from Stone Age megaliths, Egyptian pyramids, and Roman Corinthian columns to perpendicular Gothic arches, arched Tudor structures, and elaborate Baroque styles. There are also some nods to Art Nouveau and Surrealist art present in elements such as the "melting" clock face.

In the final color piece you can see how the tower, title character, and scenery come together to evoke the quirky, strange, and timeless kind of atmosphere I wanted to portray with this concept. (NH)

Right: The reader's eye is drawn to the mysterious, rambling tower in the distance.

Above Right and Far Right: Detailed preliminary sketches of the tower. Make an effort to flesh out as much as possible in the pencil stage so that you can really picture how it works in three dimensions.

Above: A Gaudi-esque doorway.

Above: Arched, Tudor-inspired structures.

Above: A Roman column

Above: A Stone Age doorway.

BACKGROUND AND PROPS:
DRAWING NATURE

Drawing Nature

It isn't necessary to have climbed a mountain or hiked through a jungle to present them in a believable fashion to your audience. A combination of research and these tips will set you well on your way to creating lush natural worlds for your characters to inhabit.

TIP 053

Terrain

You need to think very carefully about terrain because it is one of the most important aspects in creating the world you are about to draw. Is it mountainous? If so, are they rough and rocky or gentle slopes with a lot of trees? The more you decide about the details of the terrain, the more believable your scene will turn out to be.

Look for references. Collect landscape images that inspire you, and you can play with them—for example, mix them up and piece them back together differently to create a new landscape.

To back up an imaginary landscape, do some research on geographical features, such as variations of mountain shapes and even the geographical distribution of plants. This research is especially useful when you are drawing real places.

As for technique, to show a sense of depth in the scenery, use not only general perspective principles but also different inking touches for creating the difference between the nearer and farther object. In my case I use thinner and smoother lines for drawing terrain at a distance and slightly thicker lines with accents for foreground terrain. Distant scenery often looks blurry, so not only using thin but also irregularly intermittent lines will be good for representing this kind of blurriness. In contrast, draw more obvious details in the foreground.

I also change the type of lines according to the nature of the soil. To draw muddy or green areas, use slightly curvy lines; for sandy areas use dots; and to draw rocky areas, use short, sharp, and straight lines.

Especially when you are drawing green or rocky terrain, the crosshatching technique is useful. Use dense crosshatching for shadow in foregrounds and slightly rough hatching for distance. Paint the darkest part, such as under a tree or a dense wooded area, with black and gradually use crosshatching to create a gradation or simply use gradation tone to give solidity. When using gradation, it is very important to decide where the light (most of the time from the sun or moon) comes from. (CK)

Top: A few examples of representation of terrain.

Above: An example of bird's-eye-view terrain.

The Book of Five Rings
© Seán Michael Wilson,
Chie Kutsuwada, William
Scott Wilson, Shambhala.

TIP 054

Water

Water comes in so many forms that drawing it really depends on what kind it is. If the water is not running fast, such as a lake; a wide, slow river; or a calm offshore scene, using screentones is the most common way to depict it. I often use gradation screentone or mix different shades of tones, to represent the depth of water and distant sea from the foreground. (Note: use the same density of tones to avoid an unnecessary moiré effect.) Occasionally I add some random vertical lines to express subtle waves, and add sparkles and reflections by scratching highlights off the tone or by using white ink.

Don't be afraid of adding darker shadows or reflections with solid black, since it will give a nice accent to the scene. You could use dense, solid black for areas such as the shadows of ships or rocks, or for reflections of plants on a beach.

Use wavy lines and shapes to represent reflection bends. And don't forget that if water moves, all of the reflections and things underwater look slightly distorted. I use slightly wavy soft lines to draw these instead of strong straight lines.

Let's talk about how to draw details such as breaking waves, ripples, and a circular wavelet on the surface of water. First, it is always a good idea to check how they look in real life, so study references as much as possible. When I draw breaking waves, I often use gradation screentone—the bottom of the wave is darker and the breaking point is almost white. Add splashes with white ink or by drawing the outline of the splash with thin, delicate lines. For ripples, use irregularly intermittent wavy lines. For a circular wavelet, as it is quite technical to draw, you might need some reference images, a pair of compasses, and a set of French

Top: An example of the most common way to express water surface using screentone.

The Story of Lee, Volume 1 © Seán Michael Wilson & Chie Kutsuwada, NBM.

Center: Examples of pouring water and a swirl of water.

The Book of Five Rings © Seán Michael Wilson, Chie Kutsuwada & William Scott Wilson, Shambhala.

Below Left: Some expressions for shadows and reflections.

Hagakure The Code of The Samurai © Seán Michael Wilson, Chie Kutsuwada & William Scott Wilson, Kodansha International Ltd.

Right: A circular wavelet and waterfall.

The Book of Five Rings © Seán Michael Wilson, Chie Kutsuwada & William Scott Wilson, Shambhala.

curves. A circular wavelet is very stylized, so be sure to use smooth curvy lines and make it look regular.

Finally, if you would like to draw water from a tap, or pouring water, use a few soft wavy lines and draw them in spirals. When water pressure is very high, such as a tall waterfall, you can use more sharp straight lines and maybe add some splash where water hits the other surface. (CK)

BACKGROUND AND PROPS:
DRAWING NATURE

TIP 055

Seasons

Before you start planning a Manga scene with seasons, what should be mentioned here is that Japan, Manga's mother country, has very clear seasonal differences. The atmosphere changes every month, along with the fashion. It's almost inevitable to have depictions of seasons in the background or characters' clothing in any Manga that features Japan. Japanese people have been enjoying each element of the seasons throughout history. The following is a list of elements of each season in Japan, which may inspire you in your creations:

Spring: cherry blossoms, butterflies, spring breeze, nightingales, a graduation ceremony, a school entrance ceremony

Early summer: rain, hydrangeas, green leaves, picnics

Mid-summer: sea, beach, fireworks, summer festivals, ice cream, kaki gori (shaved ice, usually served with flavored simple syrup), watermelons, fireflies, sunflowers, gold fish, yukata (summer kimono)

Autumn: Japanese pampas grass, colored leaves, moon festival, rabbits

in the moon, typhoons, red dragonflies, Halloween celebrations

Winter: snow, seeing your breath in the air, stoves, winter gear, Christmas trees, New Year's celebrations

Manga artists use different seasonal elements to hint to readers that time is passing from season to season, showing how time passes artistically.

For depicting spring scenes, the most popular effect is a cherry blossom petal storm. The petals should not be randomly placed in the panel, but follow the direction of the wind.

In summer, depicting bright sunlight is one way to show the heat of the sun. To create the strong shade, the whiteness of the sunbeam stands out.

In autumn, colored leaves can be a good visual clue, but it is also effective to seize the moment of a quiet night with a big full moon and autumn plants to give a contrast from lively spring scenes.

In winter, a hazy view for heavy snow is depicted. Everything in view is covered by

settled snow. Each snowflake is not just a white ball but almost looks like a white scratch on the image—falling snow should look like scratches. Adding snow crystals can also look beautiful.

The benefit of associating your Manga with seasons is that it gives every episode a variety of activities, such as a cherry blossom stroll, a picnic, swimming, a snow fight, or a fireworks display. They are especially useful for dramatic love stories, as a seasonal depiction is extremely powerful for adding lyricism to scenes. (IK)

All images: "Ketsueki" by Richmond Clements, published by Markosia Enterprises Ltd.

Left: A summer scene with strong shade to emphasize the bright sunlight.

Above: An entire page with all seasons depicted to show that time has passed.

Animals

Animals can be so rewarding and fun to draw. When presented in a Manga or Anime style, the depiction of animals can vary greatly. They may be highly realistic with minimal stylization, anthropomorphic (taking on human-like traits), super-deformed, or caricatured to the point of almost being abstract.

I've included some varied samples of my animal art here. A key rule for drawing animals—rather like drawing characters —is to pay attention to anatomy. Understanding the anatomy of animals will help you draw them, even if it's in a very stylized and unrealistic manner. It will make your animals more believable, which is especially useful if you are depicting mythical beasts, monsters, or other imaginary creatures.

If you are drawing a dragon or a unicorn, for example, details like muscle structure will look best if they are based on some real-world counterpart. So for a dragon, you could refer to images of dinosaurs and take their skeletal makeup into account, while unicorn art would benefit from a similarity to horses.

Textures are another aspect of animals that are good to convey in your artwork. Study things like animal markings and the play of light on different lengths of fur or hair, and practice ways of getting scales and other skin textures across.

When it comes to the more cartoon-like and crazy types of animal design, I like to have fun and experiment. You can caricature animals by reducing them down to basic shapes; an extreme example of this would be a spherical bumble bee. As with super-deformed characters, limbs can be reduced to nubby little conal shapes or stick-like appendages with rounded blobs on the ends for feet or paws. You can play around with proportion to achieve ultra-cuteness; tiny wings look particularly adorable, as can baby-like proportions applied to animals in an anthropomorphic manner. As with human characters, you can also use different eye styles to make your animals appear cuter or scarier. (NH)

Above and Right: Reptilian fantasy creatures like basilisks and dragons should still be based on real-life lizards and dinosaurs. It gives you a point of reference for the texture of the scales and skin, as well as the muscle structure so that you know how it moves and supports itself.

Below Right: This fluffy bumblebee looks very comical, as it is simplified into a spherical shape, with short legs and wings.

Left: This beastman's head is based on wildcats and lynx. The posture is animal-like—upright, but stooped over with curved knuckles and claws, and legs that still resemble an animal's hindquarters.

Ultra cute

Scary

Baby-like proportions

Cute

BACKGROUND AND PROPS:
DRAWING PROPS

Drawing Props

Any objects your characters interact with will need to be realistically represented to give your readers a view into the workings of your world. Even if the items are pure fantasy, consistency and the appearance of reality will help lend your world, and its inhabitants, credibility.

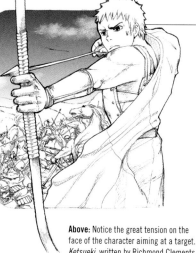

Above: Notice the great tension on the face of the character aiming at a target. *Ketsueki*, written by Richmond Clements, published by Markosia Enterprises Ltd.

TIP 057

Weapons

It's best to draw from an actual object in front of you to maintain the accurate proportions of weapons. While you're not allowed to possess certain weapons, you can still figure out how to hold them by using similarly shaped objects that you can find at home or in your studio.

You can give longer weapons such as staves or swords extreme angles to express dynamism and speed. But if extreme perspective takes over the actual proportions, the weapon still has to look the same in each panel. Consistency is very important for any object in Manga, but drawing weapons also involves four other key aspects that are useful to know:

Kata (forms): The way a person holds a weapon is different depending on what type of weapon is used and the style of fighting. For instance, Japanese sword-fighting kata entails more slicing, while Chinese style has more stabs.

Tension: If a character is using a target weapon, such as a bow or a gun, show tension on the face to demonstrate them aiming. This also depends on the distance between the character and the target.

Weighting: Some weapons are made deadly by their heavy weight, and visually expressing this weight is key to creating great impact.

Direction of force: When artists depict a moment of attack, they need to decide a direction of force. When a weapon strikes a target, the target must be blown in the opposite direction, but leaving a trace to show some parts trying to remain in their original position before the strike. If the target has long hair or a scarf, they should be dancing in the air in the opposite direction from their owner's fall.

During a long battle, weapons may start to look battered, scratched, and dirty. These "heavily used" effects show how hard and difficult the battle was.

When introducing made-up weapons, either nonexistent or customized, it's better to show their special shape as much as possible so the audience can remember them and recognize the shapes. When they appear in your Manga, have a full-body shot or show off a unique part of these weapons, and make them visible in panels as much as possible. (IK)

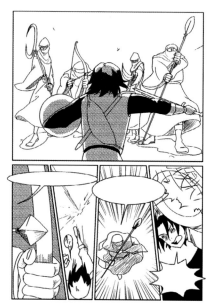

Above: Showing various weapons. *Fantasy World*, written by Theo Ajibode, published by Ajiey Media.

Below: An example of how the impact of heavy weapons can be represented. *Ketsueki*, written by Richmond Clements, published by Markosia Enterprises Ltd.

Vehicles

As a teenager I was really interested in vehicles; I liked building and painting model kits of warplanes, sci-fi movie vehicles, and tabletop-gaming battle tanks. I was also really into concept cars. In this tip I will take you through the process I used to create some vehicle artwork, inspired in part by the concept car magazines I used to read in my youth.

For this sports car (below) I did my initial sketching using colored lead (in this case, red), then reinforced the final lines in black pencil. If you want to create authentic concept car designs using traditional methods, I recommend adding a set of French curves or a flexible curve ruler to your arsenal of tools. These are essential for drawing perfect curves and are widely used by concept vehicle artists when drawing on paper.

Next I scanned and tidied up the line work digitally before applying some preliminary shading in Photoshop. I configured the brush settings to make an effect I considered akin to alcoholic marker pen (also widely used by concept car artists and technical draftspeople). Finally, I added more digital polish. I used the dodge tool to make the headlights appear lit and also to imply movement, as well as neon lights reflected in the car windows. I made a blue-violet toned color variation on the piece and paired the car up with a suitably futuristic-looking driver.

Below is a pinup piece featuring a pair of pretty girl characters taking a breather from a moped ride. The moped, like the racing car, is one of my own designs and was built up in a similar way, except with this example I used photo manipulation techniques—such as adjusting the brightness, contrast, and color balances —along with Photoshop filters to break up the smooth glass surface on the headlights and bring in more realistic textures and chrome effects. (NH)

Left: Two girls take a break during a moped ride. Look closely at the textures on the headlights.

Below: Color variations are great for showcasing concepts to clients. It's also good to have a character *in situ* for a sense of scale.

Bottom: Initial sketches of a futuristic car design that are neatened up. Shading is added, then the car is tinted to the desired color.

Creating Illustrations

Now that you have done your research and practiced your drawing skills, you are ready to begin work on your final presentation pieces. Avoid false starts and wasting precious materials by planning your compositions and learning how to frame your work to show it off well. Draft your drawings in rough using quick strokes and simple shapes before moving on to your final illustrations in your chosen mediums. Learn some of the techniques used to outline your art effectively with traditional or digital inks. When scanning your artwork for digital publishing or editing, keep your options open by using the right settings. Follow the theories behind lighting and shading to add a sense of three-dimensional depth and contrast to your work. Then learn the basics of color theory and the subtleties of how lighting and other environmental effects come into play when coloring your artwork.

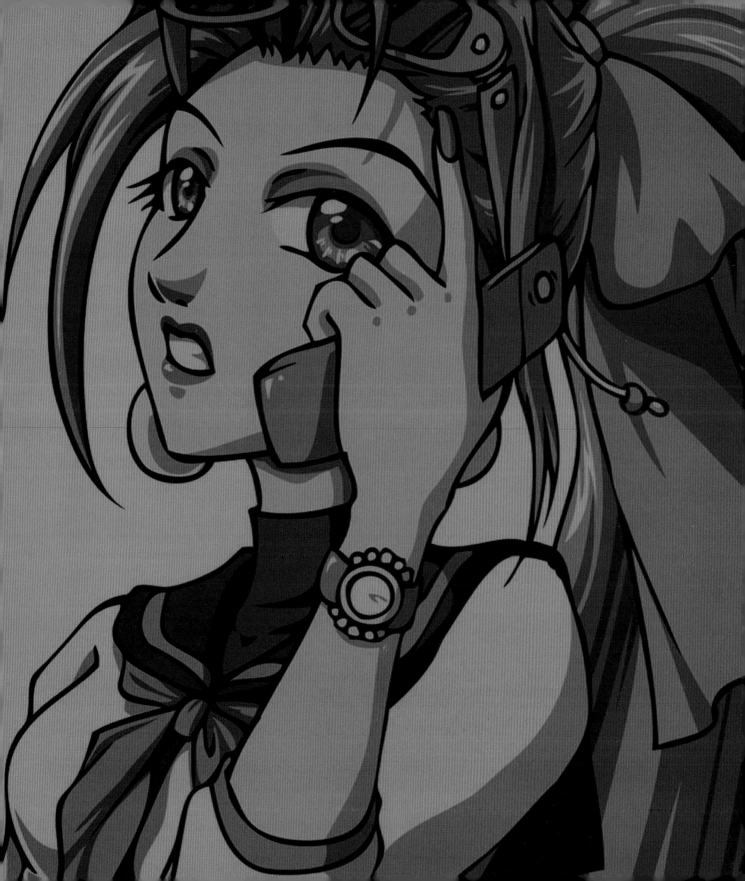

CREATING ILLUSTRATIONS:
COMPOSITION

Composition

Composition is incredibly important to any kind of picture making—photography, portraiture, filmmaking, you name it—and certainly to illustration. Composition relates to how you choose to arrange elements in a picture to achieve your desired effect and to create an appealing design. Good composition feels natural and goes unnoticed, whereas bad composition tends to stick out like a sore thumb and lessens the impact of the picture. This is why composition is both indispensable yet hard to put your finger on.

There are many ways that you can work with the composition of a picture, and here we're going to look at a few of them.

TIP 059

Flow, Stability, and Subdivision

One principle of composition is to arrange your picture elements to lead the eye across the page. Most of us are used to reading text in the left-to-right order, so it's not so strange that our eyes tend to scan a picture in the same way. By arranging elements in a way that brings the eye into the picture, you can draw in and immerse the viewer. In this example, the moons are aligned with the girl in a way that creates a smooth path from the top left of the picture and across the page. The curved dome on the right-hand side of the girl acts as a stopper and keeps the eye from traveling too far. The point of interest—the girl's face—rests in a compositional valley, which makes you want to return to look at her.

Above: This image illustrates a few principles of composition.

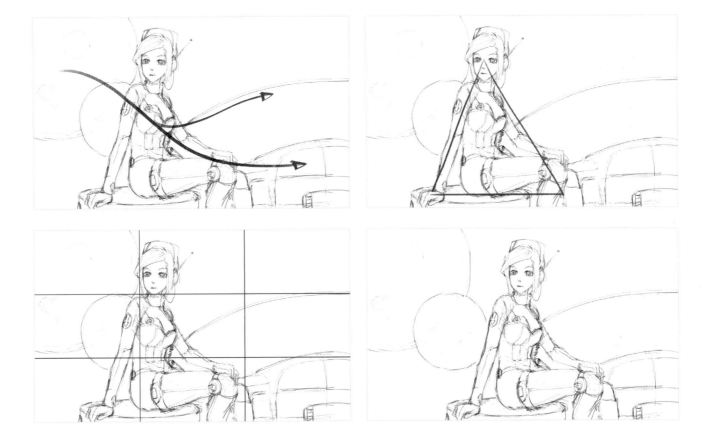

We can also look at the girl's pose as a compositional element. The arrangement of her arms forms a triangle, which conveys calm and stability. (There's a reason the pyramids have stood the test of time!) This works well with the atmosphere of the picture. The overall effect is that the picture feels balanced and serene.

Finally, we can divide the picture by the rule of thirds. This is a guideline, heavily used by photographers, which says that important compositional elements should fall along the lines and vertices that divide the picture into thirds. What the rule is getting at is that you should avoid centering points of interest too much, as this usually

results in a dull and uninteresting layout. This might seem counterintuitive, but more often than not a centered composition tends to feel limp and lifeless.

These examples show that there are many ways to look at the structure of an image. Since all of these principles act together to make a good picture, there are no definite dos and don'ts. Instead, different compositional principles should simply be tools for creating a more interesting image that conveys what you want. They may not always apply for a particular purpose, but what's important is to be aware of them, so that you can use them if you need to. (NL)

Top Left: The eye is led along a path formed by the arrangement of the moons, the girl, and the dome, and the vehicle in the background. The girl's outstretched arm helps the flow.

Top Right: The girl's pose can be read as a compositional triangle, which is a symbol of stability.

Bottom Left: The rule of thirds is a commonly used compositional guideline to help create a balanced composition.

Bottom Right: If the main point of interest, the girl, is moved into the middle of the picture, the composition feels less interesting.

CREATING ILLUSTRATIONS:
COMPOSITION

TIP 060

Orientation, Size, and Zoom

People go through different stages with photography or artwork and how they think it should look. Filters, finish, and details aside—if you look at what is in the picture and how it is cropped, there is a world of difference between a beginner and someone who is experienced.

First, let's talk about the orientation and shape of the art. The easiest way to think about this is to look at photography. Imagine a typical vacation photo taken of a tourist near a landmark. Now imagine a professional photo shoot of a model at this landmark. What do you think would change?

A beginner would just step back a bit, hold the camera horizontally at eye level, point at the person, and press the button. It will come out in landscape format, the feet would be cut off just below the knees, and the angle would make the person look top heavy and probably block the landmark.

Above and Right: A classic tourist photo versus one styled more like a photo shoot.

An experienced photographer would most likely tilt the camera sideways and shoot from fifteen to thirty feet away with a slight zoom and from a low angle. The resulting picture would be portrait-oriented, so the model's height will be emphasized, the low angle and distance with zoom lengthens the legs, and the photographer would artistically frame both the model and any features in the background. There are always exceptions, though; if the model has long hair or is wearing a long scarf that flutters in the breeze, a close-up landscape photo may work better, or even a square photo may be effective.

Photography is a good way to practice these choices because you don't have to set anything in stone or draw everything before cropping. Artists learn very quickly to decide the viewing angle and orientation of their drawing before they start, or at the very least, format their artwork in editable layers to avoid costly mistakes.

Someone who is new to commissioning Manga artwork—for example, someone who attends an Anime convention for the first time and asks for a sketch—may automatically want a full-body shot of themselves or a character of their choice. In actual fact, given a fixed size of paper and for the degree of personalization they really want (to show off the fact that it is them in the portrait, or to show my version of their favorite character), it can be much more effective to zoom in a bit and draw them from the hips upward.

That said, just because something is printed in a large format, like 11 x 17 inches or more, it doesn't mean you should shove it full of detail. At times, very simple and graphic designs work best when blown up in scale.

The key is to experiment; don't be afraid when working on your piece to try tilting it, or blocking off parts of it to see if it works better. Plan and draft things in advance if working straight to traditional media; before taking on something complicated, do a stick figure drawing in a frame of the same proportions. If working digitally, it's best to keep different features of your drawing on separate layers. (SL)

Left: I designed this artwork to work in both portrait and landscape format, as the client needed to be able to use it online (which is usually landscape) as well as print tall banners and posters.

Below: If restricted to a certain paper size, it can be more evocative to zoom in on a character.

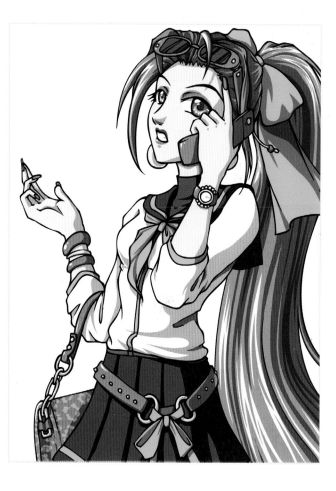

CREATING ILLUSTRATIONS:
CONCEPT

Concept

Creating concepts and finding inspiration can be one of the most inconsistent parts of the artistic process. Some days you'll find yourself bursting with so many ideas that you don't have enough hands to get them down fast enough, whereas other days you'll be in a creative drought that no amount of sweat and tears can quench. At those times when you need to draw, but you have no ideas, shaking up your usual sketching routine can help you work through the block.

TIP 061

Processes and Priorities

It may sound contrary, but giving yourself limitations can loosen up your mind and start the creative sparks flying again. If you sketch on paper, you can try spicing it up by using different materials. I often draw small sketches straight to ink or with colored pencils when I'm trying to get ideas flowing. Because any mistakes are impossible to erase, the sketches have a throwaway quality—if I don't like it, I just stop and start drawing something different. If I feel frustrated, I stop and draw something amusing and frivolous.

Another favorite tool for concept art is using software specifically for sketching and creating concepts. Alchemy is a piece of free software that was designed for experimental drawing. At its most basic level, it is similar to drawing with a brush; however, Alchemy contains several settings to introduce randomness to your drawing, as well as settings for working symmetrically or working blind and in other odd and interesting ways.

Left: Some software is great for experimenting with design. This image was creating using Alchemy.

All the brushes and shape settings behave quite differently if you set them to "line" or "solid shape," and it's fun to play around and find the one that suits you best. Alchemy is also particularly useful for designing spaceships, robots, monsters, and buildings; many concept artists use the silhouettes they create as a base to paint over.

For those of you who are comfortable in digital media, speed painting is a good discipline to learn. Speed painting is about teaching yourself to create within a limited time frame, often under an hour and sometimes with a suggested topic.

You might not use speed painting very often for creating concepts, but it is a useful exercise for teaching you how to think on your feet and get the basics of an idea down quickly. There are a number of groups for speed painting on the Internet, or if you have artistic friends, you could group together and suggest drawing subjects for each other.

By removing the technical barriers to drawing and creating art, you can relax and break the psychological barriers that are giving you artist's block. And you get to have fun playing with materials and software in the process. (SD)

Left and Above Right:
Use limitations to inspire creativity. Try working on small pieces of paper, or go straight to messy inked scribbles.

Right: Paint as much as you can within a short time frame. Build things up from broad brush strokes.

CREATING ILLUSTRATIONS:
DRAWING

Drawing

A skilled artist usually has the whole image in mind before putting pencil to paper, including the viewing angle, composition in the space, and level of zoom into the subject matter. Particularly when penciling the panels of a Manga comic page, you need to have a good grasp of what you actually want to draw inside the panels, as if you are directing a film. But even if you take away the intricacies of all of this, beginners struggle with where to start a complex drawing, so here are some methods to help you begin.

Left: A basic stick figure of a person.

TIP 062

Methods and Workflow

Artists in their different fields will be stronger with some methods than others. From the point of view of a Manga artist, drawing for comics is different from drawing from a direct reference (such as drawing from something actually in front of you, a still life of various objects). Our subject matter often comes from our imagination and a buildup of stored knowledge of the structure of the subject matter.

As such, it's all about starting with a stick figure or a rough indicator of what you're drawing and how it will fill the space on the paper (or panel within a comic page). Using basic shapes and outlines to begin your drawings is also really useful when providing thumbnails of comic pages to an editor or publisher to look over and offer feedback before progressing to detailed work.

I find it useful to start drawing people as a slightly thicker version of a stick figure with the torso in rough sketch, especially when it's a complicated pose. It's good to define the twist of the body and overall

Above: The main muscle groups are fleshed out.

Right: Finer details of the face, hair, clothing, and props are layered on top.

line of action, taking into account realistic limb lengths in relation to the size of the head. Then I flesh it out fully and build up the muscle groups so I have a good idea of the naked body—no need to go into too much detail unless much of the body is actually on show. Only then do I add finer details to the face and clothing, which should follow the contours of the body.

With most organic subject matter—animals or plants—it is important to identify the curved volumes and lines underneath the structure and use them to build up a real sense of weight and build. Study various examples and learn the shapes and distances between them.

In contrast, when I draw something that is less curvy and more blocky—such as most buildings and some vehicles—I map out the key edges of the object with the right sense of perspective and identify the vanishing points. When a subject matter has a lot of straight lines, it looks far more convincing if everything that is supposed to line up or be parallel originates from consistent vanishing points. (SL)

Above Left: Horses are made up of lots of ovals and circles, joined to each other with gently curved lines. Just watch out for the differences in size of the ovals and how far apart they are.

Above: You can start adding extra muscle and bone definition and character features once you're confident of the general proportions.

Above: The main skeleton of this cottage is drawn with two vanishing points in mind. Thankfully a cottage does not have to be perfect like modern buildings, so I estimated the ratios and distances.

Right: By using the perspective lines as a starting point, you can add various layers of complexity safely and effectively.

CREATING ILLUSTRATIONS:
BLACK-AND-WHITE ARTWORK

Black-and-White Artwork

When using traditional methods of drawing on paper, or digitally, the creative process usually starts with a pencil sketch, which is then completed with ink overlay. Depending on the effects you wish to achieve, it's worth experimenting with different materials—both physical and virtual—to give you an idea of those materials' best uses for the drawing and for your own needs as an artist. Below are some hints on how to get the best result from your materials.

TIP 063

Pencil Drawings

Once you have a story to tell, you can prepare for the final image creation. Size, backgrounds, panel layouts, the flow of a story, the overall look of the page, whether a page balances with the page next to it . . . everything matters when you start planning and drawing.

It's always best to start with soft pencils between 2B and 6B on a good quality paper, such as Kent paper, which has a slightly uneven surface for a pencil drawing but is tough enough for erasing and thick enough for ink. The pencil lines you draw in this process will not appear on the finished image. They are guidelines for the inking process.

There's no need to worry about lines being jagged or wobbly, or thick or thin—just concentrate on experimenting with the best look to depict each scene and make a solid base for your images. Keep erasing and redrawing till you are certain that your image is ready to ink.

Normally figure drawing starts with circles and lines to pin down the size and positioning of the characters in a panel. In all comics, artists must reproduce the same character over and over again in different angles, poses, and expressions, but it all has to look like the same character to the readers. If the character has a unique aspect, highlight it as much as possible in panels to keep consistency and allow readers to recognize it.

Feel free to draw images without being limited by panel boundaries; lines can go over them. However, some images come out beyond panel boundaries to give the illusion that a character or object is jumping out from the frame. Make it clear when you pencil which parts will break out of panels in the final page.

No matter how brilliant your artwork is, some parts will be hidden by speech bubbles, so leave space for bubbles to

keep important parts of art visible after lettering. The positions of the bubbles should be in places where you can guide readers to follow the right order of dialog and make it clear which character is speaking. Think about the best position for the bubbles when you draw.

Right: A rough pencil sketch of figures from "Fantasy World," written by Theo Ajibode, published by Ajiey Media.

Below: Character consistency: The character should look the same in different angles and poses. Character designed by Mayamada.

After penciling several pages, make sure that there aren't too many repetitions of the same panel sizes, angles of faces, and close-ups. Look through and amend to prevent the pages from looking dull and repetitive as much as possible. There is always a way of making the same scene more creative, fresh, and effective. You will learn so much by actually creating several Manga pages, which you wouldn't be able to achieve by solely creating one-off illustrations.

Be careful when erasing pencil images; if you do it too hard, the force might damage the paper. A feather sweeper comes very handy to sweep off eraser shavings without making smudges.

For digital penciling in Manga Studio, you can start with a thick pencil to do rough sketches, and then use a thin pencil to refine them. After completing the pencil drawing, it works well to change the color of the drawing so that it's easier to distinguish between pencil and ink lines. If you have several ideas for final lines, use a separate layer per idea by switching the layer on and off to make it visible or not visible; you can then check if the ideas work as part of the whole art on the page.

While you lose the direct feeling of paper texture and pencil when working digitally, there are benefits to flexible image editing, such as adding extra panels, making mirror images, and changing the position/proportion or scale of images. These changes are incredibly easy to make when drawing digitally as compared to analog methods.

When you feel confident about the drawing, you are ready to ink! (IK)

Below Left: A "panel breaking" example. The character drawing goes over the frame at the bottom left. "Ketsueki," written by Richmond Clements, published by Markosia Enterprises Ltd.

Below: A page with many speech bubbles still manages to show the artworks efficiently. "The Old Well" in *MangaQuake* Issue #7, published by FutureQuake Press.

Right: A color has been changed on the pencil drawing to make it easier to distinguish from inked lines. "Search & Avoid" in *WAR: The Human Cost*, published by Paper Tiger Comix.

CREATING ILLUSTRATIONS:
BLACK-AND-WHITE ARTWORK

TIP 064

Working with Pens, Brushes, and Ink

Using pens, brushes, and ink can be difficult, but once you have learned how to use them effectively it can make a world of difference. Finding out which materials are best for you is very important. You should try several types of pens, brushes, and inks to determine your favorites and the most suitable ones for your style. Check which types you like and also which brands you prefer—this is especially important for inks. In order to create the best possible circumstances for drawing, you need to know how thick the nib is and how quick the ink dries. So take your time and invest in some ink trials.

If you are a digital person, try different settings on pens and brushes and find out the best for you. Also, do not forget about customizing the settings of your pen tablet, such as pressure and tilting.

It does not matter if you use digital or analog, but it is better to take your time to get accustomed to using them and train yourself. The best way to master how to use pens is practice. Do some exercises drawing even and smooth lines with certain lengths, then practice on making a line thicker or thinner smoothly on a continuous line by changing the pressure on the pen. Also, make sure you can draw a line that starts very thin then

gradually becomes thicker and then thinner again by the end. Controlling the pressure of how you ink/brush in and out is always the key for a beautiful finish. Physically, try to concentrate on the snap of your wrist and stroke of your arm. Steady and even movement is what you need to achieve to be able to draw smooth, beautiful lines.

When you become quite certain about your control on pens, practice hatching and crosshatching as well. If you can use wider variations of lines, your drawings will have wider variations, leading to richer expressions.

Left: Some examples of different uses of lines with main characters, background, and moving images from *As You Like It*, © SelfMadeHero.

Right: An example of using thin lines with no accent for drawing flashbacks or "story within story" scenes from *As You Like It*, © SelfMadeHero.

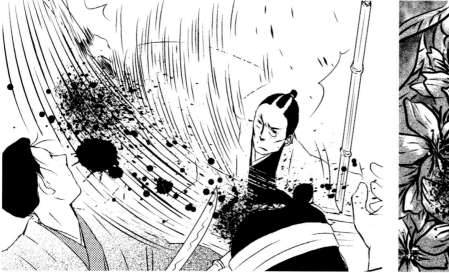

Let's talk about deciding what kind of line to use in different subjects. In my case, the lines for drawing main characters should stand out and be dramatic. It makes the image sharper if the parts where shadow will be, such as under the chin and shirt collars, are drawn with slightly thicker lines than the other parts. The lines for drawing backgrounds or people in the background are better if drawn weaker than the lines for main characters. Thinner, even lines with fewer accents work well.

When you are drawing moving objects, shaggy running lines can be used in order to enhance the action. However, when you use shaggy lines, please make sure that those lines are not just caused by careless drawing. This can be done

by matching the thickness and angle of all the lines as much as possible.

I also use different ink/brush strokes in different scenes. For a flashback, I often use medium-thin, even lines with no accent to make it obvious that they are events from the past. Or for a "story within a story," I use something more unique, such as a brush with strong lines.

Even within the same subject, it can be effective to use thicker lines for outlines and main features and thinner lines for the details, such as shadows, facial lines, and creases on clothes.

The technique of using a brush, again, relies on practice. Always keep an eye

on the amount of ink the brush is holding. Make sure that the tip of the brush is always smooth and pointy, since it allows you to make a delicate stroke. Brushes are also useful when you want to draw a splash of liquid, such as blood. Use slightly more ink on the brush than usual and either flick the body of the brush or blow on the brush. Don't forget to run some experiments on how much ink you need and how strong you need to flick/ blow to create the appropriate splash!

Usually blowing creates a finer splash. If you use digital techniques for touching up your drawing, I recommend you create several different splashes with ink on paper, and then scan some of your favorites and save them as data for later use. (CK)

CREATING ILLUSTRATIONS:
SCANNING SKETCHES AND LINE ART

Scanning Sketches and Line Art

When scanning pencil and ink artwork to finish digitally, the settings you use will make a big difference in the outcome of the image and your ability to manipulate it. Here are a few tips to help you get the optimal scan for your purpose.

TIP 065

Getting the Best from Your Scanner

Aside from scanning a sketch to neatly ink and color digitally, there are a few techniques you should follow to digitize your traditional artwork successfully.

First, regardless of whether you're scanning a finished full-color marker piece or you just want to get a clean scan of your inks so that you can color and finish it digitally, you should scan it with an appropriate level of detail. Most scanners allow you to specify how many Dots Per Inch (DPI) at which you would like to scan (and therefore, in the future, reproduce in print) your artwork.

It refers to how many individual dots can be printed in the span of one inch: the higher the figure, the higher the dot density and detail. Some figures are quite common; 72 dpi or 150 dpi is really only for Web and on-screen images. For printing full-color artwork, 300 dpi at actual size is acceptable, but 425 dpi or 600 dpi will look clearer and sharper. 1200 dpi is really only useful for very delicate black-and-white Manga artwork with fine screen tone and is only just visibly sharper than 600 dpi to the human eye. So be sure to scan at the appropriate DPI or print resolution.

If I intend to scan some line art in to be colored digitally, I often work in colored pencil, and then ink (or very neatly pencil) on top in black. This means that I can scan the artwork then, playing around with the color channels in image-editing software like Photoshop, filter out the colored pencil. So I don't need to erase any pencils. Depending on the color you used, you may need to switch between RGB or CMYK color modes to find the channel with clean black lines. (SL)

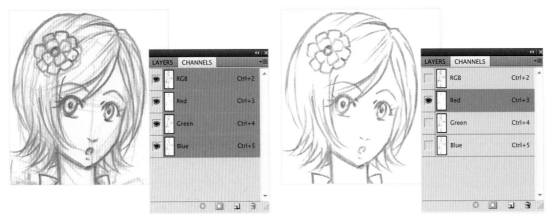

1: Once I've figured out which color channels to remove, I convert the line art to grayscale. If you have used normal pencils and inked on top then erased your pencils, your scanned artwork should be in gray.

2: Make your inks darker and remove any soft grays and other artifacts by adjusting the levels. This allows greater control than simply adjusting the brightness or contrast, but does the same thing essentially. If you're dealing with a fully finished, colored artwork, don't be afraid to play around with these settings, as scanners can make your work look very washed out due to the bright lightbulbs used in the machine.

3: Now, many artists leave it at that and just put the line art as the bottom layer, or paste it on top and set the layer option to "Multiply" so the white becomes transparent. But if you want full control over your inks, like when you have inked digitally on a transparent layer, then this is very useful: Make sure your art is grayscale, but in RGB color mode. Then duplicate your layer, and while the layer copy is selected, head to the channels and click the first icon at the bottom of the box (the dotted circle).

4: This selects all the white in the image. Go back to the layers box and delete the white.

5: This removes a little of the lines as well, so lock the layer transparency and go over your lines again with black or any color you choose.

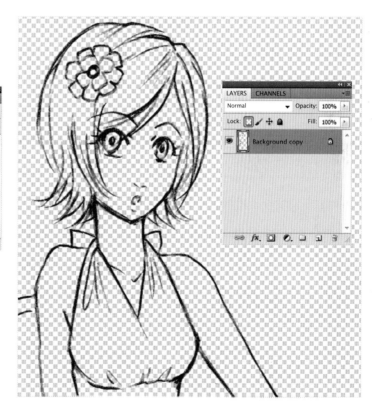

6: Now you can color your lines to your heart's content; just make sure that the transparency is locked.

CREATING ILLUSTRATIONS:
LIGHT AND SHADOW

Light and Shadow

Light and shadow go hand-in-hand in Manga images; while shadow lends depth to people and objects, light informs the tone those shadows should take for the most realistic portrayal. In this section, we cover shading for multiple eventualities, from faces to fabric.

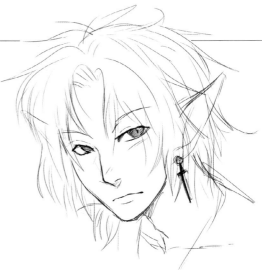

TIP 066

Building Up Your Shadows

Shading can be a really daunting prospect: Where do you start, and how do you know where to put it? Shade can tell us a lot more than the line art; no matter how many outlines you draw, sometimes it's simply better to allow your shading to do the talking for you. What is the main goal of highlighting and shading? Without it your image looks flat, so it builds up shapes you might not have been able to see otherwise.

First and foremost, select your light source. This will be the side most of your highlights are present on, and the direction from which your shadows are cast. More specifically, think about what shapes, bumps, or objects are going to be obstructing that light, and draw the shape beyond it.

Though shading can get a little more detailed than that, those are the basics you will need to get yourself comfortable with before you tackle the more complicated steps. And you'll constantly learn new things as you experiment. I'm still figuring out techniques on every picture that I do. It's important to challenge different directions of light

so that your images don't fall into a similar pattern. It is possible to get too comfortable.

Highlighting and shading can determine whether an object is hard or soft, smooth, or has a varied surface. But even then there is a difference in how it forms. For a solid object you'll want harsh, straight, and strong shades.

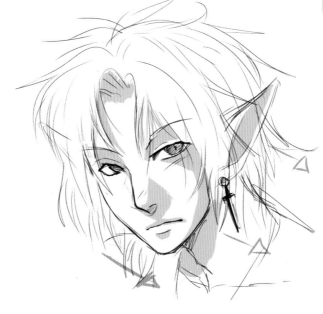

Top: Here is a rough sketch to start from.

Above: First, think about your light source. Which direction is it coming from?

Left: From there we can figure where the shadows go. Think about facial features and other definitions, and most importantly the direction in which the shades stretch.

Below: The soft fabrics are reinforced not only by shapes and folds in the lines and shadows, but also by the simple, lower contrast shading without too many extreme highlights (compared to the shiny hair).

Left: The shading here is softer than typical cel art. The muscles are shaded with soft gradients and airbrushed.

Below: Subtle backlighting gives the impression of complex lighting with multiple light sources.

Looking at the example directly above, you can tell it's primarily soft fabrics. For the cravat around the character's neck and centered against the chest, I wanted a sense of the padding and thickness of the fabric, and of the soft cushioning. Using smoother, more circular shapes will help you achieve this more easily. Don't forget that the fabric has folds and creases of its own that catch the light and create shadow.

For facial contours, there isn't going to be that much extra creasing or detail needed unless you want the person to look a little more aged. But again, unless you're going for a rigid facial structure, stick with more curvature to accentuate the side of the cheeks and other features.

How, then, do we determine the stronger shadows from the lighter ones? It all depends on the type of light. A strong light will create smaller but darker shadows. A darker scene will have stronger highlighting to draw on what little light there is, but will have a larger variety of shadows within it.

Putting aside all intricacies, your darker shadows will be where the least light hits. Sometimes I use a darker shadow for those deeper details I really want to get in. I tend to use it for those finishing touches, and then use a lighter gradient for overall contrast and contours.

In the scene above there's a good percentage of light that's getting into the picture, but also a high amount of contrast that creates nice dark shades. Most of the highlighting is being caught from the right-hand side and being drawn in over the curvature of the muscles. Most noticeably it is darker in the left-hand portions of the image. Obstructing elements would be the arms casting shade over the lower abdomen and over the left part of the character's face.

But what about alternate sources of light? Can you have more than one? Your main light source will always be strongest, but if you want to create more depth you can add backlighting. Objects aren't flat, and that means light escapes around the sides and creates what we call a backlight

and forms the illusion that more light is coming in from behind. This makes the shape a lot more dynamic.

For instance, the image of the arm above gives a sense that the arm isn't two-dimensional. Light is obviously creeping in from behind and from the gap within the center. In almost all cases, backlighting will happen just beyond where the shadows on your image are strongest, creating that further sense of depth.

Another easy way to get used to backlighting is just to study your own extremities. Hold your arm up to a light source, see where the light hits and the shadows form, and watch where the slight silhouette of light from behind it appears. Practice makes perfect; you won't learn without observing! So make sure to study objects and references with all sorts of directional light and build up your own understanding of it. (DS)

CREATING ILLUSTRATIONS:
COLOR THEORY

Color Theory

Color theory is always a tricky area, as it seems a lot more complicated than it actually is—and it's more experimental than your art classes at school will lead you to believe. From primary colors to how color affects shadow, here are some tips to help you achieve the most effective use of color in your images.

Below: Here you can see the three primary colors of red, blue, and yellow. When they mix, they produce purple, green, and orange.

TIP 067

Basics

When deciding on your palette for your picture, it's always good to start with the basics: the primary colors. Made up of red, blue, and yellow, this is a good starting point for everyone. In their pure forms, these colors are very bright to the eye, and so generally I stay away from using them as pure and mute them down with either black or white to lighten or darken them as needed.

As you start to mix the primaries together, you make secondary colors—greens, purples, and oranges, which will make up a lot of your coloring. It's very rare to just use the primaries when making a color palette up, but it would be very striking to say the least!

Once you have built up these colors, this is where your standard color wheel comes in, and therefore your complementary colors. Complementary colors are the colors that are positioned opposite each other on the color wheel and provide the most contrast when used together.

Below: The color wheel shows how the colors of the spectrum move into each other. You can use this to figure out which colors clash and which harmonize.

If you really want your image to stand out, using complementary colors will really make them pop. Fun fact: If you mix these two complementary colors together, you will always make gray! Most paintings and colored images you see these days will be using this exact principle: Teaming multiple complementary colors to make a well-rounded and contrasted composition.

Sticking with one particular color from the color palette and modifying the colors with black and white to produce a spectrum of that color will give the feeling of nostalgia or fantasy. I have picked blue for the mermaid image to enhance the feeling that the mermaid is under water. I could have used a complementary orange for the koi fish, but I wanted to maintain the idea of fantasy, hence the repetition of the blue.

Use the color wheel to really experiment in your images—most editing packages will have a color wheel and picker to start with. So try things out with your line art and see what interesting color combinations you can find! (RK)

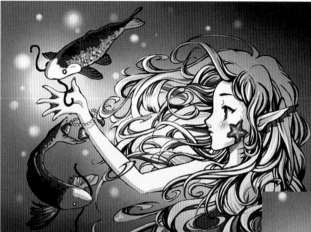

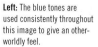

Left: The blue tones are used consistently throughout this image to give an other-worldly feel.

Below: Experiment with changing the hues of the image to find a combination that works.

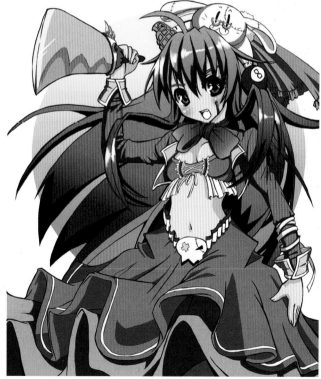

CREATING ILLUSTRATIONS:
COLOR THEORY

TIP 068

How Colors Affect Shadows

Typical sunlight gives you a "normal" looking shadow in a darker shade. The minute you introduce colored light into the mix, it will drastically affect the color of the shadow produced. A blue light will give the shadow a blue hue. Adding colors with lights doesn't follow the same rules as your basic color wheel, as you are using the light spectrum. The primaries for colors in light are red, green, and blue (RGB). When coloring on the computer, this will be your standard palette.

Have you ever seen that effect when you're in a disco with multiple colored lights? If you look on the ground or walls, you will notice that the shadows will also be colored. One thing to always remember about shadows is that mixing two different shadows together will not make a darker shadow; instead, the shadows will merge with one another. It's tempting to overlay shadows on top of each other, as logically that should be the case, but in reality, if you do this, the shadows will look very strange, so it's best to avoid this.

Right: Think carefully about the color of your lighting and how it affects the shadows and highlights.

In the image on the opposite page, the character is being lit by the sunlight above, but it is filtered through clouds, so the effect is dewy. She has shadows on her back but highlights directly on the bridge of her nose. Knowing what type of hue the sunlight is, especially when filtering through clouds, can really alter the effect. I picked a light magnolia color for the sunlight, making the shadows adhere to their initial colors.

Softening the shadows and lights in your image can really change the scene entirely. In this image (below and right), the character is being lit not only from above but also by the reflection of the water underneath her. Blending and softening the shadow brings out the highlights and dulls certain shadows, so always know your light source. (RK)

Above: Compare the difference between these two images. Taking into account bright sunlight and multiple sources, I added contrast and saturation to some areas and softened the lighting in others.

Software and Media

Digital artwork plays a huge part in the life of a modern-day Manga artist. You can achieve slick, clean, and vibrant results by creating or coloring images digitally. Drawing and painting software has flourished in recent years. There are many packages available at different price points with varying levels of complexity and capability. It is important to find and invest (both time and money) in the right software for you. Each has its own algorithms for line smoothing and color mixing so you may find you get different effects from what you were expecting. The focus for natural media is on the most popular and easily available. Test the colors, intensities, and layering effects. Never assume that a technique which works well in one medium will work well in another. It is particularly important to know the limits of various mediums so that you can best portray color mixing, shading, and texture effectively. With practice and experience, you will learn which combinations of materials work best together to produce the style and finish you are looking for.

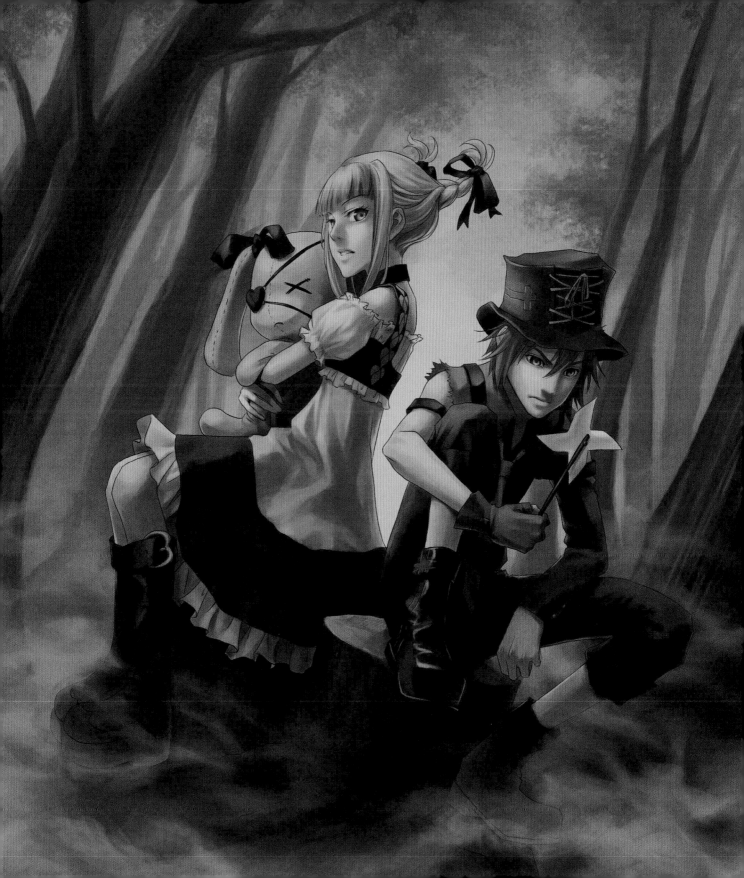

SOFTWARE AND MEDIA:
PAINTING IN PHOTOSHOP

Painting in Photoshop

Drawing or enhancing artwork digitally is almost unavoidable these days, and Photoshop is one of the most popular and widespread artists' software. Here are some tips for getting the most out of Photoshop, from basic brushwork to advanced cel shading.

TIP 069

Photoshop Brush Settings

Photoshop can be an extremely powerful piece of software for creating artwork if you know what you're doing with your brushes. It is very easy to customize every aspect of your brush strokes to suit your style and the effect you want to achieve, but that in and of itself can present a problem, as you may find it difficult to figure out where to start!

Even in older versions, Photoshop comes with a wide variety of default brushes. Drop-down menus will vary depending on the version you have and how you prefer to have your workspace set up, but if you open up the brush window, you'll see lots of options to play with, as well as a stroke window, which shows you what will happen if you draw with the brush and change the pressure as you move along. To take advantage of its full capabilities, you'll need a graphics tablet that can detect pressure and tilt.

I often pick one of these default brushes as a starting point and modify aspects of it to suit the project that I am working on. For characters, a simple round brush is fine. The most useful settings to adjust are:

Size can be changed to match the scale of your project. You can link size to pressure

so that when inking, it works like a real dip pen, getting larger if you press harder.

Hardness will affect how fuzzy the edges are, so a soft, airbrushed look will have a very low hardness, but a crisp-edged inking pen has a high hardness. Most coloring and shading will be somewhere in between.

Spacing affects how much space is in between your basic starting brush shape. Low numbers will make your stroke look like a long, continuous line. High numbers make your circles appear as distinct, separate points.

Opacity is a great setting to link to pen pressure—having a brush fade in and out gently can be effectively used for shadows and highlights.

Apart from the basic circle brush, Photoshop gives you other shapes for common effects. The autumnal example above starts with a leaf shape, set to a high hardness, color/hue, and angle jitter (which means it has a random element), as well as a high spacing, scatter, and size linked to pressure. (SL)

Above: A screenshot of the default brush window.

Left: From top to bottom, using the same starting brush you can adjust whether it's soft-edged, hard-edged, spaced widely, variable in size, or variable in opacity.

Below: One of the default brushes with a leaf shape with color and scatter effects.

Bottom: Use a combination of brushes and effects to achieve your finished look.

Photoshop Layer Settings

Layers are a power tool in managing and editing your images digitally. Even without special effects, by keeping things on separate layers you can shift items and add color and shading without fear of messing up what you've done before. But experimenting with layer settings can lead to beautiful results and vibrant optical effects, and it can save you time by making certain actions easier.

Think of a layer as a pane of glass. You can put many panes of glass on top of each other, but you can still see through them. But if you paint something on the layer, then that piece stops being see-

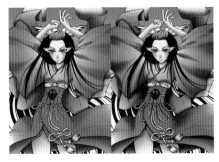

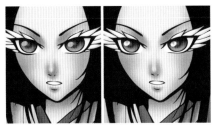

through. However, you can change the layer settings to figuratively change the type of glass, paint, and lighting. Older versions of Photoshop will not have as many settings, but they are conveniently grouped into overall effects.

The first group is made of Normal and Dissolve. Normal is the basic pane of glass with paint on it. The paint can be solid and opaque, or it can fade out so you see more of the background beneath. Dissolve converts any soft painting on this layer into solid pixels dispersed among transparent pixels—this is very useful when shading in black-and-white comic pages to avoid anti-aliasing.

The next group is the layer effects, which darken your image: Darken, Multiply, Linear Burn, Color Burn, and Darker Color. While there are slightly different results and calculations with each of these, it usually involves combining the colors and values of the layer and its background together, resulting in a darker and often more saturated picture. Try them out and see what works. If the effect is too strong, you can always play

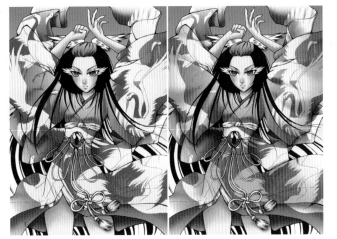

with the layer's opacity. These settings are useful for adding many layers of shading that pick up the underlying colors effectively.

Now for the group of effects that lighten your image: Lighten, Screen, Color Dodge, Linear Dodge, and Lighter Color. These effects will achieve a brighter result, as the calculations will usually involve inverting values and subtracting or dividing it by the background. Again, play with the different settings, as you may get some surprising results and color combinations.

The final group I will talk about (as I find the other settings to be too harsh or awkward to be useful) are those in which dark and light values on this layer can both darken and lighten the image, regardless of what is on the background. The settings are Overlay, Soft Light, Hard Light, Vivid Light, Linear Light, Pin Light, and Hard Mix. These settings are wonderful for tinting your image subtly, or adding textures or patterns to your image while still picking up all the shading you have done so far. (SL)

Left Top: Compare the shading on the Normal layer (left) and the Dissolve layer (right).

Left Center: Compare the shading when set to Normal (left) and Multiply (right).

Bottom: A dark orange on Normal (left) becomes a vibrant highlight if set to Color Dodge (right).

Left: The crane pattern just sits on top under the Normal setting (left), but becomes part of the textiles when set to Overlay (right).

SOFTWARE AND MEDIA:
PAINTING IN PHOTOSHOP

TIP 071

Painting Hair

Hair is one of those wonderful aspects that can add a lot to the richness and texture of a painting. The key to painting hair is to work with a constant light source and start out with the biggest shapes before moving on to smaller strands. It's also important to be mindful of the twists and turns of these strands across the head.

Lay down a fairly light base color, lighter than you want for the final hair color. Whenever you start painting, it's important to establish the light source so that the shadows are consistent throughout the illustration. Here, I imagined the light shining right down at the picture so that the girl is lit on the side of her face that's closest to us. I took a large, soft airbrush and applied a slightly darker shade to areas that turn away from the light. The softness of the edge gives a sense of the big forms of hair and the roundness of the head. I also applied the airbrush at the base of the bangs, since the hair mass parts there and turns in toward the scalp. Next, using a hard-edged brush, with Opacity set to pen pressure, I started detailing the strands of the hair in an even darker shade. The brush strokes followed the flow of the hair, from the scalp to the ends, and tapered off toward the highlights. This allowed the base color to show through.

I continued working on it with darker tones to create more depth. Be careful not to use too many different shades (I tend to use three to four), or the painting will lose contrast. As a final step, I used

the Levels and Hue/Saturation tools in Photoshop to raise the contrast and adjust the color balance.

Perhaps the easiest way to pick your shadow colors is to simply use a darker version of the base color. You can also use a different hue for shading, as long as you stay fairly close to the base color in the color wheel. In this case the base color was pink, so I could use purple and violet to give the hair a different shimmer. (NL)

Above: I chose a very light pink for the base color, laid down as a flat tone on its own layer.

Left: A large, soft airbrush was used to depict the forms of the hair as they turn away from the light.

Above: I used a hard-edged brush to paint the details of the hair strands. Try to vary the thickness of the strokes; this makes the strands look more random, like actual hair.

Above: I painted a darker shade of pink into the darkest areas in shadow.

Above: I only used two types of brushes to paint this hair—a soft-edged airbrush for large shapes and a hard-edged brush for detail. Both can be found in Photoshop's preset brushes. The opacity needed to be pressure sensitive, which can be set in the brush window. If you're using CS5, go to Window > Brush and check off the "Transfer" check box. In earlier versions of Photoshop, this feature is called "Other Dynamics."

Right: Shading with a color that's a different hue from the base color, in this case violet on pink, gives the hair a shimmery effect.

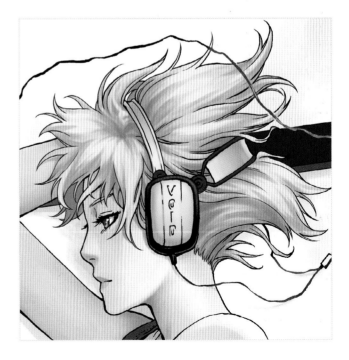

SOFTWARE AND MEDIA:
PAINTING IN PHOTOSHOP

TIP 072

Painting Skin

If painted right, skin can add to the story of your character—its history, background, and age. However, if done badly, skin can leave your character looking dull or ill. Skin is more important than you first might think.

Before you start shading, flat color your whole image so you know the overall color scheme works together. Use a separate layer for the color of the skin, and then lock the transparency of that layer so when you shade you will only be adding color onto the skin.

The first thing to do is choose where the light is coming from. In my example the girl is out on a summer's day, and the sun is shining from the top left of the image; this means that shadows will be cast under her hair and on the bottom of her nose and chin. On a more realistically styled drawing like this, it can be a real help to find a photo shot in a similar light; have a look at where the shadows are cast on the skin.

For the first layer of shading you don't actually want a darker color at all. Move the color picker right to a more saturated version of the original color, then move the hue slider down so that the base color is more red. If you just choose a darker version of your original color, your character will end up looking gray. Use a

soft round brush at 60% opacity to add the shading color. Keep the blending smooth and gradually build it up.

For the next layer of shading you'll need to choose a darker color; make sure it is more saturated as well. Again, move the hue slider down so the new color is also a little more red. Slowly add your shading, building it up to create darker shadows. You can use the color picker tool to select midway colors so you can blend them together smoothly. Remember to also add gray shading to the whites of the eyes, as there will be a shadow cast by the eyelid.

This is a good start, but skin is not just one uniform color—this is especially noticeable on the cheeks and lips. Select a red color that is brighter than your current darkest color. Using a large round soft brush at 20% opacity, add your red lightly over the cheek and lips so it adds a tint.

While our main light source is the sun, there will be other light bouncing off objects and reflecting back onto our character. Perhaps she is standing by a lake; if so, a blue light will be reflected onto her skin. For this, set your brush's opacity to 20% and choose a pale blue color. Because the light would be bouncing up from below, you gently

add the pale blue to the underside of the chin and nose, covering some of the darkest shadows. Remember, it should be subtle, but having it really adds depth to the drawings.

One great thing about digital painting is that you can get your coloring very smooth. However, skin can sometimes look overly smooth. If you check out your face in a mirror you can see it actually has a lot of texture to it: pores, freckles, veins, wrinkles, and scars. To finish off drawing our skin, let's add some of these. Create a new layer on top of the skin layer, take a small round brush with opacity set to 70%, and, using a brown color, go over the cheeks and bridge of the nose, randomly placing lots of little dots; it'll look best if you vary the sizes and color slightly. Then set your brush opacity to 50% and take a light yellow color to add some more lighter dots along with the brown ones. Then set that layer's opacity to between 40–60%, depending on how obvious you want the freckles and pores to be. To finish, merge the layers together and add a bit of texture to the lips, as they have more creases than regular skin.

In the finished drawing I added a little more texture and depth to the skin and made sure the colors and light sources were consistent. (DB)

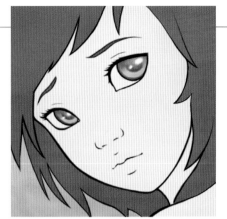

1: Flat color your whole image—I've gone for a pale peach to start the skin.

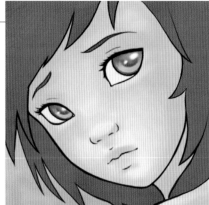

2: Blend in your first shading color, keeping in mind where the light is coming from and where shadows will be cast.

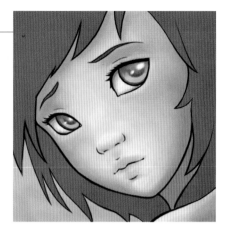

3: Keep the blending smooth when adding your darker shading color.

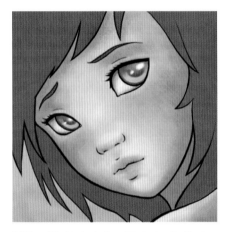

4: Add a red blush to the cheeks and lips to give a healthy glow.

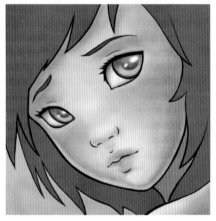

5: Don't forget your secondary light source; here, it's a pale blue reflecting from an imaginary lake below.

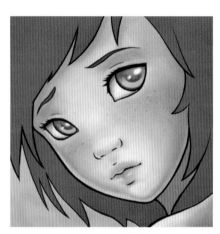

6: Roughen up the skin a little—add texture with freckles and pores.

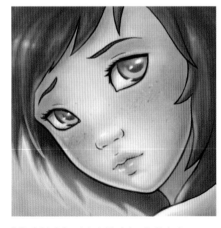

7: The finished piece. I shaded the hair and added color to the line art and balanced the colors together.

Left: Skin comes in an array of interesting colors and textures, so experiment! Add personality to your character by including things like scars, freckles, and tattoos.

SOFTWARE AND MEDIA:
PAINTING IN PHOTOSHOP

TIP 073

The Process of a Painting

There are many ways to start a painting, and every method has its own benefits. I usually tend to ink my drawings first, so that I have clean line art to work from. This gives the final illustration a tighter finish and makes it easier to separate characters from the background.

As always, when doing an illustration I think about the overall composition when I arrange the elements on the page. For this illustration I wanted to create a sense of unease, so I framed the characters with ominous tree trunks for a claustrophobic atmosphere. I also felt that the composition was a bit too stiff, so I tilted the horizon. This is an easy way to add dynamism to an otherwise static image.

Whenever you paint a scene that carries a certain mood, you should start by working out the colors of the environment. This is because the characters are affected by the light reflected from their surroundings. If you paint the characters first, chances are that you'll run into trouble when you get to the background. If your character and background colors don't match up, your figures may look like they were cut and pasted into the scene.

The background in these images was painted on one layer. At this early stage I was simply working out the color palette and the framing of the characters. I didn't ink the trees so that they could be deliberately left fuzzy, which made the characters stand out more. The base colors for the characters were laid down on a separate layer from the background and the transparency of the layer locked to keep everything contained inside the line art. The warm, reddish colors of their hair and outfits were chosen to contrast against the cold green and blue of the backdrop. Sometimes you would separate different colors onto different layers. In this case, everything was tinted by the cool light of the forest, so I decided to put everything on the same layer. I wasn't too worried about adjacent color fields going over the lines—I could go back and tidy that up at the end.

I placed the main light source at the top left of the scene, and I kept it constantly in mind as I worked out the forms and folds of the outfits and the strands of the hair. Since this was a misty forest scene, the light should be quite diffused so that it didn't create any sharp highlights or long-cast shadows. The blues and greens of the surrounding forest tinted the colors of the shadows. This was perhaps most noticeable on the white areas of the girl's dress.

To further add mood to the scene, I created another layer for a mist effect. Using a low opacity and a fairly hard-edged brush, I painted in wisps of white. Smoke and mist has a billowing, wave-like quality, so I erased and worked back into the mist until I was happy with texture. (NL)

1: First, I worked out the colors of the background, since this would inform the shading of the characters.

2: The base colors were painted on a separate layer from the background.

Left: The horizon in this composition sketch has been tilted to create more drama.

6: Here, final adjustments were made and the mist refined to look wispier.

3: Here, I started working out the shadows in the scene, while also keeping the light source in mind.

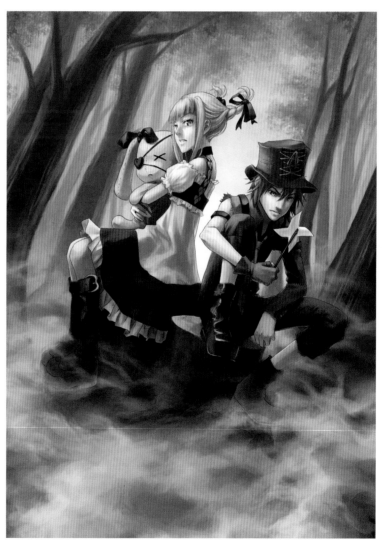

4: The painting has been tightened up and given more detail, and a rough mist has been painted on a separate layer.

SOFTWARE AND MEDIA:
PAINTING IN PHOTOSHOP

TIP 074

Cel Shading

Cel shading can be daunting to tackle. Although it seems simple, we have a tendency to overcomplicate things. Here are some of my personal methods of coloring within this style.

First of all, you're going to need some clean line art that won't be too difficult to color. Something bold works best. I've inked with thicker and stronger lines to accompany the type of coloring we will be using.

Begin by filling in your base colors. This is where stronger, cleaner lines really come in handy. Use the magic wand tool to highlight a section of the artwork. I fill in each section of color on its own layer and gradually work through them. In my case, I started with the hair. When I'm sure everything is selected, I'll start filling in the created layer below the line art with my color of choice.

Now, if you're anything like me, you'll find that sometimes just selecting via the wand tool may not be enough to catch everything, and some areas will need more attention. Make sure you go back after you fill in and tidy up those rough edges or unfilled selections. It's usually best to do this after you've finished a single area of the image so that you don't have a mammoth task to finish later. Being organized will make things much easier for you in the long run.

With all your flats filled in on different layers, you can get to the interesting part—adding that much-needed shading, which is both iconic and necessary for the completed image.

Above your layer options there should be a "Preserve Opacity" check box; check it, and this means it will not conflict with the other shades that you've laid out, making it far easier to start adding some depth to your artwork.

There's a lot more to think about when adding shade, most of all which areas you'd like to accent. Also, what shapes can you add that the line art doesn't make obvious? These could be the contours of the nose down to strands of hair and the fabric folds on clothing. I started shading the hair first with the light source coming in from the left.

One thing to bear in mind is that if you want your shading to be as bold as your line art, you'll need to use the same tool.

1: Make sure you have some clean line art on the top layer, ready to start coloring in layers underneath.

2: Fill in your base colors on another layer beneath the line art. Use the magic wand and bucket tools to full large areas.

I used the pen tool for both color and lining, with the minimum size set on 0%. This draws the perfectly sharp strokes that I find easiest to work with and that create a nice stranded effect on hair. For larger areas I draw out the shape and then fill in. And thankfully with my layers and colors already set out and tidied, I don't have to worry about going over the edges!

So work through your layers and eventually it will all come together. When cel shading I personally try not to go overboard with the amount of shades and shapes; this is very difficult to achieve, especially when trying to define folds. You want it to look clean and almost simplistic.

There are many other methods to use for cel shading so, most of all, remember to experiment. (DS)

3: Clean up any remnants or areas missed by the magic wand and bucket tools. Paint them in manually.

4: Keep blocking in flat colors until all areas of the image are ready for shading.

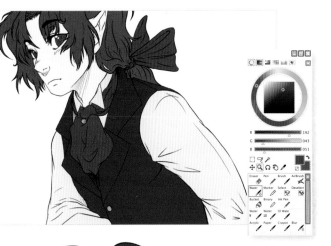

5: Using separate layers for each color or section and checking "Preserve Opacity" means you can color over the areas you already laid down without messing them up.

6: Make sure your brushes are sharp and fully opaque to get the best effect on hair with crisp strands.

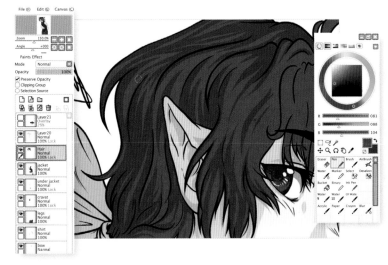

7: The final image with all the shadows and highlights added.

SOFTWARE AND MEDIA:
OTHER SOFTWARE

Other Software

After Photoshop, other, often cheaper, programs are making more headway in the professional artists' market. Here, we examine PaintTool SAI and OpenCanvas to find out what sets them apart from Photoshop—but we also take a look at Adobe Illustrator to uncover the advantages of vector illustration.

TIP 075

Working with PaintTool SAI

PaintTool SAI is increasingly popular among younger artists due to its ease of use and affordability. Like OpenCanvas, the brushes and style of inking and coloring feels very intuitive and smooth. The trade-off is that it is a fairly basic piece of software, lacking the more complex editing tools found in other programs. I find PaintTool SAI to be most useful when I import/export artwork to other software to start, tweak, and finish.

Like many other drawing/painting software, PaintTool SAI allows you to work in layers. You can sketch digitally or scan in some pencils to ink over. I like to change the opacity of the sketch so that when I ink on a separate layer on top, it's obvious which elements I've inked and which I haven't.

PaintTool SAI's strength lies in going back to basics. I like to paint things on as few layers as possible, as the colors blend beautifully together with high saturation. Here, I've painted a background fairly quickly and simply, as the focus of this picture will be on the characters. Use your sketch to plan the order in which you tackle certain areas—anything far away that forms a backdrop should be

done first, before painting the foreground on top.

Before I start painting directly onto the background, I duplicate what I've done so far as a safety measure. Just like before, start with whatever is likely to be underneath or behind anything else. In most cases, this would be the skin. If you're having trouble keeping things neat at this stage, and if your inks are neat and joined up, use the magic wand to select the areas you want. Be careful when using the magic wand, and remember to increase your selection by at least one pixel to ensure no scrappy parts are left next to the lines. In PaintTool SAI, you do this by heading up to the Selection drop-down menu and selecting "Increment." In case I need to deselect and work on the background— and to save time having to reselect everything—I created a separate layer to mark out the character artwork. Again, it's a safety measure and makes clipping and overlay effects easy to apply later on.

The default tools and settings are geared toward easy use; it's mainly a matter of

1: Sketching and inking are kept to separate layers.

selecting them and playing with the options below to see whether you like how the colors blend as you paint. I rarely use the pen tool during coloring; I stick mainly to the brush and marker tools for laying down colors and shading, then I use the airbrush and water tools for blending any hard edges.

Despite its limitations in terms of editing, PaintTool SAI has some great layer settings to add some pretty colors to your work. I exaggerated them on this piece because I wanted to show how much you can do. With the right colors, playing with Overlay and Luminosity can add a lot of sparkle, warmth, and colorful contrast to your basic shading. (SL)

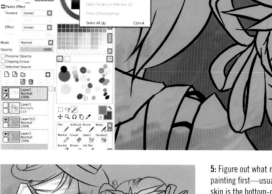

4: Keep your paints neat by selecting with the magic wand tool and increasing your selection as needed so that your fills aren't scrappy.

5: Figure out what needs painting first—usually the skin is the bottom-most element, so start with that.

2: Use the sketch at low opacity and set the layer to Multiply to plan and paint your background on a layer underneath.

3: Duplicate your background layer as a safety measure if you are going to paint everything on one layer.

6: Painting on one layer can lead to a flat look, so don't be afraid to color balance and add effects as needed.

7: The finished image with all colors and effects.

SOFTWARE AND MEDIA:
OTHER SOFTWARE

TIP 076

OpenCanvas

OpenCanvas is a Japanese shareware program described by its publishers as painting software. Since 2000, it has been a popular choice for young people due to its ease of use and affordability. It has many features found in other graphics software and has been translated into English fairly well. OpenCanvas can read and write in multiple file formats, so it is great for switching files in and out of Photoshop, for example. And one of its

1: An overview of the dialog boxes in OpenCanvas 5.5: all the basic drawing, coloring, and selection tools, which you can clearly organize and customize.

key unique features is the Event File, which records and replays each step of your progress on the work like a time-lapse video.

While Photoshop has more advanced image-editing capabilities, OpenCanvas has a good mix of features most users need and a very natural and intuitive feel when drawing and painting—the line smoothing is good and colors mix well together in a very saturated way. As such, I recommend setting up your artwork to paint and shade in nonadjacent sections separated by layers so that you make the most of the software's painting strengths.

I prepared some line art for coloring by scanning in something I had drawn on paper. I made it transparent by filtering out the whites in Photoshop, coloring the lines in sepia, and importing the lines into OpenCanvas, but you can also just set the layer to Multiply, and if you want to tint the lines, insert a clipping layer above and overlay any colors you like.

I inserted a layer under the lines then painted in a base for the skin. There's no need for it to be very neat; it is actually better to paint over the edges then cover them up with layers on top later or erase as needed after shading. You can also lay

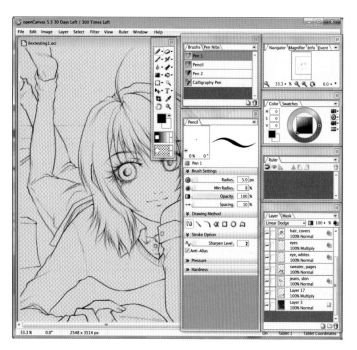

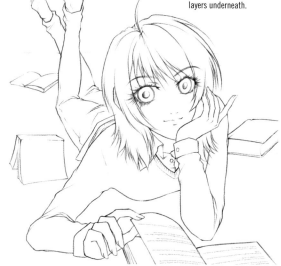

2: The lines are in pencil but are cleaned up for use on a transparent layer and tinted sepia. Keep the lines as the top layer and introduce coloring layers underneath.

a base for a few other parts of the drawing as well, as long as they are not right next to the skin—in my case, I flattened the jeans.

Then I locked the transparent sections so that when I shaded with a watercolor brush, everything stayed within the areas already painted on. There's no shortcut to this; I picked darker and lighter colors as I saw fit and gradually painted.

Then I repeated this process of flattening, locking the transparency, and then shading again and again for various sections. Notice how the hair obscures

the messy top part of the skin shading I did. I knew the hair would cover it up, so there was no need to fix it.

I already knew what the background and feel of lighting was going to be like when I started, so I added it in partway through coloring and toggled the visibility on and off as I needed to while checking edges and filling areas. But it's advisable to view the background with your subject matter *in situ* to get the lighting right!

Once I was done with the majority of the shading, I added in colorful highlights to

the eyes and hair with a dodge layer for a bright, saturated feel. Extra areas of shading, sharp highlights, or loose strands of hair are on another layer again on top of everything else, but with no effects for full opacity, allowing me to pick solid colors with pipettes.

This example shows just some aspects of OpenCanvas that I use when painting digitally, but it can also be used for black-and-white Manga comic work. You can choose to switch off anti-aliasing, and they have a selection of tone patterns to drop in as fills. (SL)

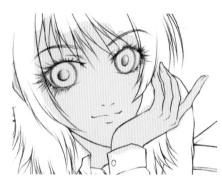

3: The first section to flatten is the skin, as it lies beneath most aspects of the image. There's no need to be precise in areas where it will get covered up later.

4: Start painting the skin with hard and soft brushes in a style that you like, always thinking about the light source and where shadows would go.

5: Lock the transparency of the skin layer to keep your shading on the same areas you've already covered without smudging anything beyond the edges.

6: When finished with the skin, add other parts of the image above, like the hair and the first layer of clothing.

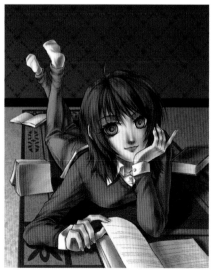

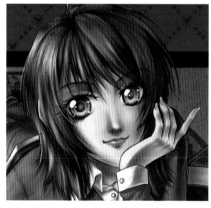

7: Continue shading and adding layers as you see necessary, in the right order whether the area is in front or behind another area.

8: Finish off the image with any highlights and adjust the overall lighting if required.

SOFTWARE AND MEDIA:
OTHER SOFTWARE

TIP 077

Using Illustrator

Illustrator is a vector art package primarily used by designers and illustrators. It requires a slightly different approach than painting programs such as Photoshop or SAI, as Illustrator is based around creating images out of shapes and paths rather than brush strokes. Working with Illustrator is great for creating sleek, bold artwork, and because it uses vectors, you can resize your work infinitely without losing any quality.

Even though vectors are usually created by working point by point, I prefer to start by loosely drawing the shapes using a graphics tablet and the pencil tool. I begin by tracing the shape over the top of a sketch, and then I clean up any stray lines with the smooth tool.

For fine adjustments to the shape I use the Direct Selection tool—choose the point to adjust, and then click and drag to move it around. This is good if I need to move a line slightly, but what if I need to adjust the angle of the line? Still using the Direct Selection tool, first I click the point I'm adjusting. This will reveal the "handles" that control the curve. I then move the handles together by clicking and dragging either of them. Or to make a point in the line, move each one individually by holding "Alt" while clicking and dragging.

For more complicated shapes, I draw the shape in several pieces then use the Pathfinder/Shape modes to create a "compound shape," which is one shape made out of many smaller shapes. Shape

1: Illustrations should be planned in rough before drawing the final lines, shapes, and fills. Shapes are traced over a rough drawing.

modes can be used to stick shapes together, cut one shape out of another, or intersect or exclude overlapping shapes. The results aren't permanent until the Expand button on the panel is clicked, which means I can adjust the shapes just by double clicking them with the selection tool, then move them around, resize them, or even adjust them point by point before making the shape final. I've shown the before and after with a stroke around the shape of the face and ear, so you can see how they combine into one.

Shape modes can also be used to create the outlines on your drawing. Rather than using a stroke on the shape as an outline, I create a shape just for the outline itself so I can create a more natural variegated

line. I take the shape I'm working on, copy it, scale it, and then adjust the points to make a good-looking outline. Here, you can see the original shape with the outline shape underneath it in black, and the result after I've cut away the original. Now I can color and shade more loosely underneath the outline.

You can also import artwork into Illustrator to convert into vectors if the artwork is very neat and precise. Recent editions of Illustrator have a "Livetrace" function, which is a tracing tool that detects strong outlines and shapes very well. You can make adjustments to the minimum stray lines it will ignore, or place restrictions on how many colors it can detect. Once you expand and

2: Once your basic shape is down, you can adjust it by smoothing it down, working on the angles, filling the shapes, and changing the stroke line.

3: You can create compound shapes by selecting several pieces and combining them. You have plenty of scope for adjustments before committing to the final shape.

4: Make your outlines look more organic, and display different line weights by copying the shape and warping it as needed for a pleasing effect.

5: You can cut away the original to see the natural-looking lines. This makes it easier to shade and color.

6: Final image.

confirm the trace, you can then edit and adjust the generated vectors as required.

By drawing and combining shapes in clever ways, you can create precision work simply and intuitively. Using a graphics tablet to draw straight into Illustrator makes working with vectors more approachable to anyone used to more traditional drawing methods. (SD)

SOFTWARE AND MEDIA:
USING NATURAL MEDIA

Using Natural Media

As easy to use and available as digital illustration software is, sometimes only a back-to-basics, on-paper approach will do. Here, we discuss using markers, watercolors, colored pencils, and mixed media, giving tips on how best to use these different materials to enhance your artwork.

TIP 078

Using Markers

Alcohol-based markers have been a popular medium in Japanese illustration for many decades and were used for professional Manga-style artwork long before the popularization of digital artwork. Their bold colors and subtly blended texture gave the artwork a richness that was perfect for the style, and the qualities are still a great option for modern artwork.

One of the most important things to consider when working with markers is to prevent the line art from bleeding into the colors. Many fineliners will smudge with the alcohol, dirtying the color and sometimes even spoiling the marker tip. Do some tests beforehand to make sure the paper and line art work nicely with the markers.

Creating a photocopy of your line art can help prevent smudging, as the toner used is often resistant to alcohol. You may also consider using a scanner and a laser printer, but it's important to test beforehand. Some laser printers are also susceptible to bleed. Inkjet printers will always smudge and smear, so never use these for marker illustration.

Coloring the skin is often a good way to start, as it helps to establish the character and prevent the clothing colors from clashing with the skin tone. It's also useful to work with paler color tones early on so that any mistakes can be covered up by the darker tones. Prepare the skin area first by applying a blender pen to the paper in all the areas for skin. Using the brush tip, you can easily fill the areas quickly but still capture the curves.

Continue to fill out skin tone in all the skin areas of the picture. Pay attention to which areas you want to be marked with highlights at this stage, as flesh tone in particular benefits from white highlights.

Using the same skin tone that you started with, add some light shadows to the face around the overlaying hair. Be sure to add a little shade beneath the chin. You can use the same skin brush to draw in the lips too, which keeps them subtle but neatly defined, and a darker shade than the original skin. This darker tone is partly from overlaying, and partially because a blender pen was used on the skin areas originally.

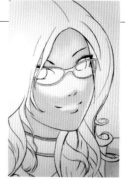

1: Start by coloring in the shadows of the skin. Use the blender pen liberally if you want to have a color fade in or out.

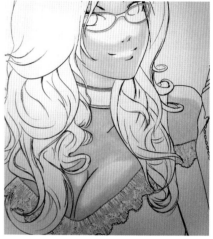

2: Color enclosed sections one at a time fairly quickly to avoid streaks. Use the white of the paper as highlights.

3: Layer more color onto the darkest areas of the skin. Use darker shades if you think it is necessary.

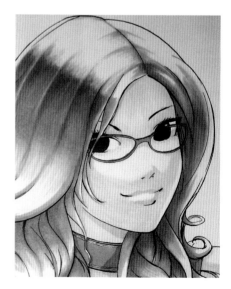

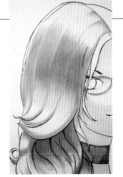

1: For a soft, gradiated feel to the hair, start light and generously shade it in, leaving the white paper blank for highlights.

2: While wet, layer on the darker color. It will softly blend into and mix with the lighter color.

3: Pay attention when shading and highlighting, as there are many overlapping sections and weaving curls.

4: The top of the head is subject to the strongest light, so leave generous amounts of white.

5: Adding slashes of darker color increases the contrast, giving a very shiny feel.

The hair is layered up using two or three different colors. These curls are easily separated into smaller sections that can be worked on one at a time. Start off by applying the base (here, the yellow/orange), leaving only the highlighted areas untouched. Use the brush tip and stroke outward, following the shape of the hair and releasing to mark out the highlight areas.

While the orange is still wet it is time to apply a deeper tone (here, the light purple), and again apply the brush tip in the darkest areas, brushing outward along the shape of the hair. Be sure to keep your strokes nice and short, and always stay within the orange shade. If you go onto the white it will show a purple line, which is undesirable. Don't worry if this does happen, as it can be easily fixed by using the orange to cover it up.

Repeat this technique across all the small curly sections, paying attention to the light and shade of the overlapping hair. If you want extra definition, use another lighter color similar to your shading (here, dusky pink) and the fine tip to mark out some extra strand lines, or to deepen shadows in the most heavily obscured areas.

The top of the hair requires more care, as the area is larger. Make sure you have a good idea of where the highlights will fall so that you can prepare to block out

a base. Always use the brush tip, and follow the shape and direction of the hair.

Then, using the shading color again (light purple), focus on the darkest area of the

hair and work outward from there. This can be used in the middle of an area to emphasize the shininess of the hair. Use a little purple on the undersides of the hair as well to add depth. (HS)

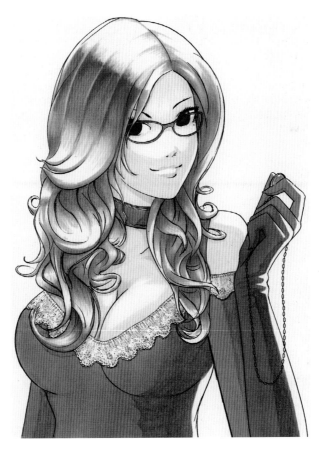

4: The finished image. Her clothes appear matte due to the sharper style of shading and less contrast in the shadows.

SOFTWARE AND MEDIA:
USING NATURAL MEDIA

TIP 079

Watercolors

Watercolors are an entire discipline of their own, with whole books dedicated even to specific subjects within the field, like landscapes or portraits. It is important to remember to take advantage of the strengths of this medium and work with its nature rather than against it.

Of course, the quality of your paints and your brushes will affect the outcome, but you can achieve great results on a budget. What you need to think about is the type of paper—the cheapest paper has more texture and lends itself beautifully to large, translucent swatches of colors but can almost entirely obscure any fine details. As I tend to use a small-scale letter size (or less) to draw detailed areas of Manga characters where I want the skin and hair to appear smooth, I use hot-pressed paper with the finest grain and smoothest finish possible.

Below: Here, colored lines were drawn with waterproof colored fineliners before watercolors were added.

While watercolors can be built up to very strong and bright finishes, they really shine when used in a delicate manner. As such, it's important to consider the type of line art you will use. Traditionally, most watercolorists stick to light pencils to let the painting stand out. You can also use colored lines—try fineliners with colored inks, but check to see how waterproof they are first. I sometimes use very fine (0.05 or 0.1 mm width) waterproof fineliners in black. That said, I'm sure you can get some great impact with bold lines and rainbow washes, like stained glass. Just consider your options and the result you want to achieve.

There are many ways to apply color to the paper; the first technique is to apply a wash. You can achieve a gradient effect if you start with more pigment and gradually use more and more water until the color fades into the white of the paper. Another great technique is wet on wet: You paint one color wash onto the paper and, while it's still wet, paint another wash in a different color on top. Depending on how long you leave it and how wet or dry it is, you can also achieve interesting concentrations of color and watermarks.

Adding some salt to the paper while the paint is still drying can create beautiful results, as the salt absorbs the water. The effect leaves pockets of lightened specks depending on how much salt you used and the type of salt—for example, large flakes produce different patterns than small grains.

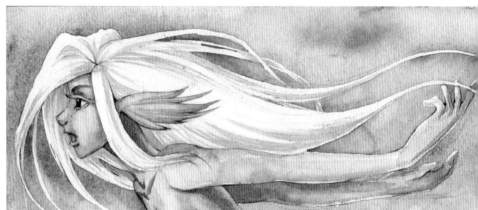

1: The initial pencil sketch should be neat and clean to avoid smudges and standing out too much when painted with pale light colors.

Below: The lines were kept very fine and thin, drawn with a pencil. Wet-on-wet painting was used for the background to create a blended, ethereal halo around this character.

Masking is very useful for artists who want to leave strong highlights or fine details in light colors against a large wash background. Apply masking fluid to the areas you want to keep clear of paint. Wait for it to dry, and then paint freely on top. Wait to dry again, and then rub or peel off the masking fluid. All brands will react differently when dry or when peeling, so test this out on the paper you'll be using before working on your final piece.

Some general advice when painting: Test the strength of your paint mixes against a spare sheet of paper so you always have the right level of saturation. Avoid mixing black or white into your pure colors unless absolutely necessary, as it dulls the paint, and always try to achieve what you can with learning the right ratios of water to paint. Blending colors gradually works best when the paint is still wet. Layering colors (like sharp shadows) works best if you leave the base color to dry before adding a shadow layer.

And a final word of encouragement: Watercolors are an extremely mercurial medium, so even with the best will in the world, they will sometimes turn out wrong. But don't get discouraged. You can solve most problems if you react quickly while everything is still wet. Soak up any excess with a tissue and add water (or alcohol, if you need to lift even more paint), then wait to dry and try again. Watercolors are relatively inexpensive, so they're great for you to practice and experiment with until you get the hang of it. (SL)

2: Use masking fluid to cover and protect any fine areas you want to keep white for highlights or lighter sections.

3: Salt works very well on wet watercolors to absorb water and create interesting marks.

4: Once the wash has dried, you can peel or rub off the mask to reveal the clean white paper underneath.

5: Build up your colors and shadows carefully, using the white paper effectively for highlights. When dry, add any final pencil marks for extra definition.

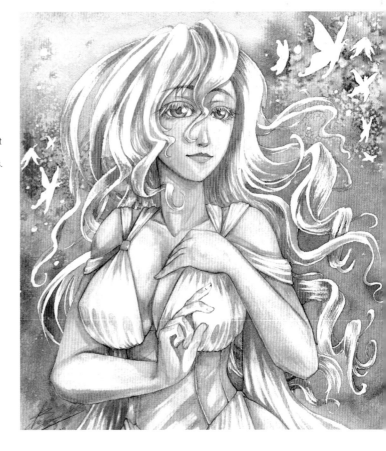

SOFTWARE AND MEDIA:
USING NATURAL MEDIA

TIP 080

Colored Pencils

Colored pencils don't just allow people to work in color; they offer a rich foundation for blending and can introduce texture to illustration in an exciting way. Developing pencil techniques will allow you to create pieces of art that are impossible to replicate with other media.

When using colored pencils, it helps to use them for all of the lines. If you need an outline on an area, use a deep version of the pencil. Working the outline into the rest of the coloring will make the image feel much richer.

Complex pieces of art can be produced by taking advantage of the sharp lines from the pencil strokes. By layering many different colors, you can add texture and shape to otherwise flat areas.

Even monochromatic artwork using one or two pencils can have a richness that is unique to watercolors. The soft application of pencil will bring out the texture of the paper, but the fine strokes will remain fully intact.

Watercolor pencils are a great blend between pencil and watercolor, having the qualities of both. Applying a light layer and brushing water over it gives a watercolor-style look to it.

Layering additional pencil work onto watercolor pencil pieces can add a lot of texture, which can be used to good effect to add impact to different parts of an image. (HS)

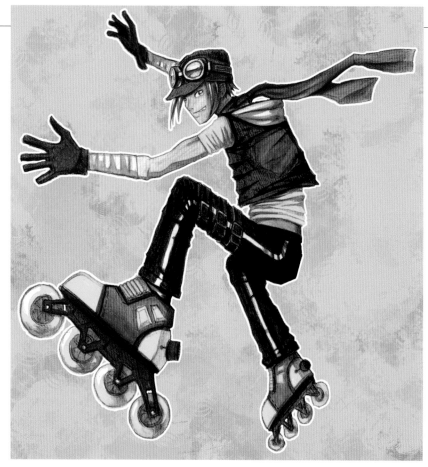

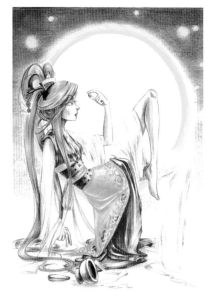

Opposite: Watercolor pencils are the best of both worlds. Over soft, smudged areas of pencil, apply a wash and work it into the paper to get smooth sections. It's particularly effective if you want to achieve very strong, saturated, and dark areas.

Opposite Bottom Left: Here, a lot of blending is used for the smoothest result possible to give a delicate effect. The texture of the pencils is minimal and the stroke direction is unobtrusive. The only obvious strokes are the outlines and the hair.

Opposite Bottom Right: This chunky character design benefits from strong textures. The pencil strokes follow the contours of the character and outlines of the ghosts in the backdrop. The layering of different colors form a strong outline around the character.

Right: Sometimes a picture can look more striking if the color scheme is kept very minimal. Only blue tones are used in this portrait, showing a combination of smudged shading and crisp strokes.

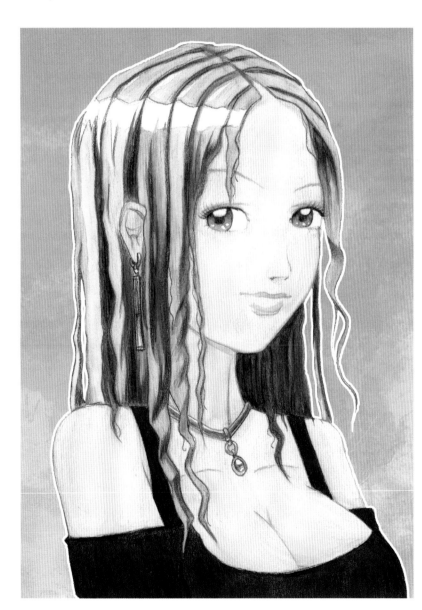

Left: This girl is colored with a striking degree of contrast. The white of the paper works well for her hair highlights, and there are strong dark blue accents for the darkest sections. Her top is a mix of colors, creating a rich, sumptous texture.

SOFTWARE AND MEDIA:
MIXING MEDIA

Mixing Media

As we have seen, each artistic medium has unique
qualities that can add to your Manga. Sometimes you
will want to use a combination to make the most of these.

1: Rough out your image lightly in pencil first.

TIP 081

Mixed Media Combinations

When you say the words "mixed
media," it can conjure up images from
art school of figures scratched out in
ballpoint pen with splashes of red
acrylic and festooned with newspaper
clippings. For Manga purposes, the
effects are far more subtle due to the
size and level of detail required—
most of our work is done on a smaller
scale than the typical artists' canvas,
so large and chunky layers are
inappropriate. The key to mixing your
media is knowing the strengths of each
medium and using it to create the
desired effect at the right stage.

Working traditionally, one tends to forget
about coloring the outlines. We pencil
a rough base and go straight to inks of
some sort—and since most of those inks
are waterproof or markerproof, or we get
so preoccupied with widths and type of
pen, that we just use black inks.

Here, I used waterproof brush pens in
various colors so that I would achieve a more
harmonious outcome once fully colored. This
does require planning and testing, though, so
try out your colors on a rough sheet of paper
and see if they work with the final palette.

2: Outline with colored pens and erase pencil lines.

3: Color the work very simply and lightly with markers or watercolors.

4: Add sharp details with colored pencils, pens, or opaque paints.

Then I used markers to do my base coloring and shading, where I wanted smooth and blended surfaces. I tried not to get too bogged down in detail at this stage and kept to lighter colors. Watercolors can also work for this—it's all about having a nice, clean image to further enhance.

I added more contrast and interest by layering extra details on top of the smooth marker base with other mediums. Colored pencils are wonderfully effective for getting sharp lines and texture into your drawing. Sharpen well and use on the darkest areas of hair, adding texture to the eyebrows and darkening the outlines when needed. I used colored

pencils extensively on the irises to get a multicolored feel to the patterns and gradients within. You can blunt your pencil and use it to add a textured feel to cloth and fabrics, particularly if you draw on a textured surface.

It's great to finish off an image with whites and other light opaques to give a 3-D feel to the subject—a white and silver gel pen on the eyelashes, a few slashes of white extending from the highlights of the hair—as this makes it look like some strands are in front, or above, interweaving. I sprinkled a few drops of white along the main highlight bands of the hair to add a sparkly, shiny feel.

Now let's look at what all of us will probably end up doing at some point: mixing our traditionally produced artworks with digital enhancements. Almost everyone will either photograph or scan their artwork to digitize it for reproduction or upload it online, but there are plenty of things you can do before it's finished. For example, it is easier to paint solid-colored cloth and its shadows with markers or watercolors than it is to add patterns. You can add patterns and complex textures digitally. It's also useful for adding large and gradual lighting effects when your original artwork uses a limited number of marker colors, and it is difficult to create an overall fade by hand. You can also frame your traditionally drawn characters with digital borders and backgrounds. (SL)

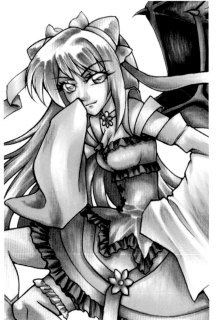

1: A close-up of the original marker drawing.

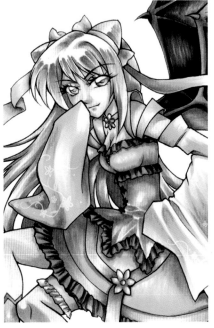

2: A pattern, which picks up the underlying colors and shadows, has been added to the sleeves digitally.

3: A stripy background and a border around the character artwork help to frame it.

Making Comics

The real meaning behind the word Manga is comics; it's not just pretty pictures, it's telling a story. Many budding illustrators never get to this point. Drawing comics, particularly in Manga format, may seem like an insurmountable hurdle because of the complexities involved in getting a polished finish, but try to break it down into manageable steps to achieve it. Work on your story and script, then allocate the correct amounts to each page. Draw rough page outlines to plan out how you will split the action and dialog across several panels per page. Try to change your layouts to match the pace of your story. Use the theories discussed to make the ebb and flow of action seem natural and easy to read. When producing your final pages, learn how to shade and letter your Manga authentically, using your choice of mediums.

MAKING COMICS:
STORY AND SCRIPT

Story and Script

There are myriad ways to plan, write, and format stories and scripts, and in this section we go through several options for you to try. But the most important thing to remember is to do what feels best and is right for you, so that you're more likely to keep writing and to improve as you go.

Below: In need of a deus ex machina?

TIP 082

Planning Your Story

Story ideas can come from anywhere, but once you have one you like there are several things you can do to grow it into a full-fledged plan. The first thing I do is write my idea down—usually in a text file on my computer. Then I let it stew in the back of my brain, thinking about it when I have the time and letting connecting ideas surface. I write those down too.

When you start planning the story, you should bear the ending in mind. An excellent story can be undone by an unsatisfying ending, and it's very easy to write your characters into a hole you can't get them out of without breaking the narrative flow.

So when you have your idea, think about both the beginning and the ending. Then, when planning the middle, you can keep in mind where you're going and where you've come from, and it should all come together as a coherent whole. I don't find it necessary to plan the middle of longer stories out in detail, but I do plan the rough shape of the tale and the events that need to happen in order to get to the intended ending. I prefer to leave the smaller details until I get to scripting each chapter, that way they stay fresh and spontaneous, and the characters have room to grow and develop.

Planning chapters can be helpful for pacing. A rough layout helps you plot chapter transitions, such as cliff-hangers, which keep the reader rushing on to the next chapter, and pauses, to give the reader a chance to breathe. Of course, you could choose to make all your chapter endings cliff-hangers.

Be wary of prioritizing your characters over your story, or vice versa. If you think up your characters before you think up your story, you risk having the story feel like it's just there to serve your characters, but if your story came first then your characters can feel flat and unrealistic. Make sure your characters are well-rounded and believable people, and that your story is not just there to show them off. (ML)

Above: The recurring comments about thievery were not in the initial plan.

Scriptwriting Methods

When writing a script, you should keep your intended audience in mind. Writing for yourself is much easier than writing for another artist. My own scripts for myself consist mainly of brief descriptions of what needs to happen; dialog, which I find easier to work out before I do the thumbnails; and occasionally instructions for what the characters should be doing or how they should be reacting to what has been said or what has happened. As you make your comics, you will find out what works best for you. Don't be afraid to change your script as the story evolves; as the ebb and flow of the narrative becomes familiar to you, you may find that it would be better for the story to reroute what you had originally planned.

Writing for another artist requires much more effort because another person isn't going to be able to read your mind and, unless agreed between you, will not be taking many liberties with the story you've planned. Good communication is also important—find out how your artist(s)

would prefer to work. Some artists like to work with a loose script, with just the basic story written out and freedom for them to lay out pages and communicate emotion as they choose, in which case you may end up simply writing your comic like an abbreviated short story.

On the other hand, some artists prefer to have every panel laid out for them, up to and including character positioning within the panels. Some may even ask you to draw out the thumbnails for them.

Either way, if you have a specific panel in mind, its placement on the page or the positions or expressions of the characters within, you will need to describe them accurately enough for someone else to understand and reproduce what you want. You may want to check the artist's thumbnails or pencils to make sure you're happy with how it's going, or you might want to leave it up to their judgment. Maintaining discussion and feedback is essential. (ML)

Above: The comic page.

P13

Sailing around the cliffs

Ember: But the cliffs are sheer.
Ember: There's no way off except the bridge.
Ember: Which means they've got someone in the town.

Sunset over the islands

Ember singing in the crowded tavern

Above: Note the difference between the script and the page: The third sentence has been split between panels for effect, but that was done in the thumbnails and not in the script.

Ember sails around the island, seeing the sheer cliffs and coming to the realization that there must be someone in the town allowing the raiders access to the smaller island.

In the evening, Ember pays the landlord's dues by singing in the crowded tavern.

Above: A textual, almost narrative description of the page. Most of the details—even the page breaks—have been left for the artist to choose.

Right: A precise description of the panels on the page, although even with this example script not everything is exactly specified.

P13: Five panels with two inset

1, top left: Ember's boat sailing around cliffs.
EMBER: But the cliffs are sheer.
EMBER: There's no way off except the bridge.

2 and 3, top right: Horizontally split panel showing the boat sailing close-hauled around the island.
Top panel: EMBER: Which means...
Bottom panel: EMBER: They've got someone in the town

4: Full-width panel showing the islands at sunset.

5: Full bleed panel across the bottom half of the page showing the crowded barroom of the Black Pig. To the right, EMBER is superimposed on the rest of the panel, playing the mandore and singing.
EMBER: Be still, my heart, the sea is calling,
EMBER: The fair sea with a bright wind blowing,
EMBER: The cruel sea with it's rocks awaiting,
EMBER: And still I will return.

6 and 7: Inset panels on left of panel 5 showing details of the barroom and OPTAE entering.

MAKING COMICS:
LAYOUT AND PACING

Layout and Pacing

There's more to a story than just a concept—how you choose to tell a story is just as important as what you're saying. In this section we'll examine how the layout of a strip can affect the story's meaning and flow, and how you can improve both through thoughtful paneling.

TIP 084

Setting Up

First of all and most importantly, you need to consider the paper, trim, and the bleed size. Especially if you are planning to submit your work to publishers or/and competitions, always double check the required dimensions.

You can buy specially designed paper for Manga, which usually has all the trim marks and bleed marks (3 mm to 5 mm all around) printed. And if you are using specialized Manga drawing software, the possible sizes are already set up so you can just choose the appropriate one. If you use normal paper, you should mark them on each sheet by yourself, ideally with a pale blue or yellow pencil that will not show up when printed.

After marking all the trim and bleed lines, and assuming you already have your story plan, it is time to start drawing the first roughs. Think about the position of speech bubbles, the size of the panels, and the balance of images in each panel.

In my case, I take a particularly long time adjusting the rhythm of dialog. To achieve the right rhythm, the position of each

speech bubble is very important. Often I read out the dialog as if I am an actor to check the timing, and then assess if the positions of the speech bubbles properly represent the timing I want to

realize. It is also important to check if readers' eyes can follow the speech bubbles naturally, and in the correct reading order.

Above: An example of trim and bleed marks.

Above: A close-up of the trim and bleed marks.

Another thing you should consider at this stage is the width of each frame. Usually, horizontal frames are slightly wider than vertical frames, and generally you should keep the same width throughout the story. However, when you want to depict a pause, a slow moment where nothing happens and time passes, you can try to make the relevant frames a little wider.

Conversely, if you want to create the effect of "a lot of things happening in a hurry," small panels with thinner frames in between can work well.

Once you start inking, less correction is better, obviously. So I strongly recommend checking everything very carefully at this rough stage. (CK)

Below Right: Showing an example of width of vertical and horizontal frames.

Below Left: The process of checking the positions of the speech bubbles and the balance within a page.

MAKING COMICS:
LAYOUT AND PACING

TIP 085

Paneling and Pacing

Paneling and pacing is essential to your storytelling clarity and the passage of events within it.

I start my paneling and pacing process at the thumbnail stage, as it's part of my initial storytelling process—I need to mark down the important storytelling points as panels in sequence to tell my story. I will lay them out over a two-page spread usually, and the content and design will often be influenced by whether or not I need to use the page turn as part of a "reveal" to the next part of the story. I'm fairly lucky, as I don't often have a set page limit, so I can pace my stories as I want to rather than being regulated by the number of pages I have to work with. But even if I have that restriction, I will take advantage of the layout and page flow to plot the pacing in my panels, and try and use as many of the reveals as are available to me. Because you'll start from where your reading direction begins, across and from top to bottom, even leading to the base of a page can be a buildup to a surprise on a panel on the next page. This way you can build up events as well as let them run along as a continuous flow just by careful planning of your panel pacing.

For me, the more panels per page, the faster the pacing in the story timeline, although the content of the panels will also influence this—action-packed panels flowing quickly in reading order, one into the next, can feel speedier, whereas clearly drawn stand-alone still-looking panels, even in a multi-paneled page, can feel like they lead to the next more

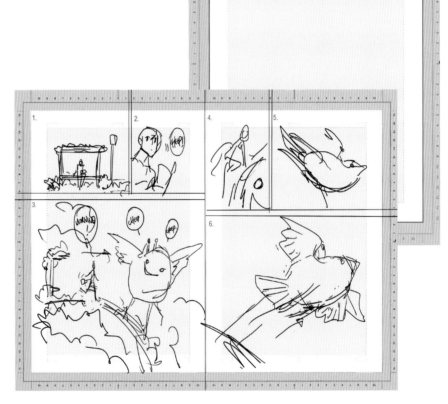

slowly. When I want to draw things out for longer, I'll generally use fewer panels per page and give a sense of space within the panels, as well as clearness.

For drawing my neats and roughs, I'll use a pre-ruled guide. I draw using a Wacom, so this is a scan that I use as a base and draw on layers above it. Once I've got my thumbnail content as I want it, I'll then start laying them out in drawing size on this page guide. The guide is set up with bleed and safe print areas

Above: The template guide I use for plotting out my rough pages. They are pre-ruled with measurements, bleed, and safe print areas. On here I've marked the bleed in pink. The area within the red line is the actual page area and blue is the safe area.

Above Right: I'll plot across two pages, as I'll usually be doing work in book form. It lets me look at it as a spread. The pages read from right to left individually; panels are read across, then down.

so I know not to place important drawing work or speech bubbles in these areas, which may be cropped or uncomfortably composed when the page is printed and bound in a book.

Above: Rough drawing on the pre-marked paper. Note how all important parts of the picture content and speech bubbles are within the blue print-safe zone.

The ruled guides along the edge let me plot my panel lines more easily. I choose a measurement for space between panels and stick to it for the entire project unless certain storyline elements require a deformed panel and the use of certain areas. Special Manga papers and pre-ruled papers are easy to find, but you can just borrow the rulings and make your own. Just be aware of your eventual page size and, if you're printing, the page specifications before you start your neat work. (NM)

Reading Flow and Panel Order

With the rise in popularity of Manga, we now also have a small proportion of books designed to read right to left as well as the traditional left to right for most English readers. Even then, it's fairly easy to establish a clear reading rule: across (in the designed direction) and down as you would regardless of reading direction. This applies to both the paneling and any speech bubbles present.

You may sometimes find when you read a comic that the flow of the work is hard to concentrate on or follow. Often you can use directional cues to help the reader and make the pages and panels easier to understand and follow. These can be as simple as making the characters face or move in the direction of the flow, or placing a speech bubble and the character speaking leading in the direction of the next panel.

In panels showing a flow of action, make sure that the panels show a consistent directional flow, leading fluidly from one panel to the next. This doesn't mean you have to draw all the panels the same as if you're animating it; you can still change viewpoints and design, but do them in a way so the action flows continuously toward the next point.

If you read through a page and feel a bit uncomfortable with the flow, ask yourself: Is there something within the panels that stutters or jumps a bit and goes against the directional flow of the text? You'll find very often that the comics you feel most at ease reading will subtly use this cue of directional flow within the work.

However, going against the flow of reading can also be used to create a pause or a surprise. You can use this for vignettes of different moments or characters. (NM)

Above and Left: When I design my pages at the thumbnail stage, I will check the flow before I move to roughs and neat work. Setting the contents of the panels with directionality makes it simpler for the reader to be directed along.

MAKING COMICS:
DRAWING COMIC PAGES

Drawing Comic Pages

There are necessary technical steps you must take before you begin to draw, such as deciding your page size and marking trim and bleed, which we explain in more detail below and will make your work more professional. Knowing whether you plan to create your work digitally or by hand can inform your creative process, so make sure you know the pros and cons of each method before you choose.

TIP 087

Methods and Processes

Knowing the methods and processes behind comic page creation gives you great control over creating artwork as a whole. With smooth preparation for each step of the way, you can accelerate your production speed and change some aspects of it to enable you to work comfortably and effectively in a style that suits you. So let's have a behind-the-scenes look at Manga creation.

It's rare to see a collaboration of a separate writer, artist, colorist, letterer, and cover artist in Manga, unlike in Western comic creation. Manga is generally created by a single artist with some assistants, which means Manga artists do it all. Hence, story making is included in the process.

Brainstorming your ideas is the first step. Keep a note of all the ideas you come up with in writing or sketches. A character can be based on a real person, an animal, or even an object. A story can come from an old folktale, but maybe with a modern twist, or it can be exaggerated versions of incidences you have experienced. Let your imagination run free.

Some artists make a script; some make storyboards to tidy up and finalize the story. Then there are some practical facts you have to face, such as how many pages and at what size. After deciding, the next step depends on whether you're using a digital method or analog method.

Analog methods and processes include creating a panel layout plan on paper, penciling, inking, adding effects, lettering, and printing. It's better to create the original Manga drawing on a bigger scale than the printing size. If the final size is B4 (13.9 x 9.8 inches), it's better to work on A3 (16.5 x 11.7 inches) or bigger to be able to depict small details and then shrink them afterwards.

Account for a trim border around the edge of the page, which will be cut after pages are printed. Leave text and any important part of artwork inside a safety margin.

Pencil drawings can be very messy, as this is for focusing on getting an idea of how the page will look. After the pencils are finished, refine into a slightly neater version so it is ready to ink.

Top: Manga paper with guides, which will not be printed on the final image.

Above: A panel layout example.

When inking, you only need to pick the crucial lines from your pencil drawings. If you study Manga closely, you will realize there are no unnecessary lines. Each stroke is a decision of which line to leave. You can use different dip pen nibs, such as a Maru pen for small details or a G-pen for thicker strong lines. Normally, inking character outlines in a thicker pen makes them stand out from backgrounds.

One method you can use for shading is screentones. These are translucent stickers you can buy, with small dots printed on to give gray tones or patterns to black-and-white Manga. Cut out areas to paste onto your artwork and slice away any excess. There are countless varieties of gray shades and patterns available.

Below: The pencil drawing.

Bottom Left: The inking process.

Bottom Center: Screentones and focus lines have been added.

Bottom Right: A completed page with lettering. "Ketsueki," written by Richmond Clements, lettered by Dave Evans, and published by Markosia Enterprises Ltd.

Common effects are speed lines and focus lines. Speed lines are for expressing a quick movement or the direction of the movement of objects; focus lines are for drawing readers' attention to an object. Both are very powerful.

For the lettering process, add all text including sound effects and onomatopoeia. Unless there is an intentional purpose, keep the same fonts and case all the way through the Manga.

If you are printing by yourself, you need to scan the images into a computer and plan how to bind them together once printed. If you are taking the artwork to a professional, you need to follow their guidelines of how to create printing data.

Digital methods and processes include making a panel layout plan in the Manga Studio application—for example, penciling, lettering, inking, adding effects, and exporting to Photoshop, adding more effects, and finally printing.

The benefit of using a digital method is its flexibility. Even after inking, changing size, making a mirror image, or adding an extra panel will all be easy.

Of course, some artists mix analog and digital processes—for example, after inking on paper, they'll scan the image into a computer and use software to add tones, effects, and text. These processes are easier to handle digitally unless the artist needs a handwritten, crafty look for their Manga for artistic reasons.

Although digital methods are useful, please don't end up using only the available choices from applications, like the most common fonts or patterns on clothing. It limits the originality of your artwork. You should be a total perfectionist of your creation rather than just using easily available options. Manga is like a marathon; its creation takes a long time and so much energy, that finding the best methods and processes to suit you is necessary to obtain maximum efficiency with your work. (IK)

MAKING COMICS:
TONING AND SHADING

Toning and Shading

In the modern era there are plenty of digital programs to assist you with toning and shading your work, so much so that doing it by hand is often seen as unique and individual. We take you through the most popular options and throw in a few tips to get you started.

TIP 088

Using Manga Studio

Once upon a time, in order to screentone a comic page, the artist would need all sorts of tools: sturdy Bristol board, burnishers, cutting tools, metal rulers, and of course the sheets of tone themselves. These days, in the age of digital artwork and comics, software and a graphics tablet can act as a wonderful alternative. Here, we see how Manga Studio has earned its title as the software of choice for so many creators.

As with any good digital art package, Manga Studio operates in layers. So, just as in non-digital practice, the artist can lay down screentones and effects as new layers. One massive bonus to working digitally is that, unlike in traditional screentoning, the inked layers are not affected and can be preserved. What this means is that Manga Studio offers far more potential for experimentation and trial and error. Though be aware of this as—if you want to hit your deadlines—you'll have to avoid spending too much time playing with variations.

Furthering this "safe" way of working is the fact that Manga Studio will automatically create a new layer for every "material" you lay down on the page. This means that

Above Right: The line art without any tones added yet.

Right: This image is the finished page of artwork, inked and shaded.

every separate tone sheet or effect can be tweaked and amended before exporting the page. This is incredibly handy and avoids the dangers of accidentally placing two or three tones on the same layer.

Each tone layer is designated to the tone or pattern that it is created for. This means that, while a tone layer is selected, all tools in the tool bar become specific to that particular pattern. So the pen tool will now draw screentone, the fill tool will fill in according to the selected tone, etc. Couple this with the software's handy close gap feature, which will allow a

simple "click fill" even if inks aren't entirely closed, and what's provided is a very malleable and flexible tool for applying screentone. With the layer selected, the pen tool can be used to paint in missed spots or add detailed shade, or the pattern brush can be set to tone use. Set the layer tool color to transparent and use this to create some nice burnishing effects.

Once laid down, tone details like lines and angle can still be adjusted using the tone properties layer, helping to darken or lighten the tone over all.

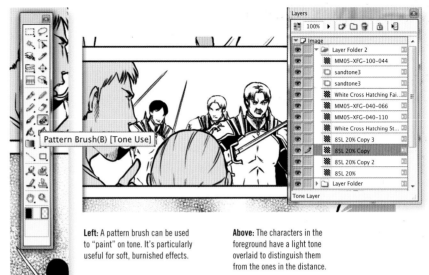

Pattern Brush(B) [Tone Use]

Left: A pattern brush can be used to "paint" on tone. It's particularly useful for soft, burnished effects.

Above: The characters in the foreground have a light tone overlaid to distinguish them from the ones in the distance.

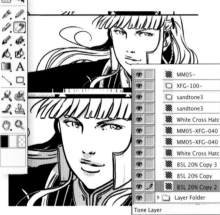

Top: Each tone effect has its own layer or "material" laid down on the page. This keeps things separate and easy to adjust.

Above: You can see the areas where a light shadow has been added to the character.

Manga Studio EX comes equipped with a generous serving of screentones. These vary from traditional dot tones to gradients to atmosphere and mood tones. You can also import new tones using the import option from the main menu. Whether saving new tones as materials, or simply using them as a standard layer, tone sheets are certainly not limited to the library provided.

Be wary of over-toning pages. Again, digital tools do offer a lot of scope for experimentation, but by the same token they can inspire a tendency to add far too much tone and drown out the line work.

The spread shown here was taken from the book *The Avalon Chronicles: Volume Two*, written by Nunzio DeFilippis and Christina Weir, and published by Oni Press. The artist is Emma Vieceli, and tones in this case have been added by Nana Li. Tones in this spread are used in four ways:

Depth: In panels two and three, the foreground figures are in shade. This separates them from the background characters, adding depth.

Shade and highlight: Areas of tone have been used for minimal shade in areas of deeper shadow. The figure closest to us in panel three has an area of tone cut away that adds backlight.

Mood: That last gradient is dark and foreboding. This achieves mood. The

tone behind the dragon is light and fantastical, in contrast to the apparent danger in that bottom panel.

Shape: The gradient tone on the dragon itself is partly shade but also pulls the shape of the dragon out of the white background of the page. The unshaded head adds perspective and depth.

Of course, as with any digital option, what the artist is really doing is emulating a traditional process. Digital options allow a massive degree of detail and tweaking that isn't necessarily possible when working with standard, non-digital tools. So be aware of zooming in too far and adding detail that simply won't be seen when the page is in print, or of adding effects to your tone layers that might be lost at print size or would not be possible when working with traditional tools. That's not to say that you can't go wild and create some really unique effects, but it's worth considering these cautions if the final desired result is one of a traditionally screentoned page. (EV)

MAKING COMICS:
TONING AND SHADING

TIP 089

Using Photoshop

Photoshop, like many other types of image-editing software, allows you to work in layers, which means that you can add screentone in a way that feels very similar to doing it by hand. It is a matter of having a layer for the lines, then adding layers as needed above for various tone patterns. What you have to account for is that Photoshop is not specifically made for toning black-and-white comics, so you need to know what settings and tools to work with to get the best printed results.

Make sure that you set up your page at full bleed size and at 600 dpi to 1200 dpi resolution—this may seem high, but the final product will be flattened and sent to the printers in pure black and white and needs to print sharply. Use Grayscale mode, as Bitmap mode will not allow you to work in layers, so this is the next best thing to restrict your palette and keep the running size of your file down.

For basic toning, open up a sheet of tone in another window. You can make these yourself, buy CD packs, or download files of patterns. Ensure that the tone is a pure black-and-white file; if it looks soft and fuzzy when zoomed in at 100%, convert it to Bitmap mode. There are various options when you convert a gray-shaded image to Bitmap. If you choose 50% threshold it makes anything darker than 50% gray become black, and anything lighter than 50% gray become white. The various options are just other ways of converting the gray shades into black through an evenly distributed dotty pattern or a random noise pattern.

Copy an area larger than you need and paste it as a new layer above your lines. Set the layer to Multiply so it effectively becomes transparent and you can see your lines underneath. Then use the eraser (set to Pencil mode for hard edges) to remove unwanted areas of tone, or use the lasso or magic wand (with Anti-Aliasing switched off for hard edges again) to select larger areas to delete. I like to do this when I'm toning large areas to give a sense of color or texture.

You can combine this with a layer mask if you want finer control to mark out small sections or areas of shadow. That way, you don't waste time with accidents. If you remove more than you wanted, just switch between black/white brush to show and hide as needed. You can even give a watercolor feel to your tone work by using a brush with opacity linked to pen pressure, but to cancel out any grays being introduced, set your brush to

Dissolve mode so it works more like a real airbrush, dispersing specks of ink on the layer mask.

Alternatively, you can set your tone sheet or a small tiling image as a pattern, and then use the pattern stamp tool to "paint" the tone on the areas you want. This is also a great way to add in small touches here and there, like shadows on the face or hair.

You can add effects like sparkles, highlights, and outlines in white ink or extra blacks as you wish—just remember to keep track of all the different layers. When you're finished, save as your fully expanded .PSD file; then, for supplying to the printer, flatten everything and save as a Bitmap file using the 50% threshold option. You can then make PDF files or whatever the printer wants, but supply them at high resolution without it taking up a lot of space. (SL)

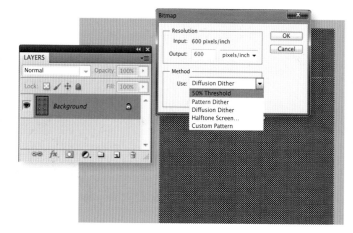

Left: Make sure your tone sheet is black and white only by setting it to Bitmap mode and dither or threshold any grays.

Right: Paste your tone above your lines and remove unwanted areas with an eraser.

Far Right: You can fill and remove large areas with a lasso tool.

Below and Center: It's good to get your basic shades done first and on a single layer or grouped together. It's like flatting your base colors.

Below Far Right: For subtle shading, I lay darker colors above and then apply a layer mask so I can paint in specific areas where I need them.

Bottom Left: You can tone using the pattern stamp tool as well.

Bottom Center and Right: The finished panels.

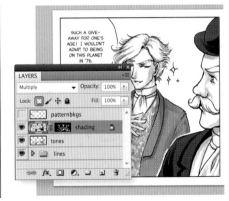

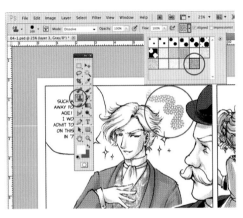

MAKING COMICS:
TONING AND SHADING

TIP 090

Shading by Hand

Before everyone had access to personal computers and their associated drawing tools, Manga artists added screentone by hand to shade their artwork. It is a lot less forgiving than doing it digitally, but there are various reasons for being old-fashioned! First, it's cheaper to buy a few pieces of paper, sheets of tone, and a good craft knife than to buy a computer, hardware, and software. Second, if you want to make a unique original artwork entirely from traditional methods, screentoning by hand is the way to go. And third, some people just prefer to work this way, like how I always prefer to pencil and ink on paper rather than on the computer. Just remember that no matter how complicated the final result may appear, we all start with shading something simple a little at a time.

Draw on heavier weights of paper—when you use your knife to cut tone, you will slice into the paper slightly, so the paper has to be robust. Ensure your inks are nice and clean. Use colored, non-photo pencils if you don't want to erase any normal gray/black pencil marks. If you're a beginner, ink with a thicker style so that you don't need as much precision when slicing out details.

Tone sheets are essentially large, clear stickers with dots printed on them. Cut out an area larger than the area you wish to tone so that you have full coverage, and then stick it onto your inks very lightly. Then, with a small craft knife, slice away the pieces you don't need. If you have trouble doing this on the fly, mark out guidelines in colored pencil.

Be careful about rotating basic dot tones—try to keep the angle of tone consistent if you are using the same tone sheet for many parts of your image. It's tempting to shoehorn your scraps in any which way, but it makes for a messy image and can lead to problems later on when layering. As a guide and to reduce wastage, stick to ninety-degree angles of rotation.

Once you're certain you've removed everything you don't want, you need to stick your tone firmly to the paper before doing anything else. Don't rub directly on the tone with your fingers! Put a sheet of paper on top first before rubbing down. There is a specialist tool called a tone hera, which I'm using here, but you can use a plastic ruler or anything that gives a consistent push. (SL)

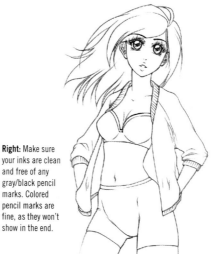

Right: Make sure your inks are clean and free of any gray/black pencil marks. Colored pencil marks are fine, as they won't show in the end.

From Top to Bottom: Cut out and stick very lightly to a larger area than you need.

Carefully slice along the lines to cut out the areas of tone you wish to remove and lift off gently.

Keep the scraps nearby, as they're great for toning small areas, such as creases in clothing.

When you're sure you don't want to lift it any more, lay a sheet of paper above your artwork and rub to firmly stick your tone to the paper.

1

2

3

4

5

6

Here are some additional techniques you may wish to use to make your tone work look fancier:

1: Use an abrasive eraser to remove some areas of tone softly.

2: Layer your tones for added depth and contrast. Just be aware of the effects that laying multiple patterns over each other can create.

3: If you've sliced too much tone away, it's not a problem: fill in small mistakes with your pen afterwards.

4: When slicing long, straight lines, use a metal ruler to keep it neat and controlled.

5: You can add highlights by applying white ink or correction fluid.

6: For fine highlights on large areas of tone, you can get great results from etching away with your knife tip.

7: The finished image!

7

MAKING COMICS:
LETTERING

Lettering

Lettering can be a tricky process, and it often seems like there are more Don'ts than Dos in this particular aspect of Manga creation. But because text readability is essential to your story's success, we've included tips and tricks for placing speech bubbles, choosing fonts, and creating sound effects both digitally and by hand.

TIP 091

Speech Bubbles

Speech bubbles are as much a part of your comic page as the art is, and they need to be thought about when planning the page. I prefer to put my speech bubbles into the page when I'm drawing because it helps me to plan with them in, but there's nothing wrong with doing it on the computer as long as you know where they're going to be. Whichever way you do it, it will get easier as you get better at working out how much space your text is going to take up.

The most important thing with speech bubbles is their flow—that is, in what order they read. English is read from left to right, top to bottom, and it enhances a panel if the speech bubbles are ordered in the same way, as in the example shown at the top right.

Checking that your speech bubbles (and panels) read properly is very easy—just remove the art and text from your page and ask a friend what order they'd read the page in. If they go in the wrong direction, you need to change things.

Speech bubbles house text, and there must be room for the text to breathe.

Don't squeeze it all in, and don't have too big a speech bubble either. Wrapping the bubble tightly around the text also doesn't work very well. The text itself should fit the bubble; left- or right-justified text rarely works.

The shape itself can also imply different things about the text: boxes are commonly used for narration, and a cloud shape is used for thoughts. Spiky bubbles are good for shouting, and perhaps a wavy outline would imply confusion or drunkenness. Experiment and try new things, but as always, don't overdo it.

Top: The speech bubbles here run left to right and top to bottom.

Above: Changing the position of the third bubble makes all the difference to the reading order.

Below: Examples of different kinds of speech bubbles.

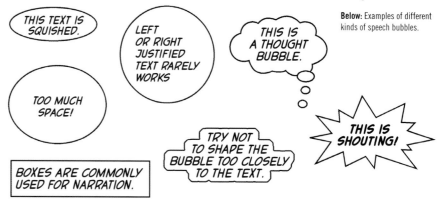

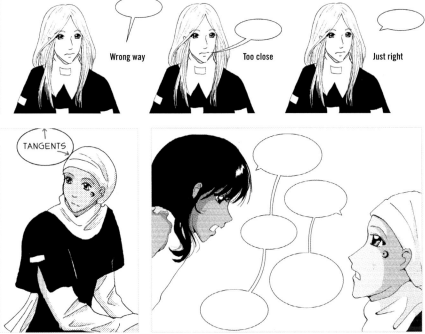

Wrong way

Too close

Just right

TANGENTS

It's also important to make speech bubbles fit the panel. One way to do that is to make the panel border the bubble border if it's close by. If that's the case, you may want to left- or right-justify your text in that bubble. You can run a bubble across a panel border, but if you do that the reader's attention will probably be drawn to that panel next. That's fine if that's the flow you want, but don't do it otherwise. You can even use this trick to direct the reader's attention if your panel layout could be confusing—a cross-panel speech bubble that is clearly in order with the others will lead the reader the right way. Don't rely on that too much, though, as it's better to keep your panels in a clear order if you can.

When placing bubbles, avoid tangents at all costs. Tangents in this sense means the effect of placing a bubble so its edge touches another edge, whether it's the panel border or a line within the frame. It creates an unpleasant visual effect but is easy to avoid—just make your bubble slightly bigger or slightly smaller.

I prefer the tails—the little tags that show who is responsible for the speech bubble—not to always lead straight to the character's mouth. It looks forced and unnatural. However, if possible, try to make your tails point in the direction of the character's mouth rather than, say, their stomach. It will make the speech bubble easy to attribute and instinctive for the reader to understand.

Connecting bubbles directly is one way to get around the problem of having too much text. If you do use connected

bubbles, make sure the break in the text between the two bubbles is a natural one—where someone would draw breath, for example. Using a connecting line between bubbles is generally not a good idea; it can be useful in a crowded panel, but if that happens you should really think about re-paneling the page so it's not necessary. It's not as easy to read a string of connected bubbles crammed into one panel as it would be if there were several panels. This can work in some cases, however, like for a heated argument. If there are just two people talking, then it's not hard to work out who says what, and the rapid-fire back-and-forth would be better represented by a set of speech bubbles in one panel than it would be by repeated panels with one or two bubbles each.

Finally, are bubbles necessary? Most of the time they are, but an aside—a comment that isn't part of the normal conversation—will often work better without one as long as it's visible against the background. (ML)

OH, NEVER MIND THAT. IT DOESN'T REALLY MATTER. WHAT DID YOU THINK ABOUT THE OTHER PLACE WE VISITED? LAST WEEK, I MEAN.

GYBE-OH!

WATCH YOUR HEAD!

Top Left: A leading speech bubble.

Top: Tails pointing the wrong way, too close, and just right.

Above Left: Tangents with speech bubbles.

Above: Connecting bubbles can work.

Left: Throwaway comments often work better without bubbles.

MAKING COMICS:
LETTERING

TIP 092

Fonts

Comics are a marriage of words and pictures, and the words are just as important to get right. Even more basic than simply dialog, however, is the choice of font. It might seem like a small and silly thing, but the font you choose for your comic will make a difference to the reader—at worst, it will remind them that they're reading a comic, rather than allowing them to immerse themselves in the story. Ideally, you want a font that is barely even noticed by the reader. Picking a good font is not difficult, though. Here are some Dos and Don'ts:

Don't use your own handwriting.

Don't use Comic Sans. It's overused and the main message it sends out is "I was too lazy to find a decent font."

Don't use a "normal" font, such as Times New Roman, without a very good reason—partly because it also implies laziness on your part, but also because normal fonts aren't made for comics and don't fit the speech bubble so well.

Related to the above point, don't pick a font that places too much space between lines (leading) because this will make your speech bubbles look odd, and it wastes space. Using a font with proper spacing for a comic means you have more room to play with the text.

Don't choose a font size that is too large or too small. It's very tempting to pick a small size

to allow you to fit more words on a page, but if it makes it hard to read, your comic won't work very well. Remember that more words do not necessarily help the overall readability, even if they all fit on the page. Too much text makes for a clunky comic. If your font size is too large, even if you don't have many words per page, it will look overemphasized.

Don't use funny effect fonts for speech, or at least, don't do it all the time. Using a gothic-style font for, say, a magician casting a spell is a good idea, but having them speak that way all the time will make the comic a difficult read.

Changing font size is a good way to imply shouting or whispering, and using bold or italic lettering adds emphasis to individual words. Changing the font itself can imply all sorts of things, from accents to languages. Changing font color can be very effective in characterization. But don't change parameters all the time, or the reader will become immune to the effect and it won't mean anything. (ML)

Below: A good font for casting a spell.

Right: Different fonts for different purposes—but use with care.

Above: Example of fonts and spacing that don't work.

Sound Effects

The most important thing to remember with sound effects is that they are not speech, and you should not be using the same font for both. Sound effects are necessarily different, and if you're thinking of adding one to your page it's because you want the readers to hear the sound as they read. Using the font you use for speech takes away from that effect.

I personally keep one font for most of my sound effects—little things such as tapping on a door, which don't make a huge impact on the characters but are required for a panel. My important sound effects may use the same font, but I often layer them to add to the effect.

Sometimes I'll draw a sound effect in by hand. Unlike normal text, where it's better to use a font because it's more consistent and easier to read, doing sound effects by hand is often quicker and provides a better fit for your effect than searching endlessly for that "one right font." If you're going to do this, rough it into the page in pencil first, and make sure you have enough room for the effect as you want

it to be. If you're unsure, draw it on a separate piece of paper and then add that in digitally to the finished page as a separate layer. By doing this you can move your sound effect around and change its size and angle very easily.

Here are some things to think about for your sound effects:

Make the sound effect fit the sound. Use a spiky font for surprise, a big, chunky font for heavy impacts like a door slamming shut, and a rounded, "soft" font for quiet sounds.

Make the sound effect fit the image. A "nee-naw-nee-naw" needs to follow the siren. It might look even better if you made it wavy.

Make the sound effect fit the panel. Like your speech bubbles, it needs to be part of the page, not superimposed on it.

Make the sound effect fit the modulation. Does the sound grow or fade? Change the size of the font to match.

Finally, however you do your sound effects, be sure to keep them legible— there's no point in having them if the readers can't read them! (ML)

Above Left: Layering a font gives it additional effect.

Left: Different fonts for different effects.

Finish and Output

The last thing you want is for all of your hard work to go to waste when you send your illustrations or comic pages to the printer, or upload it for fans to look at online, only to get very little response. It is important to consider the formats you wish to publish your work in, be it on screen, on paper, or both. There are positives and negatives associated with any format, the most important of which are to do with the financial costs. Webcomics are a great way to publish your work to an unlimited audience in full-color and any size for little investment, but can be hard to monetize. Printed comics have to be saved in the right image formats so that the printers are able to produce sharp edges and the correct colors. Manga in particular uses screentone for shading which requires special attention when being prepared for print to avoid any fuzziness. Mistakes here can be very expensive, so lots of tests are necessary.

FINISH AND OUTPUT:
OPTIMIZING FOR THE WEB

Optimizing for the Web

These days Manga creators are no longer limited to the often financially prohibitive print medium to get their comics out to potential audiences. Webcomics and e-books, available to e-readers, provide cost-effective and immediate methods of making your Manga available to the masses. Here are a few tips to get you started.

TIP 094

Webcomics

Webcomics are a great way to make your comic available to many people without having to shell out for print copies— especially if you work in color. They offer the chance of a wide readership and instant feedback, and constant drawing means constant improvement. They are also much more flexible than print comics; you can animate sections of your comic, or make use of sound and music. However, webcomics are not an easy ride. They require reliability, commitment, organization, and dedication to deadlines.

Webcomics can be roughly grouped into two categories: gag strips and story comics. Gag webcomics are the kind of comic a reader can dip into whenever they choose. They can have short story arcs lasting a few strips, or occasionally long-running story arcs, but in general each strip can stand alone, with its own joke or point.

Story webcomics maintain an ongoing story. The disadvantage is that each page offers little immediate payoff. Unless you can upload several pages at once, your comic can end up feeling very slow. Just imagine reading only one page of your

HUMANS ARE THERE TO OPEN DOORS FOR CATS

Left: This is an example of a gag comic, complete in and of itself.

Right: This is a page from a story comic. I uploaded this in chapters, adding a new chapter about every other month. If this had been an entire update on its own, it wouldn't make much of an impact on readers, but it works very well as part of a chapter.

favorite comic twice a week! That shouldn't put you off, but bear in mind how it will be for readers. The extreme end of this type is the webcomic that updates with an entire chapter every few months or so. That might actually be a more satisfying experience for readers.

If you want to make a webcomic, try running it for a couple of months without actually putting the strips online. You'll have the experience of making the comic regularly without the stress of the actual commitment, and at the end of the trial period you'll have a nice backlog.

Above: A character page from my current webcomic.

When you do start, keep that backlog going. I make sixteen to twenty strips at once, and when I draw near to the end of each set I start on the next. That gives me time to work on other things in between. Even when you're not actively working on the comic, though, be thinking about what's next, and jot down notes and ideas.

There are thousands of webcomics out there, so promotion is very important. Be in every webcomic listing you can find, and mirror your comic strips—don't just keep them on one server. Also, appreciate your fans. Make it easy for them to comment and reply to comments and emails—and fan art, if you are lucky enough to get it. Add extra material to your site, such as an image gallery, character details, and fan art pages.

Finally, always update on schedule. Plan time to make your webcomic and be reliable. (ML)

TIP 095

E-versions

The advent of the Kindle and other specific e-readers provides comic creators with another way to get their work into the hands of readers without paying for print. The process of making an e-book is going to differ depending on your chosen format, and the best way to discover the tricks to making the actual e-book is to do a Web search—there are plenty of tutorials online. The vast majority of them will be for novels, however, so here are a few things you may find helpful when converting your comic to e-book format.

If you want to convert your comic to an e-book, you are best off actually having the relevant e-reader to test pages on. Every e-reader is different, but when I converted my comic to the .mobi format (a common e-book format readable by many e-readers, including the Kindle, which I was using), I spent several hours testing different sizes, resolutions, and filters to make sure the page and its text came out as clearly as possible. You can download free e-reader software for your computer that ought to imitate a Kindle screen, but the real thing is always best.

A Kindle 3G screen has a resolution of 167 dpi and sixteen shades of gray. I found an image size of 700 pixels tall and 500 pixels wide worked best for my comic on the Kindle 3G, but you may wish to try other sizes. If necessary, allow white space at the sides or top and bottom of your image—it might not be possible to resize your page perfectly to fit the e-reader screen. When converting your pages, first change their size (in pixels) and resolution, then dither the resized images to sixteen shades of gray. Then you can try sharpening the line art of the resized image, or perhaps darkening it so it stands out better. Make sure you test your images as part of a .mobi file; if you put them

Above: A converted comic created using KindleGen and uploaded to Amazon. The text and tones are clear after optimizing for the Kindle.

into a .pdf to view them on your Kindle they will look different from a .mobi file containing the same images. I saved my comic pages as .png files, but check your chosen e-book format to make sure you choose the right type. Avoid .jpgs if at all possible.

Converting your collection of images to an e-book can be done with a number of tools. I used Amazon's free KindleGen program, which makes a .mobi file. The format requires an .html file for the content of the book (for a comic, it will mostly be a list of images); an .ncx file, which holds the table of contents; and an .opf file, which specifies the details of the book, including the cover image. The cover image can be in color—it is what will be displayed at Amazon if you choose to upload your book there. Other tools and other formats will have different requirements. If you follow their instructions, making your comic into an e-book should be a simple process. (ML)

FINISH AND OUTPUT:
PREPARE FOR PRINT

Prepare for Print

There's nothing more exciting than holding the printed pages of a comic you've created in your hands, and print is still a very popular method of producing Manga despite the advent of digital delivery. But readying a comic for print has its own unique problems, and we've tackled the most common below.

Above: Text nearly disappearing into the spine of a graphic novel.

TIP 096

Layout Considerations

There are two ways to print a comic: You can make a booklet of folded paper, often bound by staples or perhaps a ribbon to add a touch of class (this is commonly known as a "floppy"), or you can print a perfect bound book, which will have pages glued or sewn to a spine. Books are typically ninety-six pages or more, and you will find it difficult to make a floppy that is over seventy-two pages.

The importance of safety margins in laying out comic pages has already been discussed; this is where they come into play. Your printer will trim your pages for you (and cut off the bleed area), but there is always a margin of error (the trim area), so be sure to stick within the margins they give you. If you are making a book, it's worth thinking about on which side of each page the spine is; if an important detail is close to the safety margin on that side, it will be harder to read when the book is bound.

If you are making a floppy comic, the total number of your pages will be a multiple of four, and you should prepare it for printing in pairs of pages that will fold together to give the correct reading order. The easiest way to work this out is to fold together sheets of scrap paper, then page through them and write each page number on each side. Take the mock booklet apart, and you'll see which comic page needs to go on the left of each double page and which needs to go on the right.

Below Left to Right: A map, bonus art, and an introduction page with a four-panel extra comic.

If you are making a perfect bound book, your page count restrictions will depend on your printer. A digital printer will probably just need to have an even number of pages, but a lithographic printer is likely to require a multiple of sixteen or even thirty-two pages. Check first, and provide your pages as single pages, not as spreads.

Either way, you will probably have extra pages to play with, so don't waste them. You could have title pages, an index for a book, author's notes, extra art or fan art, small bonus comics . . . I have had recipes and even a pattern for a plushie in the back of my comics. These small extras are fun to read and round a comic off nicely. (ML)

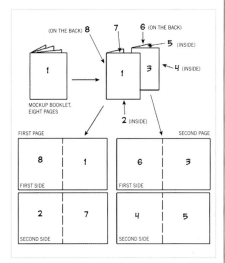

Above: Page layouts for an eight-page booklet.

Black-and-White Screentoned Comics

Screentone is both attractive and cheap to print, since the patterns are pure black and white. However, it comes with a unique set of problems. If you are planning to print a toned comic, you ideally should have planned the print size and resolution before you started toning, because when screentone is resized digitally, the calculations used by the computer to work out the shade of each new pixel tend to produce a checkered pattern from tone, called moiré. It is particularly common in toned webcomics, since images for the Web must be resized from the original print size.

Another problem that is common in black-and-white comics is the use of anti-aliased lines, or even anti-aliased tone. Anti-aliasing is the slight fade at the edge of a line that makes it look better on the screen—unfortunately, it doesn't work in print. A black-and-white printer printing a gray image has to convert it to black and white, and it will usually attempt to compensate for making a gray pixel white by making the next gray pixel along more likely to be black. This results in a spotty line—or worse, spotty tone.

The best way to avoid moiré and spotty lines, if you are working digitally, is to tone in pure black and white at the actual size of printing. The print size depends on both the pixel size of your image and the resolution of the printer. You can ask your printer about the resolution of their machines, but 600 dpi is a common resolution and high enough that your pages will look good. Be careful when setting resolution and size; many programs change the one depending on the other, so make sure your final page is both the correct resolution and the correct size. If you work in pixels, an A4 page at 600 dpi is 4960 pixels wide and 7016 pixels tall.

If you are working with real tone, or you need to resize digital tone, try using a whole number to resize (for example, reduce by 2, making the image half the original size). You should be using the pixel resize and not the smart resize, since you don't want the computer to make your tone gray. Don't forget—you can always ask the printer for some test printouts so you can choose the best options. (ML)

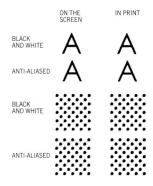

FINISH AND OUTPUT:
PREPARE FOR PRINT

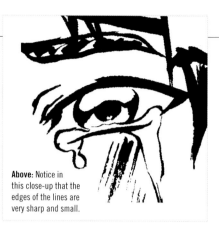

Above: Notice in this close-up that the edges of the lines are very sharp and small.

TIP 098

Grayscale Comics

Although most Manga series are shaded with screentone for accurate control over the way grays are depicted, nowadays the onset of digital preparation for printing and smarter technology means that having softer variations of gray washes in solid swatches is no longer taboo but rather a viable option for giving your artwork a different look.

For me personally, grayscale shading is perfect for using with a brush pen to give a painted look to your comic, where the story line suits the style. Perhaps you are telling a Chinese ghost story? Or, as in this example I illustrated for "Talking to Strangers," written by Fehed Said: A dark urban legend.

It's important to do as much as you can with the inks before going on to grayscale shading, as it is not as busy-looking as shading with screentone, so it can feel very flat. Counteract this by inking with a brush. Play with the tool and show off the texture and variation in lines, and do a bit of hatching and shading with the brush. But be careful about introducing too many grays at the inking stage. There is a trick to having beautifully defined and sharp black lines, even if going for soft gray shading throughout. Get rid of any anti-aliasing around the edges of the inks by turning them into pure black and white—use the threshold function to

dictate the lightest level of gray that could convert to black, where anything lighter becomes white. Or convert it to bitmap temporarily using the 50% default level so that there aren't any grays on the line art layer. It stops your lines from blending too much into your shading and reduces the muddiness. However, I have seen artists use soft lines very effectively as long as the lines are sparse and neat yet depict complex subjects—so this is ultimately up to you!

Then paint your shading on another layer. I found it very useful to keep a small palette to one side of the picture of several shades of gray from 10% through

to 70% in increments so that I could pipette it and paint as needed. It helps to keep the shade of the skin or clothes consistent but also guards against shading too light or too dark. Try to keep up the contrast and keep panning back and looking at the bigger picture to check whether it works.

Once you're done with any text, be sure to save in a format that is non-lossy—grayscale .tif files are best to preserve the sharp edges of the lines against the soft shading. You can then generate .pdf files for your printer from .tif files. (SL)

Right: For an unsettling feel, I didn't use any rulers in the final inking, going for freehand straight lines instead.

Far Right: This shows the image after all the shading was done.

Color Comics

This piece was created as a single-page story in full color. I wanted the final comic page artwork to resemble stills from an Anime, so the foreground elements such as characters and props were colored in a cel-shaded style while the backgrounds were more painterly. All the panel lines and shading/coloring were added digitally using Photoshop, and further depth was added to the color using Dodge and Burn.

When preparing your color comic work for print, there are multiple factors to take into consideration. I like to work at as high a digital resolution as possible (usually 600 dpi), but for color printing 300 dpi tends to be the accepted minimum standard, while black and white/monotone is usually higher. It's advisable to work in RGB color mode (make sure the file is set to the RGB working space profile), then if you are required to convert the work to CMYK color mode, you do this when you're

happy the art is completed and looking correct. Depending on the printer/services you are using, though, CMYK conversion may be done for you, so research or ask about this beforehand. If you're doing the converting yourself, apply it and see how it affects the colors to your eye. Highlights and shadows may appear different, so you can make adjustments to color and tone as necessary, using Levels, Curves, or Hue/Saturation adjustment layers.

You may find that through CMYK conversion, blacks appear washed-out and not as dense and pure as in RGB mode. If you wish to address this yourself, you will probably need to get into advanced color management and the nitty-gritty of separation types and black generation. In Photoshop there are settings you can play with under Edit/Convert to Profile. In Destination Space/Profile, you can select from a huge list of options, one of which

is Custom CMYK. With this selected you will be given another menu panel that lists Separation Options.

In GCR (Gray Component Replacement), black ink is used to replace portions of cyan, magenta, and yellow ink in colored parts as well as in neutral areas (where the CMY values are equal). GCR separations tend to reproduce dark, saturated colors somewhat better than UCR (Under Color Removal) separations do and maintain gray balance better on press. Within GCR there is also the option to manage the amount of Black Generation, which you can, if needed, turn up to maximum. (NH)

Below: You can fine-tune your color profile if you want to increase or decrease the level of one particular value of cyan, magenta, yellow, or black. You can also define the exact shade to be used in place of color value.

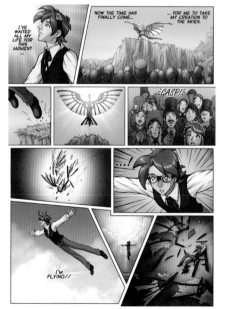

Far Left: The colors were painted in RGB mode for ease of working and natural intuition with color blending. It tends to use less computer memory as well.

Left: Nowadays, you can convert your image to CMYK without too much changing, but there will be subtle variations and desaturated areas. Check this carefully and adjust accordingly before sending to the printer.

Professional Practice

If you want to be a professional Manga artist and illustrator, there are a lot of things you have to consider outside of the world of drawing. Industry practices vary from country to country, but in every case you are rewarded for showing initiative by creating products on your own and selling them, being organized with your projects, and marketing yourself well. Successful illustrators don't get where they are through pure luck; they are constantly on the lookout for opportunities and new networks. Work will not just come your way—you have to make work come to you. Furthermore, drawing for fun is a completely different activity than drawing for a client. You have to learn how to prioritize the client's requests and get the information you need to produce the work correctly. You also need to ensure that you are protected from being taken advantage of, so you must develop contracts and invoice systems.

PROFESSIONAL PRACTICE:
ARTIST AT WORK

Artist at Work

If you're going to make a living in Manga, you're going to have to learn how to manage your time effectively on your own and work with clients. There are a few things we've learned over the years that constitute "good practice," and these tips should help keep your clients happy and keep you solvent.

TIP 100

Above: A digital calendar that you can easily access like Google Calendar is ideal.

Self-Management for Illustrators

Amateur artists can at times envisage a golden picture of the lifestyle of a professional artist—surely it's the dream job to get paid to draw Manga. But it's really not as simple as that!

In Japan, a Manga artist that has made it big will typically work for one or two publishers with several assistants on a long-running series. They would be expected to churn out pages, up to thirty or more, every two weeks. They barely have any time to work on anything else, let alone personal projects. Furthermore, they are subject to changing everything based on what their editors tell them and to extending the story if it does well. And if you haven't made it big yet, you probably will be working as an assistant—so you would be drawing mainly the background and vehicles, filling in blacks, doing the toning and sound effects, etc.

Outside of Japan, comic artists (even those who work in Manga) tend to manage themselves or will have an independent agent who negotiates for them with many publishers and clients. They are rarely tied into working with just one company, and while there may be a few successful

partnerships, they can be paired with a writer or a colorist as the publisher sees fit. Comic production is slower and more finite, so it is much more of a freelance job, getting contracts from various places rather than having one "boss" to tell you what to do.

Freelancing in illustration is a real balancing act. You have to manage your time effectively and keep track of several things at once. Ultimately, it's about keeping the money coming in and delivering work at a realistic pace.

The main weapon in your arsenal is a diary or calendar—whether it's an actual little book or a digital one. The main thing is being able to access it at all times. I use Google Calendar and it feeds through to my Android phone. Use it to keep track of meetings, project deadlines, and special events. I recommend checking it every day to memorize anything coming up within the next two weeks so you have a strong overall picture of your workload and can adjust your pace accordingly.

Also, keep track of your working hours. Some people work better with a routine

similar to normal office hours, while others prefer to have a few very long, intensive days followed by complete rest. Freelancing is not a license to slack off! Make sure you put in around 35–45 hours of actual working time a week. There are a few things I do to ensure I don't get distracted: Turn off Web browsers and tabs except for those you need for e-mail and research. Set up a timer so you can see how long you're on the clock. Stream a live video of you working on a project—you will be less inclined to slack off if you know the world is watching! It's great for promotion as well, but obviously this can only work for images you are allowed to make public.

The creative industry can be tough if during those working hours you get some form of art block, so make the most of those times with warm-up sketches or administrative work.

Try to budget three or four days a month for administration. Send out your invoices as soon as you can. To keep the money coming in, do some promotional work— clean up your website, update your social networks, showcase your latest works, and plan and book any trade shows. (SL)

TIP 101

Working with Clients

Perhaps the biggest change in mind-set when you draw something happens when you're drawing not for yourself but for a client. It is one thing when you draw something you feel like drawing, for fun, in your own time. It is another when someone else is paying you to draw something for them. You would have been hired because the client thinks you will be able to deliver the goods, but you must never forget that what matters at the end is that the client is satisfied with the work—even if you're not happy with it!

The first thing that needs to be nailed down is a good description of the work. This can be surprisingly difficult—some clients don't actually have a clear picture of what they want, and others want you to give your expert advice. I try to ask leading questions to anticipate and gauge where they're going in order to prevent back-and-forth e-mails, or to give them an opportunity to say what they absolutely don't want. This doesn't apply if the job is an event (that is, giving a workshop or talk), but when it concerns artwork. I also use reference pictures, such as images on the Web or in my portfolio. You can even get them to draw you a stick figure! A phone call can clear things up quickly, but remember to put everything down in writing as well so that communication is clear on both sides.

The next thing is some form of contractual agreement, which is a total necessity when working on a large project, or working with a complete stranger, but recommended for all jobs where possible. This can be in the form of a letter or an e-mail for a lower-paying commission, but for something like a full-sized book requiring months of work, there should be a formal contract both parties will sign. This agreement should clearly specify what the job entails,

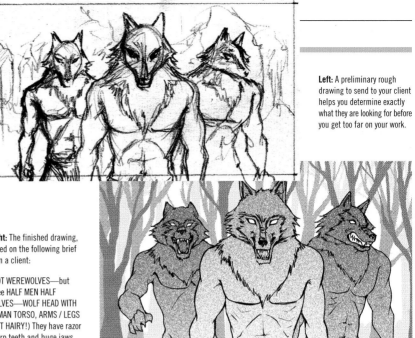

Left: A preliminary rough drawing to send to your client helps you determine exactly what they are looking for before you get too far on your work.

Right: The finished drawing, based on the following brief from a client:

"NOT WEREWOLVES—but three HALF MEN HALF WOLVES—WOLF HEAD WITH HUMAN TORSO, ARMS / LEGS (BUT HAIRY!) They have razor sharp teeth and huge jaws. It's dark, in a spooky forest."

how much you will be paid, any deadlines, any penalties, and final rights/ownership to works produced.

It's up to you how much detail you want to go into regarding the job description. You may want to specify the exact media to use, the size, and whether they need any originals (like the sketches) or if a digital copy is sufficient (and if so, what file type/format, resolution, etc.).

Deadlines are very important to confirm so that both you and your client have a clear picture of when the project will be finished. Be aware of how long it will take for you to complete the work, and budget for a few extra days or weeks if you can. There will always be the odd hiccup, so extra time is never a bad thing. For large projects, it is good to negotiate delivery in batches: perhaps roughs, followed by inks, then final colors. Or half of the images by a certain date, and the remainder by a later date. Delivering work in rough and part-finished stages is also a good strategy for spotting when something needs changing before progressing further on your work.

Penalties are never a nice thing to discuss, but it's important to know the consequences for both sides if something goes wrong. If you find yourself unable to finish the work for any reason, it's good to know if you can keep some payment for work done up to that point. For the client, they need to know the limitations of what they can ask for—if they suddenly need something faster, or if they need more changes beyond what was originally agreed, they must also understand that you may need to charge more.

Ownership is actually something you should take into account when you are pricing your work. For example, if your client wants full copyright and offers no future earnings from it, you should be paid more up front.

If the client is satisfied with the work, then it's time to get paid! Make sure you invoice as soon as possible after the work is completed and include full details on payment methods. You want to make it as easy as possible for the client to pay you, after all. (SL)

Index

A

action lines 46–47
Adobe 128
adults 70
aerial perspective 80–81
afterglows 83
age 32, 71, 111, 122
agents 172
Alchemy 100–101
aliens 62, 66–67
Amazon 165
ambience 82
anatomy 20
angles 24–25
animals 35, 59–60, 66–67, 91, 103
animation 164
Anime 6, 40, 64, 98, 169
anti-aliasing 131, 154, 167–168
architecture 77, 84–87
arms 37–38, 41, 61, 71, 111
Art Nouveau 87
atmosphere 82–83, 90, 97, 124, 153
Autodesk 3ds Max 76
autumn 90, 118
The Avalon Chronicles 153

B

backlighting 111, 153
backlogs 164–165
Baroque 87
battery packs 65
battle suits 64
binding 166–167
Bitmaps 154, 168
Black Generation 169
black and white 6, 15, 33, 104–108, 113, 119, 131, 150, 154, 167, 169
bleed marks 146, 148, 150, 154, 166
Blender 76
body language 42
body types 38
boots 57–58, 68
braids 28
brainstorming 150
brushes 82–83, 93, 100–101, 106–107, 118, 120, 124, 128, 131, 152, 154
buildings 84–87, 101, 103
buildup events 148
Burn 119, 169

C

calendars 172
caricatures 91
cel shading 126, 169
centaurs 60

cheeks/cheekbones 22, 24, 33–34, 38, 111
chibis 35, 40–41
children 35, 40–41, 68
cityscapes 79, 83–85
clients 173
cliff-hangers 144
clothing 54–56, 61–62, 68–69, 71–73, 103, 107, 126, 134, 141, 151
clumped hair 26–27
CMYK color 108, 169
Color 119
color comics 169
color palette 54–55, 57, 71, 108, 112–115, 122, 124
color picker 113, 122
color theory 112–115
color wheel 112–114
colored pencils 138, 141
Comic Sans 160
comics 131, 142–161
complementary colors 112
composition 96–99, 102, 112, 124
concept cars 93
concepts 100–101
contemporary design 68–73
contracts 170, 173
cooling systems 65
copyright 173
costumes 50, 56–57, 62–63
creatures 50, 59–61, 91
Curves 169
cybernetics 67

D

Darken 119
deadlines 152, 164, 172–173
default brushes 118
DeFilippis, Nunzio 153
depth 82–83, 88, 94, 111, 120, 122, 135, 153
designer clothing 69
dialog 146, 160
diaries 172
digital cameras 17
Direct Selection 132
direction of force 92
directional cues 149, 151
Dissolve 119, 154
distance 80–81, 88, 92
Dodge 93, 119, 169
DPI (dots per inch) 108, 154, 165, 167, 169
dragons 61, 91, 153
drawing 19, 102–105, 150–151
dust 82–83
dwarves 58
dynamism 46, 55, 124

E

e-books 165
ears 24, 35, 58
elderly people 71
elves 58, 61
establishing shots 77
ethnicity 33
Event File 130
experimentation 19, 39, 41, 57, 91, 98, 100, 104, 107, 110, 113, 119, 126, 137, 152
expressions 34–35
extra pages 167
eyebrows 31, 33–34, 141
eyelashes 30, 33, 141
eyes 24–25, 30–32, 70, 91, 131

F

faces 30–35, 41, 70–71, 92, 96, 103, 105, 107, 110–111
fairies 61
fans 165, 167
fantasy design 50, 56–61, 67, 72, 113
fashion 69, 72
fastenings 62, 72
feather sweepers 105
feedback 102, 145, 164
feet 42–43, 45, 68, 91
femininity 33, 42–43
file formats 130, 154, 165, 168
fineliners 136
flashbacks 107
flow 96–97, 148–149, 158–159
focal points 46
focus lines 46, 151
fonts 151, 160–161
footwear 44–45
foreheads 23
foreshortening 48–49
frame width 147
freckles 122
freelancing 172
French curves 93
fur 91

G

gag strips 164
GCR (Gray Component Replacement) 169
geometric lines 55
gloves 44–45
good practice 18–19, 172
gradation 88–89
graphics tablets 16–17, 106, 118, 132–133, 148, 152
Grayscale 154, 168
grid lines 76
guide points 46

H

hair/hairstyles 26–29, 54, 69, 73, 91–92, 120–122, 124, 126, 131, 135–136, 141
hand shading 156
hands 42, 68, 77
Hard Light 119
Hard Mix 119
hardness 118
heads 22–25
highlighting 27, 30, 89, 110–111, 115, 118, 124, 131, 134–135, 137, 141, 153–154, 169
hips 37, 41, 98
hobbies 12–13
horizon 78–81, 124
html files 165
Hue/Saturation 120, 169

I

Illustrator 128, 132–133
image galleries 165
image-editing software 15–17, 108, 113, 128, 130, 154
infrastructure 84
inking 15, 82, 88, 106–107, 150, 168
inkjet printers 134
invoices 170, 172–173

J

jaws 25, 33
jpg files 165

K

kata (forms) 92
Kindle 165

L

landscapes 88
laser printers 134
layers 17, 82, 98, 105, 116, 119, 122, 124, 126, 128, 130, 152, 154, 156, 161, 168
layout 97, 104, 142, 144, 146–149, 151, 166–167
lettering 158–161
Levels 120, 169
Li, Nana 153
life experience 12–13
light 82–83, 88, 91, 94, 110–111, 114–115, 119–120, 122, 131, 141
Lighten 119
limbs 37, 60, 65, 70, 91, 103
Linear Light 119
lips 23, 31, 33–34, 122
Livetrace 132
Luminosity 128

APPENDICES:
ARTISTS' DETAILS AND ACKNOWLEDGMENTS

Artists' Details

Sonia Leong (SL)
sonia@fyredrake.net
http://fyredrake.net

DestinyBlue (DB)
alice_is_evil@hotmail.com
http://destinyblue.deviantart.com

Selina Dean (SD)
bentosmile@gmail.com
http://noddingcat.net

Di-San (DS)
dice_san@hotmail.com
http://di-san.deviantart.com

Niki Hunter (NH)
niki@vk-uk.com
http://niki-uk.deviantart.com

Inko (IK)
dokoteiinko@gmail.com
http://inko-redible.blogspot.co.uk

Ruth Keattch (RK)
ruthkeattch@googlemail.com
http://spookyruthy.deviantart.com

Morag Lewis (ML)
sunkitten@toothycat.net
http://toothycat.net

Nana Li (NL)
nannali@gmail.com
http://nanarealm.com

Chie Kutsuwada (CK)
chitan.garden@gmail.com
http://chitan-garden.blogspot.co.uk

Naniiebim (NM)
naniiebim@hotmail.com
http://naniiebim.livejournal.com

Hayden Scott-Baron (HS)
dock@deadpanda.com
www.deadpanda.com

Emma Vieceli (EV)
emma.vieceli@gmail.com
www.emmavieceli.com

Huge amounts of thanks go out to all of the wonderful contributors to this book; it wouldn't have happened without you. Your skills are all so amazing. Thanks as well to Ellie Wilson of Ilex Press for working closely with me on this project and being so gracious. Finally, I can't thank my husband Matthew enough for the unfathomable depths of cool-headedness he displays whenever I am working on a book because I become a nightmare to live with. Your tea-making skills are improving, darling.

Sweatdrop Studios
www.sweatdrop.com

SelfMadeHero
www.selfmadehero.com

Shambala Publications
www.shambhala.com

Kodansha International
www.kodanshausa.com

NBM Publishing
www.nbmpub.com

Markosia Enterprises Ltd
www.markosia.com

Ajiey Media
www.ajiey.net

Futurequake Comics
www.futurequake.co.uk

Paper Tiger Comix
www.papertigercomix.com

Hachette Children's Books
www.hachettechildrens.co.uk

Oni Press
www.onipress.com

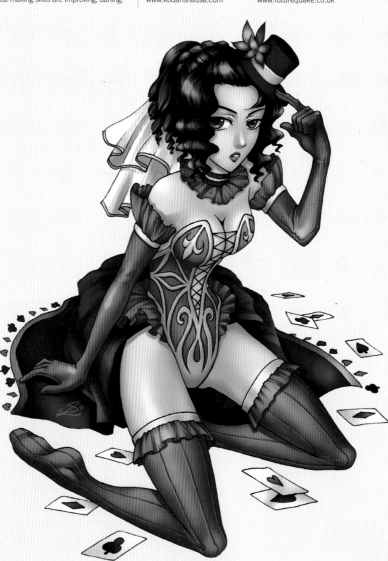